Making Their Mark

Art, Craft and Design at the
Central School, 1896–1966

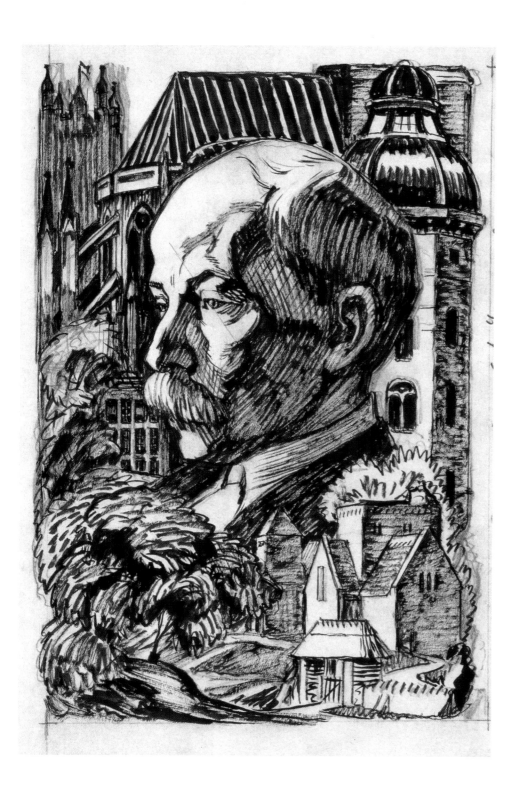

Making Their Mark

Art, Craft and Design at the
Central School, 1896–1966

Edited by Sylvia Backemeyer

Herbert Press • London

First published in Great Britain 2000 by
Herbert Press, an imprint of A & C Black (Publishers) Limited, 35 Bedford Row, London WC1R 4JH

ISBN 0 7136 5261 6

This book has been supported by the Arts Council of England

A CIP catalogue record for this book is available from the British Library

Designed by Alan Hamp
Cover design by Dorothy Moir

Cover illustration
John R. Biggs
Blockprinted design for endpapers, 1930s
Endpapers
Hilda Quick
Blockprinted design for endpapers, 1920s
Hilda Quick was a wood engraving student of Noel Rooke in the 1920s
Frontispiece
Noel Rooke
Wood engraving of Lethaby with symbols of his professional life:
surveyor of Westminster Abbey, architect of Brockhampton Church,
and Principal of the Central School of Arts and Crafts, 1935
285 x 225 mm
Central Saint Martins Museum Collection

This book has been typeset in Gill Sans – a face designed by Eric Gill based on a design
by Edward Johnston for London Transport

Printed and bound in Turin, Italy by G. Canale & C. S. p. a.

Contents

Acknowledgements

This book would not have been possible without the resources of the Central Saint Martins Museum and Study Collection which owns much of the material referred to and illustrated in this book. The editor would also like to express her gratitude to the many individuals and organisations, listed below, who gave their help so willingly. Particular thanks are due to Andrew Watson and Vijay Dhir for photography, and to David Brook for the index and help with editing.

The editor and publisher have made every effort to trace the copyright holders of works and photographs; their names are followed by the page number where their work appears. If any individuals or institutions are incorrectly credited, or if there are any omissions, we would be glad to be notified so that the necessary corrections can be made in any reprint.

Robert Addington p. 53; Diana Armfield p. 12; Edward Barber p. 86; Leonard Bartle; Susan Bennett, RSA; Derek Birdsall pp. 34, 36; Dr E. Breuning pp. 102, 103, 107; Alison Britton p. 83; David Carter p. 81; David Collins; Constable Publishers p. 23; Peter Cormack; Roy Coulthurst pp. 134, 137; Patricia Cracknell p. 14; The Crafts Study Centre; Emma Dean, MOMA, Oxford; Ruth Eisenberg; Express Newspapers p. 45; Fine Art Society p. 118; Judith Fitton p. 8; Colin Forbes p. 37; Charlotte Forman p. 51; Ken and Wanda Garland pp. 38, 39, 54, 129, 130; Ann Hechle p. 140; Heinemann p. 116; Douglas Higgins pp. 8, 19; David Higham Associates p. 63; Richard Hollis; Ivor and Marian Kamlish p. 95; Barbara Kane pp. 23, 55, 116; Sara Kestelman pp. 61, 62, 64; Robert Kinross; Ralph Koltai p. 99; Victoria Lane, The Worshipful Company of Goldsmiths; John Lawrence p. 31; David Leighton p. 26; Gillian Lowndes p. 88; Georgina Master p. 43; Jeremy Newland p. 114; Oxford University Press p. 43; Joe Pearson; Steven Bateman, Pentagram archives; Mary Reyner Banham; Jonathan Riddell; London Transport Museum; Lucy Rushin; Linda Sandino; Mary Schoeser pp. 48, 117; Scholastic Ltd p. 43; Joanna Selborne p. 20; Richard Slee p. 89; Rita Slutzky p. 78; Herbert Spencer p. 35; Alix Stone p. 97; Margaret Stavridi; Margaret Till pp. 59, 120, 121, 124, 128; Philip Thompson; Frederick Warne & Co. Ltd p. 42; Cynthia Weaver; Robert Welch pp. 79, 80; Nora West p. 60; The Whitechapel Gallery p. 36.

Foreword

Making their Mark is a book of essays which celebrates the Central School and its widespread influence on art and design and its teaching in the first sixty years of the twentieth century. It focuses on the theory and practice developed by Lethaby and his successors at the Central School and traces the history of 'the Central', as it has always been affectionately known, through the development of disciplines and the work of key individuals. Many of these champions of their crafts, such as Robert Gibbings, Margaret Pilkington and John Farleigh, were also involved in the organisations which formed the Crafts Centre of Great Britain, the precursor of the Crafts Council.

The College has had the good fortune to have had a series of Principals of vision, in particular its founder, W.R. Lethaby, and in the post-war period, William Johnstone, who appointed many talented and inspiring staff.

The Central School has had a major impact on both craft and design in the twentieth century. In craft, in the post-war period, many of the key figures trained or taught at the Central, including the ceramists Alison Britton, Richard Slee and Gillian Lowndes, the textile designers Peter Collingwood and Marianne Straub, and the jewellers Fred Rich, Wendy Ramshaw and Jane Short.

In design the Central has made just as big a contribution. Thirty-two Royal Designers for Industry trained or taught there, such as Douglas Scott (the Routemaster bus), Robert Welch (stainless steel tableware) and David Carter (the Stanley knife and other tools), and others whose designs are part of our everyday lives. The richness of post-war British graphic design, evident in posters, advertisements and book illustration, owes a particular debt to the Central with its tradition of innovative typography and printmaking which produced designers of the calibre of Derek Birdsall, Alan Fletcher and Colin Forbes.

The editor, Sylvia Backemeyer, has brought together a range of contributors known for their writing on craft and design, and in the section 'Insights from the Inside' has provided us with a more personal view from the memories of former Central students.

The publication of this book has been made possible through the support of grants from the Arts Council of England, and the Higher Education Funding Council which has funded the three-year research project based on the Central Saint Martins Museum and Study Collection. This has given the College the opportunity to undertake research on the Central School and its history, including many staff and students about whom very little had previously been published. The book is a celebration of the Central's distinguished history and its contribution to the richness of our visual culture. Importantly, in addition, there will be an exhibition, curated by Mary Schoeser, which will open in the Lethaby Galleries in late September 2000 and then tour to galleries around the country.

The Crafts Council are very pleased to give their support to this project.

Janet Barnes
Director,
The Crafts Council

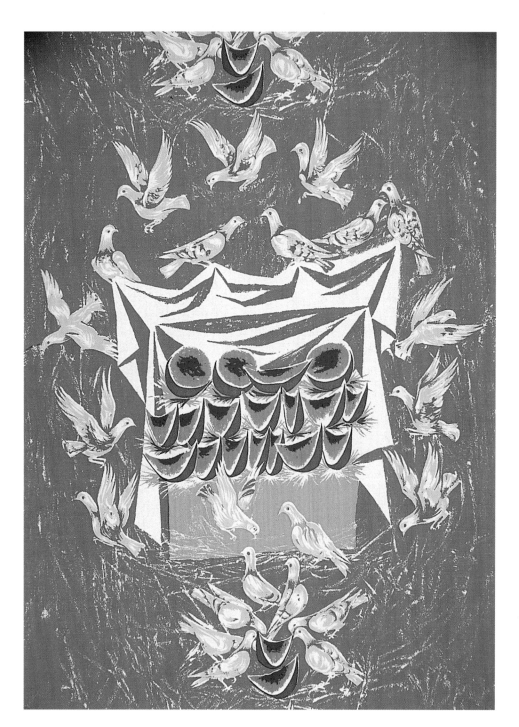

James Fitton.
'San Marco', 1957
Hand screenprinted cotton designed
for Warner and Sons Ltd. One of a
collection of six artist-designed fabrics
used in British Transport Hotels over
a period of five years.
Private collection.
Courtesy Woven Fabrics plc.

Introduction

Sylvia Backemeyer

Sylvia Backemeyer is Head of the Central Saint Martins Museum and Study Collection and is responsible for the research project which resulted in this publication and exhibition. She has curated a number of exhibitions based on the collection and her publications include Object Lessons, The Lethaby Press *and Lund Humphries, 1996*

In 1931 in his obituary of Lethaby, Noel Rooke wrote:

The whole spirit of the LCC Central School of Arts and Crafts was the creation of his vision as its first Principal. It was an entirely new experiment in education which has since been copied, more or less, by every school of art in this country, except the R.A. Schools, and by the great majority of schools in other countries. Except during the first few years, Lethaby had to build it up in the face of the keenest opposition and antagonism; but he built so soundly that twenty years after his retirement the school continues to grow on the lines he laid down.[1]

One of Lethaby's most significant contributions was his genius for selecting staff who could both innovate and inspire students. Many of his first appointments were members of the Art Workers' Guild and the Arts and Crafts Exhibition Society where Lethaby had met them. They were among the foremost craftsmen of their day and sympathetic to his philosophy of art and education. The appointment of Edward Johnston, a completely unknown young man, had the most far-reaching effects and best showed his ability to assess individuals and their potential.

Johnston's influence was enormous: brilliant young students such as Noel Rooke and Eric Gill claimed that Johnston altered the whole course of their lives; foreign pupils returned to open classes in Johnston's tradition in their own countries, and he was

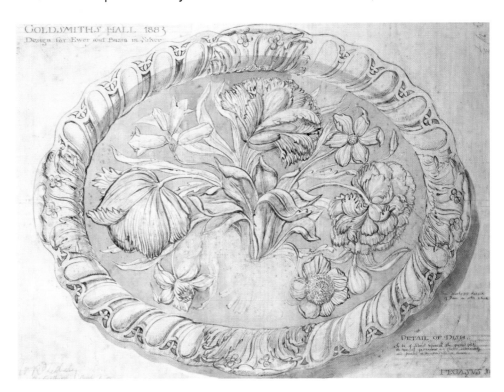

W.R. Lethaby
Design for a silver dish, an entry in the Goldsmith's Hall competition, 1883
Pencil, pen and watercolour
480 x 620 mm
Central Saint Martins Museum Collection

Edward Johnston
The 'bull's eye' symbol and lettering
designed for London Transport, 1918
© London Transport

particularly influential in Germany. His impact on book production and printmaking was profound. In the trajectory of Johnston's career, from his study of medieval manuscripts in the British Museum to the designing of his blockletter alphabet for the London Underground, we find the embodiment of Lethaby's vision of handicraft to modern society.[2]

Many of the teachers appointed by Lethaby only stayed for a few years at Central and some moved to the Royal College with him. From 1903 Lethaby worked at both Central and the Royal College until 1911 when he ceased to be principal of the Central School. But when they moved on they left a legacy of students trained in a tradition which enabled them to carry on their work to future generations. For example, Douglas Cockerell who had been apprenticed to Cobden Sanderson of the Doves Press started the book binding classes in 1897 and trained, among others, Francis Sangorski and George Sutcliffe. They became master bookbinders of an exceptional standard, and Sutcliffe taught at the college. Cockerell's son and pupil, Sydney, ran the bookbinding classes from 1930 to 1940. Christopher Whall who taught Stained Glass from 1896 to 1904 taught Karl Parsons. Parsons took over the classes in 1904 and was succeeded by his pupil Francis Spear in 1935. The tradition of Stained Glass teaching in the college remains unbroken to this day.

Other students who became teachers and carried on the Lethaby tradition into the 1960s include Graily Hewitt, one of Johnston's first pupils, who taught until 1930, and M.C. Oliver and Irene Wellington, both calligraphers, who were also pupils of Johnston. H.G. Murphy, a pupil of Henry Wilson and Augustus Steward, taught silversmithing from 1912. Leslie Durbin, one of Murphy's most talented students, taught part-time in the 1950s. A.J. Cullen took over the School of Book Production from J. Mason in 1940, and John Farleigh was trained by Noel Rooke and continued the outstanding work in wood engraving. Former students did not only teach at Central, they also taught and started courses at other colleges across this country and abroad. They carried the mark-making tradition far afield.

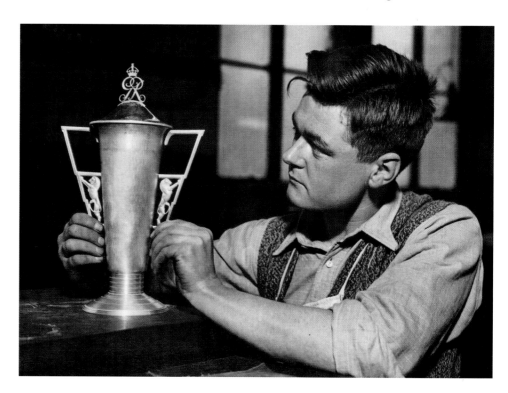

Leslie Durbin when a student at the
Central School in 1938, with a piece
of his own work
Photograph
Central Saint Martins Museum
Collection

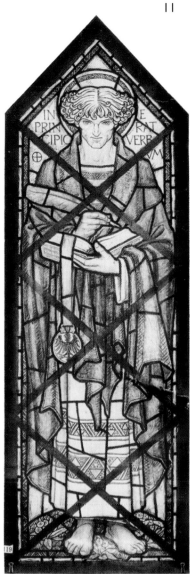

Douglas Cockerell
Beauty's awakening, a masque performed by members of the Art Workers Guild, bound in red morocco with gold tooled decoration, 1899
210 x 290 mm
Courtesy the Art Workers' Guild

Joan Fulleylove
Cartoon for a stained-glass window of St John the Evangelist in Khartoum Cathedral, 1921
Watercolour, charcoal and pencil
1500 x 500 mm
Courtesy of the William Morris Gallery
(London Borough of Waltham Forest)

Women students were in evidence from the earliest days of the school. In an article in *The Architectural Review* of 1897, the writer commenting on the Stained Glass class run by Christopher Whall says 'Happily, too, a preponderance of women students in such a class has long since ceased to convey the reproach of dilettantism or amateurishness'.[3] Joan Fulleylove, Margaret Rope and Mabel Esplin were early stained-glass students who had considerable success. Because Central's classes in printing, bookbinding and silversmithing were closely linked with these trades and their union regulations, women were excluded from them. A number of women bookbinders tried to get admitted but without success.[4] There were many women students in those areas traditionally considered 'female' such as textile and costume design, calligraphy, book illustration, wood-engraving and painting on china. Later, in the 1930s, Central had some students in former all-male preserves, such as Judith Hughes who studied Cabinet Making from 1933 to 1934, and speaks highly of the training she received.[5]

With its new well-appointed and well-equipped building which opened in Southampton Row in 1908, Central was in an enviable position. It quickly acquired a reputation for innovative teaching in the revival of declining crafts such as illumination and lettering, wood-engraving, lithography, printing and bookbinding. Students studying elsewhere were attracted to Central to use the facilities, to work with the master craftsmen, and experience the atmosphere of what was known for many years as the 'LCC School'. Edward Barnsley came specially to study with Charles Spooner, the furniture designer and maker. Students from the Royal College and the Slade, including Gwen Raverrat and Margaret Pilkington, were recommended to learn the special techniques taught by Noel Rooke. C.R.W. Nevinson 'sought out the best teacher' of lithography, F.E. Jackson[6], and in the late 1920s pottery students of Staite Murray, who was teaching at the RCA, had to attend Dora Billington's evening classes at Central to learn the necessary technical skills.

The professional journals throughout the period many times feature work of high quality by Central students.[7] Central is also prominent in all the major exhibitions of the period. On average over half the exhibits in the shows of the Arts and Crafts Exhibition Society in the 1920s and early 1930s were by Central staff or students. They were also prominent in the Paris Exhibition of Modern Decorative and Industrial Art of 1925, the Dorland Hall exhibition of 1933, the 'British Art and Industry' exhibition of 1935, 'Britain can make it', 1946, and the Festival of Britain in 1951.

Former students looking back on the Festival of Britain remember it as a very exciting and optimistic time, both for the country after the bleak years of the Second World War, and for the renaissance of art and design. Diana Armfield, a textile student at Central in 1945 and one of the Festival designers, thought it was 'a good time to be young'. She mentions the climate of the time and the training in art schools which set new trends, and especially

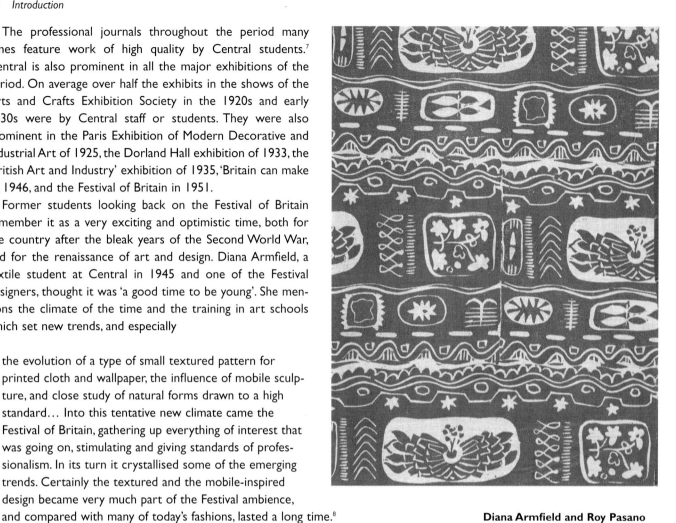

> the evolution of a type of small textured pattern for printed cloth and wallpaper, the influence of mobile sculpture, and close study of natural forms drawn to a high standard... Into this tentative new climate came the Festival of Britain, gathering up everything of interest that was going on, stimulating and giving standards of professionalism. In its turn it crystallised some of the emerging trends. Certainly the textured and the mobile-inspired design became very much part of the Festival ambience, and compared with many of today's fashions, lasted a long time.[8]

Diana Armfield and Roy Pasano
'Maori'
Design for a cartouche with ethnic patterns, arranged as a horizontal stripe, commissioned for the Festival of Britain, 1951
380 x 190 mm
Central Saint Martins Museum Collection

Many Central staff and students were involved in discussing the designs and carrying them out. Students remember the full-size maquette painted by Victor Pasmore on the floor of the gymnasium in the Southampton Row building.[9] He had been commissioned by the Festival to design a ceramic tile mural for the south wall of the Regatta Restaurant, flanking the staircase entrance, and he needed a large space in which to try out his design based on a series of flowing spiral motifs.[10] Other Central artists asked to do murals for the South Bank included John Minton and Keith Vaughan. Hans Tisdall designed murals for the fun fair at Battersea.[11] James Fitton designed a comic frieze for the seaside section.[12] Jesse Collins designed the lettered door knob for the newly erected Royal Festival Hall. Dick Negus, Morris Kestelman, Eduardo Paolozzi, Nigel Walters, Laurence Scarfe, Mary Harper, and altogether over forty staff and students of the Central School, were involved. This was a period when Central people seemed to be everywhere in the craft and design world and the students of the time took it for granted that this should be so.[13]

The involvement of many of the key Central staff in the close-knit world of the Arts and Crafts movement, and its offspring the Design and Industries Association (DIA), made for connections which sometimes had far-reaching implications for Central students. Frank Pick, a founder member of the DIA, an admirer of Lethaby and a member of the Advisory Committee of the college, was appointed publicity manager for London Transport in 1908. Pick was passionate in his desire to produce publicity which was both imaginative and effective. He acted as an enlightened patron of the arts, introducing the public to the work of contemporary artists 'influenced by the avant-garde European art movements of the early twentieth century, and the posters all became a medium for popular interpretation of these styles'.[14] Another of London's transport providers, London's Tramways, had already been

using Central students for some years for its posters. These all bear the legend 'Designed at the L.C.C. Central School of Arts and Crafts': only a few of them are signed.[15] Pick and his successors built on this tradition. From 1908 when he was appointed over twenty named individuals designed posters and newspaper adverts for London Transport. The work was always signed, so the artists became well known to the general travelling public, who looked out for it on hoardings, just as they looked for the illustrations done by many of the same designers in the *Radio Times*. The most prolific poster artist was Dora Batty who produced over 50 designs. She became head of Textiles in 1950 and is a good example of the versatility of many textile designers in the School.

It was not just in poster design but in lettering, sculpture, textile and vehicle design, that Central contributed to London Transport. Eric Gill was commissioned by Charles Holden in 1928 to produce relief sculptures for London Underground's office building at St James's Park. In 1937 Enid Marx designed woollen moquette seating fabric for Underground trains. Douglas Scott's Routemaster bus first went on the road in 1953 and still operates on a few routes. Eduardo Paolozzi designed the murals for the Tottenham Court Road Tube Station in 1984. Perhaps Edward Johnston's typeface was most influential. This was designed in 1916 for London Underground and was used in all the Underground station signage, including the famous red and blue bullseye symbol which he developed to go with the lettering in 1918. It also appears in many posters, newspaper adverts and other publicity.

Succeeding a principal with Lethaby's reputation cannot have been an easy task. Fred V. Burridge, previously head of Liverpool School of Art, was appointed his successor in 1912 with the brief of 'reorganising a school which had become unwieldy and in danger of over-looking its original aims'.[16] His clear and informative report, *The Central School of Arts and Crafts, its aim and organisation*, makes fascinating reading and shows him as someone well ahead of his time in educational theory and management. While acknowledging the achievements of the School, Burridge is not afraid to state the problems as he sees them and to make suggestions for change. The sharing of the Southampton Row building, built in 1908 to house both the London Day Training School and the Central School of Arts and Crafts, had many disadvantages, and Burridge recommended that the Central should be the sole occupier. The Day Technical Schools of Silversmithing and Book Production were flourishing and he wanted to extend the other daytime classes, but shared use made that impossible. He also recommended in his report that the Royal Female School of Art, which had functioned as a separate body within the Central School, should be integrated so that the School could operate 'with a single educational aim'. Burridge was concerned to develop Lethaby's policies and to strengthen links with industry and the trades. He writes in his report: 'The aim of its tuition should be to further the highest development of the

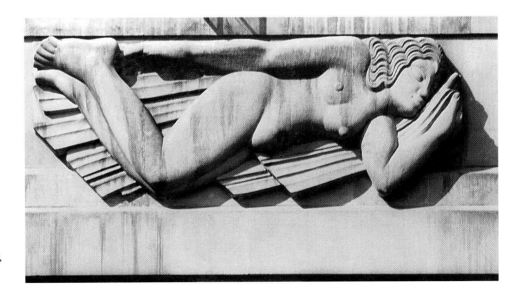

Eric Gill
'The south wind'
Relief sculpture in Bath stone, 1929
For London Underground Railway
Headquarters building at 55 Broadway,
SW1
© London Transport

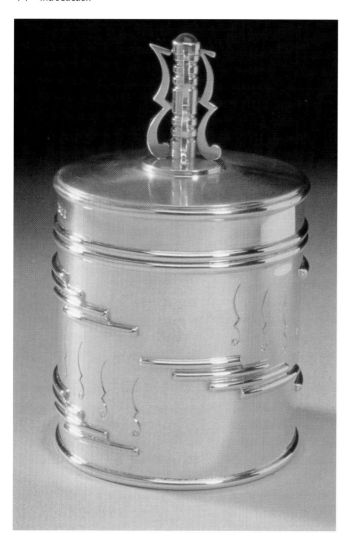

H.G. Murphy
Cigarette box in silver, made at
Murphy's workshop, the Falcon Studio,
London, 1933
110 mm high
Courtesy the Worshipful Company of
Goldsmiths

artistic handicrafts, their application to manufacture and their commercial usefulness.' He proposed that the Central School become the 'College for the Artistic Crafts, the equivalent for Craft of the Royal College and the Slade for Fine Art', and looked forward to the day when the School would have university status and carry out postgraduate work.[17]

During the Burridge years a number of major exhibitions were held to promote the work of different departments. The exhibition of book production in 1922 contained an interesting mixture of student work and early printed books from the School's Teaching Examples collection.[18] This had been started by Lethaby in 1894 and continued to be used extensively. Former students have described the wealth of examples displayed on the main staircase and studios, including cartoons by Burne-Jones.[19] It was under Burridge that the School of Book Production first became the 'semi-official printer & binder' to the LCC, producing special bindings for commemorative publications. Burridge and the Central School were closely involved with the LCC's School Pictures scheme in 1917. This was a collection of pictures designed to be lent to schools which included work by Central artists such as F.E. Jackson and Noel Rooke.[20]

Burridge retired in 1930. He was succeeded by P.H. Jowett who was principal until 1935 when he became principal of the Royal College of Art. Jowett had previously taught at Harrogate, Leeds and the Chelsea School of Art and was a fairly well known painter, exhibiting regularly at the Royal Academy and other galleries. The standard of work under Jowett remained very high. *The Studio* in its review of student work in 1933 states

Here is a school where the industrialist who seeks for design may find design both intelligent and practical. The productions of its students have the good sense, solidity and restraint which are traditional qualities, combined with a high degree of taste.[21]

In a paper given to the Royal Society of Arts in 1931, Jowett expresses his concern that competition from well designed goods imported from abroad was undermining British manufacture, and emphasises the importance of good design for industry.[22]

H.G. Murphy succeeded Jowett. Dora Billington described his appointment as 'a bold experiment'. Murphy had been a Day Technical boy who had risen to become head of Silversmithing. 'A craftsman with a contemporary outlook, he made up for his lack of wider experience by his quick intelligence and burning energy.'[23] He was a pupil of H.G. Wilson, and his time in Berlin as a student of the famous German jeweller and silversmith Emil Lettre may well have initiated his interest in Germany and the Bauhaus. It was while Murphy was principal that Walter Gropius, a refugee from Germany, was appointed to the Advisory Board of the Central from 1936 to 1937, before he went to Chicago to start the New Bauhaus. In 1935 Murphy visited Berlin, Brussels and other cities to look at art schools, particularly in relation to silversmithing. In 1938 he went to the U.S.A. for six weeks to look at the New Bauhaus Chicago and the Industrial Museum New York.[24] In 1938 he initiated the first course on Design for Light Industry, the forerunner of the School of Industrial Design. Throughout his life he maintained his high reputation as a silversmith. He died suddenly in 1939, having made a major contribution to furthering the development of design teaching in the college.

R.R. Tomlinson
'The Stalingrad Sword', 1943
Watercolour to commemorate the
making of the sword. R.R. Tomlinson
was Chief Art Inspector of the L.C.C.
and Acting Principal of the Central
School from 1939 to 1947
140 x 380 mm
Courtesy the Worshipful Company of
Goldsmiths

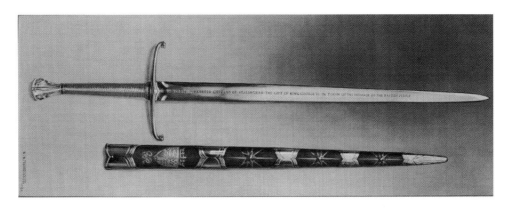

Edward Johnston
The Central School Diploma of
Fellowship, 1930s
Designed by Edward Johnston and
engraved by George Friend
520 x 295 mm
Central Saint Martins Museum
Collection

After Murphy's sudden death R.R. Tomlinson, senior art inspector for the LCC, was asked to become principal on a temporary basis. His tenure was extended through the war years. He oversaw the arrangements at the outbreak of war, and the evacuation of some of the Central courses to Northampton.[25] He also supervised the Stalingrad Sword project, a gift of King George VI to the Russians in 1943 to commemorate the victory of Stalingrad. Many of the designers and craftsmen were from the Central School. Among others Leslie Durbin worked on the gold and silver, M.C. Oliver and G. Friend on the lettering, engraving and etching, and Sangorski and Sutcliffe made the leather scabbard.[26]

William Johnstone became principal in 1947. He was probably the most influential and dynamic principal since Lethaby (see William Johnstone and the Central School). Like Lethaby, Johnstone had a talent for appointing outstanding staff, bringing many of them with him from Camberwell School of Art where he had been principal from 1938 to 1947. He was especially good at choosing 'enablers', teachers such as Jesse Collins and A.E. Halliwell, who had a talent for getting the best out of their staff and students. Although Johnstone was seen by students as rather strict and forbidding – he and Halliwell, the head of Industrial Design and also his vice-principal, would 'clock in' staff each morning – he made a tremendous contribution to the development of the college.

It was under Johnstone that the Central School Diploma was changed. Initiated by Burridge in 1921 the Diploma was an important and coveted award presented to a limited number of distinguished artists and designers who had studied at the Central School, and was mainly of honorary value. Recipients included Eric Gill, letter designer and sculptor, in 1929, Clare Leighton, wood engraver, 1930, and Alfred Fairbank, scribe, 1933. In 1948 Johnstone got the LCC Education Committee to agree to change the diploma to a qualification recognised by the Ministry of Education as equivalent to a professional qualification.[27] This was an astute move as people linked the new diploma with the status of the original Central School Diploma, and it became a sought-after qualification. This continued until the coming of the new Dip.A.D. in 1960.

Johnstone, like Lethaby, knew the importance of contacts with commerce and industry. He made sure he invited 'the great and the good' from all the major companies to join the governing body and the consultative committees for different subject areas which he set up within the college. They included

Ambrose Heal, Geoffrey Dunn and Ernest Race for Furniture and Interior Design; F.H.K. Henrion and Ashley Havinden for Graphic Design; Misha Black and Jack Howe for Industrial Design; Jocelyn Herbert and John Gielgud for Theatre Design; Graham Hughes for Silversmithing; Hans Coper and Susie Cooper for Ceramics; and Hans Juda and Lucienne Day for Textiles – a formidable resource.[28]

Johnstone retired in 1961 and Michael Patrick, the final principal in our period, was appointed. Like Lethaby he was an architect and under him changes were made to the building. The 'bridge' was erected between the Southampton Row building and the Holborn Law School. Ceramics and Textiles expanded into extra space in what came to be known as the Red Lion Square Building, and the Cochrane Theatre was opened in 1964. Although the change of name from Central School of Arts and Crafts to the Central School of Art and Design was undoubtedly discussed while William Johnstone was still principal, the change which was designed 'to better reflect the present character of the School and the nature of the work done there' actually took place under Michael Patrick in 1966.[29]

Making their mark covers the first seventy years in the history of the Central School. Many changes have occurred in this time of which only a few can be touched on here. It aims to show the School's influence on the development of art and design education and practice, its willingness to initiate new ideas and embrace new developments, its interdisciplinary approach, its involvement with commerce, industry and the craft and design organisations which were established to set professional standards.

It focuses on the theory and practice developed by Lethaby and his successors at the Central School which drew its strength from a tension between preserving dying crafts and the impetus towards innovation. The resulting primacy placed on 'the mark', developed

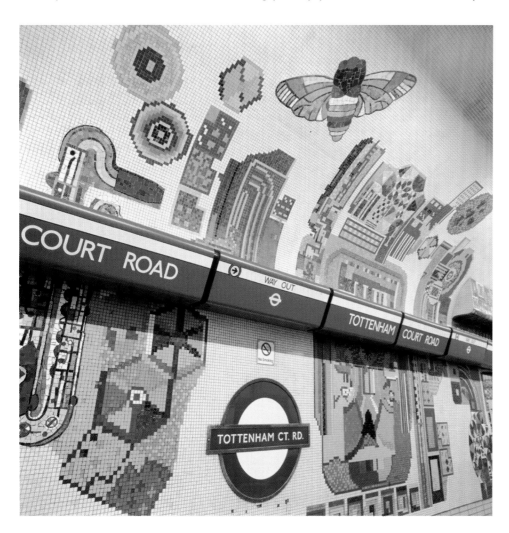

Eduardo Paolozzi
Designs for murals at Tottenham Court Road London Transport underground station, 1984
© London Transport

through Johnston's revolutionary illuminating classes and Rooke's subsequent impact on wood-engraving, produced a new environment which created new opportunities for staff and students and their various disciplines.

1 Noel Rooke, 'Obituary: W. R. Lethaby', *The Sunday Times*, July 1931.
2 T. A. Gronberg, 'William Richard Lethaby and the Central School of Arts and Crafts'. In S. Backemeyer & T. Gronberg, eds, *W. R. Lethaby 1857–1931: architecture, design and education*, Lund Humphries, 1984.
3 Esther Wood, 'The School of Arts and Crafts: part two'. In *Architectural Review*, 1897, p. 288.
4 Anthea Callen, *Angel in the studio*, Astragel Books, 1979, pp. 189–90.
5 Judith E. Hughes, 'Reminiscences of a cabinet maker'. In Jill Seddon and Suzette Warden, eds, *Women designing: redefining design in Britain between the wars*, University of Brighton, 1994.
6 J.G.P. Delaney, 'F. Ernest Jackson, draughtsman and lithographer', *Apollo*, May 1987, pp. 319–91, p. 340.
7 Journals in which articles on the Central School appear from 1897 include: *The Studio, Architects Journal, Art & Industry, Commercial Art, Design Magazine, Crafts Magazine, Eye, Journal of the Royal Society of Arts*.
8 Diana Armfield, 'Design after the war'. In Mary Banham and Bevis Hillier, eds, *A tonic to the nation: the Festival of Britain*, Thames and Hudson, 1951, p. 169.
9 Interview with Ivor Kamlish, 2 July 1990.
10 Banham and Hillier, ibid. Victor Pasmore, 'A jazz mural', p. 102.
11 Banham and Hillier, ibid. William Feaver, 'A Festival star', p. 49.
12 *James Fitton R.A. 1899–1982*, Dulwich Picture Gallery exhibition catalogue, 1986, p. 19.
13 Interview with Ivor Kamlish, 2 July 1999.
14 Oliver Green, *Underground art*, Studio Vista, 1989, pp. 12–13.
15 Interview with Jonathon Riddell, London Transport Museum, 19 October 1999.
16 Dora Billington, 'Sixty years of design training', *Art and Industry*, May 1957, pp. 131–5, p. 134.
17 F.V. Burridge, *The Central School of Arts and Crafts, its aim and organisation. Report by the Principal*, 1913, p. 10.
18 L.C.C. Central School of Arts and Crafts, *Catalogue of a book exhibition at the Central School of Arts and Crafts with a short account of the history of the L.C.C. classes in book production*, 13 May 1912.
19 Interview with Morris Kestelman, June 1992.
20 L.C.C. Central School of Arts and Crafts, *School Pictures Interim Report*, 1920, pp. 1–13.
21 'A living art school', *The Studio*, September 1933, pp. 125–88, p. 128.
22 P.H. Jowett, Royal Society of Arts Annual Competition of Industrial Designs, 1931. In *Journal of the Royal Society of Arts*, 4 December 1931, pp. 69–80.
23 Dora Billington, 'Sixty years of design training', *Art and Industry*, May 1957, pp. 131–5, p. 134.
24 Central School of Arts and Crafts Advisory Committee Minutes. 3 July 1935, and 6 April 1938.
25 George Ravenscroft Hughes, *The Worshipful Company of Goldsmiths as patrons of their craft, 1919–53*, The Worshipful Company of Goldsmiths, London, 1965, pp. 9–44.
26 *Ibid.*
27 L.C.C. Education Committee *Minutes*, 25 February 1948, pp. 407–14, p. 411.
28 The Central School of Arts and Crafts and Central School Art and Design *Prospectuses* in the period 1960 to 1970.
29 L.C.C. Education Committee *Minutes*, 1 December 1965, pp. 329–42, p. 333.

Making an impression

Joanna Selborne

Joanna Selborne is an independent scholar with a special interest in prints and printmaking. Her book British wood-engraved book illustration, 1904-1940 *was published by the Clarendon Press, Oxford, in 1998. She has also undertaken extensive research on the Central Saint Martins Museum Collection.*

'Far from being merely minor works of art, prints are among the most powerful tools of modern life and thought.'[1] Thus wrote William Ivins in his pioneering book of the 1950s, *Prints and visual communication*. Before the invention of photography, prints were the principal means of conveying visual information to a mass audience. Paradoxically, the development of photography and process methods of illustration, far from killing off printmaking as a means of communication, opened the way for enterprising printmakers to start afresh by revamping old technologies, making new marks and developing sales strategies. With an eye for an audience, they aimed to produce a modern and vibrant commodity to keep pace with new technology and popular culture. Through its enlightened attitude to industry and commerce, the Central School of Arts & Crafts acted as a catalyst for new ideas, spawning teachers, commercial artists, printers, textile designers, and so on, many of whom were trained within the School of Book Production. The impact of printmaking teaching, which evolved from Edward Johnston's revolutionary illuminating classes and Noel Rooke's wood-engraving lessons, spread beyond the realms of fine art, forging new avenues for students and staff, creating new markets and unconsciously setting standards of taste. A succession of inspirational print teachers, artists in their own right, helped to foster talent within the School, while aspiring printmakers world-wide benefited from the expertise of staff and students, especially through the many practical handbooks which were produced.[2] Edward Johnston's influential *Writing & illuminating & lettering* (1906), first in the Artistic Craft series, was perhaps the most significant.

Johnston's ideal 'to make living letters with a formal pen', had greater repercussions than he or his admirers ever could have imagined.[3] His doctrine of 'Truth to the Medium' reached well beyond the confines of his seminal classes and made a lasting impression on pupils and teachers alike.[4] With W. R. Lethaby's support, he laid the foundations for Central School educational practice with the emphasis on acquiring skills, and a distinct attitude toward mark making as a vital element of design, aspects which underpinned much of the most successful and effective commercial art up till the 1960s. The School's multidisciplinary approach meanwhile helped to erode barriers between the fine and decorative arts.

John Farleigh's belief, that a few basic principles must be learned for the process of self-expression to become possible,[5] chimes with Lethaby's view that the 'character *in* the thing made, must be seconded by the *characteristic* way in which it is *made*'.[6] All artistic processes are a form of craft, yet in a post-modern age the link between craft knowledge and the fine arts, which in Farleigh's day was taken for granted, is no longer considered valid. The modern orthodoxy is that conception and execution are separate activities and that craft has become secondary to the ideas expressed by the objects. In many circles skills are regarded as technical constraints on self-expression, creativity and imagination. Peter Dormer's view that the plastic arts benefit from a 'traditional' approach which recognises that process and content are interdependent and mutually enriching is a refreshing re-evaluation of the Central School philosophy.[7]

The 'thinking-through-making' approach is nowhere more relevant than in the field of printmaking which is heavily reliant on technical knowledge. The end product or impression taken from the matrix (generally stone, metal or wood) is arrived at through a series of processes involving various drawing implements, tools, inks, crayons, chemicals, rollers,

presses, paper, etc., depending on the medium, each of which has its limitations and responds to specific mark-making treatments. The drawn line is one-dimensional whereas an engraved line has width and depth. Engravers' tools vary with the chosen medium: woodcuts and linocuts require gouge-shaped tools for scooping movements, whereas hardwoods, such as box commonly used for wood-engraving, and copper or zinc, need permanently sharp, pointed tools to push into the material. Etching and lithography have a greater affinity with drawing. With the former, lines freely drawn on the prepared plate with an etching needle are bitten by acid, as are tonal areas made by spreading on powdered resin (aquatint) or crayon-like lines impressed through wax (soft-ground etching). A lithographic line is drawn direct on the stone or zinc plate with a greasy medium, such as crayon, and needs no cutting or biting. Each medium has a distinctive 'look', as much the result of the material and marks used as of the different methods of inking and printing, which themselves can create a new set of marks. Through a combination of sound workmanship and experimenting, Central students learnt how to handle the various media in creative ways for maximum impact when applied to commercial products.

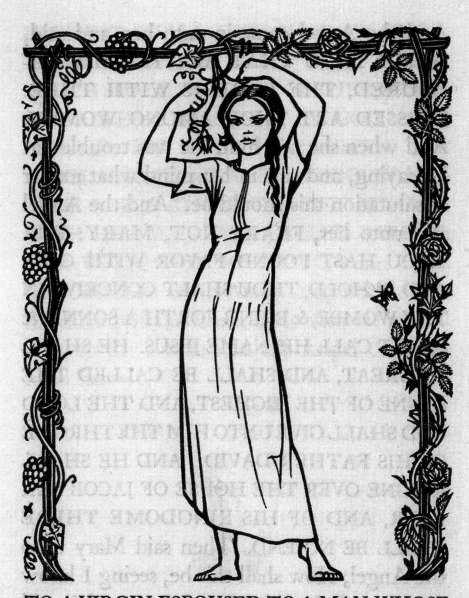

TO A VIRGIN ESPOUSED TO A MAN WHOSE NAME WAS JOSEPH, OF THE HOUSE OF DAVID; & THE VIRGINS NAME WAS MARY.

Noel Rooke
Wood engraving for *The birth of Christ from the Gospel according to Saint Luke*, Golden Cockerel Press, 1925
220 x 140 mm
Central Saint Martins Museum Collection

In an interdisciplinary environment, Noel Rooke's teaching affected a wide range of students. If understanding the physical properties of print material was a prerequisite, drawing skills were considered an essential requirement for good design, most especially where wood-engraving was concerned. As Eric Gill explained, the wood-engraver, unlike other types of practitioner, 'is forced to have some respect for the thing itself and to place an absolute value upon the art of drawing'.[8] Not only representational drawing – life, costume, nature, landscape, etc. – but also pattern making, in the Arts and Crafts tradition, were vital lessons, absorbed especially by block printing students.

Pattern is purely a stylistic element evidenced on the flat surface of the print. Printed marks, on the other hand, leave their impression in the paper and possess a tactile quality. Cut into the block, they reveal both the nature of the tools used to make them and the

physical aspects of the wood. As a relief method (where the engraved line remains white when the block is printed), wood-engraving offers the unique opportunity of drawing with light, as with chalk on a blackboard. The tonal possibilities held particular fascination for early 20th-century practitioners for whom the medium provided an entirely new means of expression. Pattern makers, for instance, enjoyed using tool marks in the same way that embroiderers employ stitches. For many, the discipline required to work on a hard, intractable material was part of its attraction. Robert Gibbings, one of Rooke's earliest pupils, appreciated 'the cleanness of the white line that [the graver] incised: even the simplest silhouettes had an austere quality, a dignity, that could not be achieved by other means. Clear, precise statement, that was what it amounted to. Near enough wouldn't do: it had to be just right'.[9] Rooke encouraged pupils to engrave in a way sympathetic to the wood, using tool marks specific to the purpose: to balance with type, for example.

At a time when wood-engravers were breaking away from 19th-century linear conventions and re-inventing a 'traditional' craft in a new and exciting manner, the value of mark making as an expression of its newness and saleability was immense, despite on-going dissensions among the more conservative critics on the merits or otherwise of black versus white line, or of fine rather than robust cutting, or on the use or abuse of the multiple tool. An understanding of the inherent aesthetic qualities peculiar to wood determined wood-engraving's modernness, not necessarily the images *per se*. As Simon Brett suggests, 'the "let the tools show" aesthetic is broader than wood-engraving – it is central to modernism'.[10]

Ray Garnett
Wood engraving for David Garnett, *Lady into fox*, Chatto and Windus, 1924
Private collection

Noel Rooke recognised that, but for Johnston, 'not so many people would have become engravers'.[11] It was Johnston's principles in calligraphy that initiated Rooke's idea of 'a revival of wood-engraving on a fresh basis', that is, by 'designing and producing in terms of the strokes of a brush or pen or pencil'.[12] Trained as an illustrator, his dissatisfaction with process work and reproductive wood-engraving led him to the conclusion that autographic white-line wood-engraving offered the best means of book decoration and illustration for the future. Rooke's insistence on the value of wood-engraving for illustrative work rather than as artists' prints shows his personal commitment to art for industry, and reflects the status conferred on the medium when he began teaching in 1905.

Rooke's close collaboration with J. H. Mason, head of Printing (1905–40) and formerly with the Doves Press, helped to formulate their ideas on book production. Charles Pickering, one-time printing student, considered that it was probably due to the growth of Rooke's illustration classes that Mason became interested in marrying text, type and illustration.[13] Rooke, in turn, learnt from Mason's purist attitude the importance of clarity, and economy of line, which were essential requirements for most book illustration and graphic art. The School's cross-curricular discipline enabled Rooke's students to learn about typography, layout and printing[14] and a few contributed woodblocks to Mason's Central School publications. Typographic awareness and a craftsmanlike feel for design were instilled. Yet Rooke was by no means solely wedded to hand work, recognising the need to adapt traditional skills to new technology. He was pioneering in the way he introduced his pupils to modern power-driven platen presses in order for them to understand modern conditions and the differences introduced by automatic inking.

Rooke's involvement helped launch many pupils on a career. He urged them to break into the world of publishing and advertising, and introduced them to private press owners and, more significantly, to commercial firms at a time when few trade publishers were interested in wood-engravings. Through his connections Vivien Gribble found work with Duckworth, and Ray Marshall with Chatto & Windus. Indeed the best-selling *Lady into fox* (Chatto & Windus, 1922), which Marshall illustrated, was one of the first commercially published books to contain wood-engravings. Margaret Pilkington consulted Rooke on her first published designs, for her father, Laurence Pilkington's *An Alpine valley* (Longmans Green, 1924), while John Farleigh's earliest illustrating commission, for Jonathan Swift's *Selected essays* (Golden Cockerel Press, 1925), came from Robert Gibbings via Rooke, who may well also have steered Margaret Lane Foster in the direction of Bodley Head.

Useful contacts were made with key members of the Bloomsbury group. In 1915 Dora Carrington attended Rooke's classes and two years later contributed four blocks to Leonard and Virginia Woolf's newly founded Hogarth Press. This press was in turn inspired by Roger Fry's Omega Workshop publications to which he contributed his own woodcuts.[15] For someone so strongly opposed to the perfectionist craftsmanship advocated by William Morris, and to the Central School emphasis on 'right-making', Fry's choice of Mason to advise him on printing the first Omega book, Arthur Clutton-Brock's *Simpson's choice* (1915), with expressive wood cuts by Roald Kristian, was surprising. Another member of the circle, Frederick Etchells, an architect and Vorticist painter who taught black and white illustration with Rooke in 1910, issued the limited edition Haslewood Books series, from his jointly owned firm of Etchells and MacDonald.

A growing public awareness of wood-engraving was increased with the formation in 1920 of the Society of Wood Engravers. Rooke, Gibbings, Gill and Sydney Lee were among the founder members, and many ex-Central students were both members and/or contributors to its annual exhibitions. It was perhaps commercial publications, especially print magazines and journals, that did most to popularise the medium. The radical two-volume production, *Change* (1919), edited by John Hilton and Joseph Thorp, and the first to champion wood-engraved illustration, contained images by Gibbings, Gribble, Marshall, Gill, Herbert Rooke and others. A number of Noel Rooke's pupils featured in the widely available specialist print publications, notably Malcolm Salaman's *Modern woodcuts and lithographs* (1919), *The woodcut of today at home and abroad* (1927) and *The new woodcut* (1930), and Herbert Furst's *The modern woodcut* (1924), as well as journals such as *The Studio, Artwork, Drawing & Design, Commercial Art, Punch* and *The Graphic*. Promising artists such as Marjorie Turberville, Margaret Haythorne, Mary Berridge, Frederica Graham, Herbert Rooke, Millicent Jackson, Edith Brews, Adelaide Swift and Muriel Jackson are now largely forgotten, although their work is beginning to receive the recognition it deserves.[16] Several students turned from wood-engraving to line drawing or lithography as their preferred means of illustrating: Lynton Lamb, John Parsons, Jocelyn Crowe and Hilary Stebbing, to name but a few.

In 1913 a pioneering printing journal, *The Imprint*, was launched by Gerard Meynell to introduce the general trade to the ideals and practices of fine printing. His co-editors – all Central School staff – were Johnston, Mason, and lithography teacher, F. E. Jackson. Mason designed the typeface, Imprint Old Face, and wrote articles, as did Rooke, Johnston, and Lethaby whose 'Art and workmanship' helped to broadcast Central principles throughout the printing trade. At Emery Walker's suggestion, Mason was invited by Count Kessler to install and manage his Cranach press in Weimar. Johnston was engaged to advise on type design and Edward Prince[17] to cut the punches. The magnificent *Hamlet*, begun in 1914, with type designed by Johnston, lettering by Gill, and woodblocks by Edward Gordon Craig, finally appeared in 1930, 'a great flowering of English craftsmanship'.[18]

In a climate of typographical renaissance, Central teaching, directly or indirectly, largely accounted for the growth of the private press movement between the Wars. In 1926 Mason described the aim of the printing class; to provide 'not merely technical efficiency, but to

embody the lessons to be drawn from research and experience of the private presses, and the revival of calligraphy, and to set new standards of typography'.[19] The most distinguished British presses such as the Kelmscott, Doves, Vale, and Eragny, had all ceased to function by the First World War and newer ones were beginning to emerge, with more to follow. Many people involved with these presses had either trained under Mason or had worked with Rooke and/or Farleigh, most significantly Robert Gibbings, owner of the Golden Cockerel Press (1924–33), Robert Maynard, controller of the Gregynog Press (1921–30); and Loyd Haberley (his successor from 1936). These two presses are considered the finest of the period.

Of the smaller ventures, St Dominic's Press, set up in 1916 by Johnston's friend Hilary Pepler, was the most pioneering, especially in its use of wood-engraved illustration initiated by Eric Gill. Inspired by Johnston's classes to take up lettering, Gill taught stone carving and inscriptions at Central from 1906 to 1910. He first tried wood-engraving with Johnston but in 1907 took private lessons from Rooke, becoming perhaps the best-known exponent and champion of the medium in his time. Although Pepler's printing was not up to Mason's exacting standards, his small-scale books and ephemeral work were a model for subsequent small press owners, several of whom were Central-trained. Edmund Walter, for instance, who worked for Pepler, set up his own printing office at Primrose Hill in 1929. An accomplished wood-engraver, he frequently illustrated the books he printed. Between 1929 and 1945 John Biggs designed, illustrated and printed a number of publications at his Derby-based Hampden Press. One, his own *Sinfin songs and other poems* (1932), he printed while a student at Central, where in 1947 he taught typography and layout. His various practical manuals include *The craft of woodcuts* (1963). After leaving the Gregynog Press, Robert Maynard and Horace Bray formed the Raven Press, while John Petts, a Golden Cockerel illustrator, ran the Caseg Press from 1938 to 1951. Joan Shelmerdine started the Sampson Press in Woodstock and from his Linden Press, Shelley Fausset produced some interesting broadsheets, illustrated by himself and other Central contemporaries.

Working with private press owners on limited editions enabled wood-engravers to experiment with marks in a way that was not always possible with blocks intended for commercial printers. Thomas Derrick's eye-catching double page opening to Ambrose Bierce's *Battle sketches* (1930), printed by the Shakespeare Head Press for the First Editions Club, is one of the most effective title pages of the period. The Golden Cockerel Press under Gibbings and, later, Christopher Sandford, employed a number of Central wood-engravers, among them Rooke, Gill, Mabel Annesley, Celia Fiennes, Lynton Lamb, Helen Binyon, Dorothea Braby,[20] John Petts, John O'Connor and Geoffrey Wales. In 1937 these last two attended part-time printing and typography classes at Central at the suggestion of Professor Jowett, Principal of the Royal College of Art, where neither press nor type were available. Both became teachers and like Derrick, advocated the use of firmly-incised typographic marks, as evidenced from examples in O'Connor's manual, *The technique of wood engraving* (1971), and in Wales's illustrations for the Folio Society (1954).[21]

Many of Mason's other students passed on their skills by teaching at home and abroad in printing schools and departments, some of which they headed. Leonard Jay, in particular, was employed as Mason's assistant in 1912, before becoming head of the prestigious Birmingham School of Printing in 1925, from where he produced many fine limited editions and a periodical, *The Torch*, containing specimen pages decorated with wood-engravings by his students.

By the mid-1930s wood-engraving was recognised as an economically viable means of illustration, largely through John Farleigh's designs for George Bernard Shaw's best-seller, *The adventures of the black girl in her search for God*, published by Constable in 1932, and Clare Leighton's large and arresting images for her own *The farmer's year*, produced by Collins in 1933.[22] Other publishers who commissioned wood-engraved work included Jonathan Cape, Faber and Faber, Bodley Head, Macmillan, Dent, and John Murray. The appearance in 1938 of ten sixpenny paperbacks in the Penguin Illustrated Classics series,

edited by Gibbings, and including wood-engravings by himself, Biggs, Binyon, and Theodore Naish, another former Central student, reached the widest audience to date, as did the advertising and publicity material which appeared in magazines and on posters. Margaret Levetus was one of a few to produce wood-engravings for the *Radio Times* to which, by the 1950s, Derrick Harris ('Radio Times Harris') was the most prolific contributor. Commissions for illustrations and dust jackets came to him from the Golden Cockerel Press, the Folio Society, Penguin Books, and *The Listener*, among others, and for a wide range of publicity material. A teacher at Hornsey School of Art from 1959, Harris was chairman of the Illustrators' Section of the Society of Industrial Artists. In Simon Brett's eyes 'no one did more than him to define the look of the 1950s'.[23]

While Rooke played a quiet and persistent role in the development of wood-engraving, Farleigh's vociferous proselytising was equally effective, his views being summed up in his idiosyncratic autobiographical textbook, *Graven image* (1940). Following in Rooke's tradition of technical and experimental development, he inspired many practitioners. Monica Poole wrote with appreciation of his classes, recalling his intellectual approach to illustration and his valuable lessons in technique and mark making.[24] His sinuous line style which verged on the abstract or surreal (in keeping with 1930s' painting trends), affected the work of a number of students, as exemplified by the design exercises in *Graven image*. Farleigh's collaboration with Mason on D. H. Lawrence's *The man who died* (Heinemann, 1935) resulted in possibly the finest commercially published book between the Wars.

The tonal work of Farleigh's pupils was in strong contrast to the boldly-defined black and white statements which evolved from Rooke's wood-cutting and engraving classes of the 1920s, and to the flat-planed Japanese-style woodcuts which emanated from Frank Morley

John Farleigh
Cover design for Bernard Shaw, *The adventures of the black girl in her search for God*, designed and engraved by John Farleigh, Constable, 1932
Wood engraving
210 x 270 mm
Central Saint Martins Museum Collection

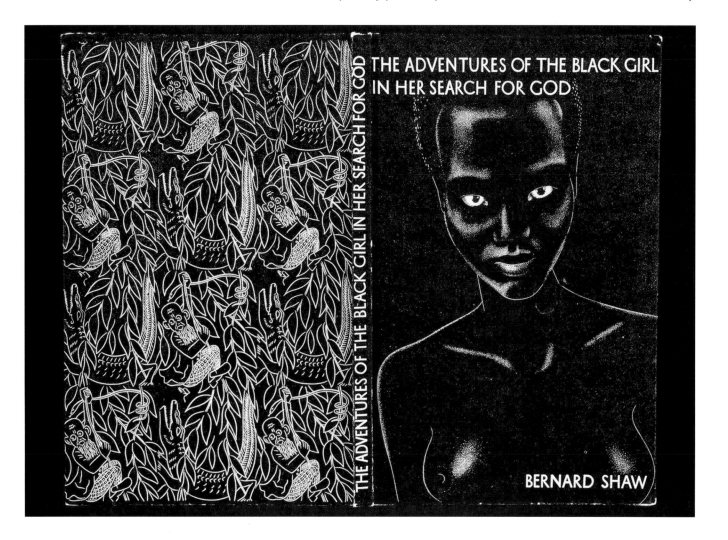

Fletcher's popular colour wood-cutting classes (1898–1904), subsequently run by Sydney Lee and Rooke.[25] In 1926, Paul Nash observed that the hand block-printed textile revival 'neatly synchronises with the revival of the art of wood-engraving and cutting which has taken such a strong hold in this country during the last few years'.[26] The practice of cutting and printing one's own blocks and the use of repeat pattern exercises led naturally to the inclusion of these skills within the textile department, from whence emerged a number of highly talented wood-block textile designers. Among the most distinguished were Elspeth Anne Little and Joyce Clissold, Doris Carter, Alice Hindson, Frederica Graham, Dorothy Hutton, and Enid Marx, several of whom also studied under Rooke and tried their hand at printing decorative papers.[27] Pattern and colour were the dominant theme, with the emphasis on bold, often rough-hewn tool marks, in line with the vogue for Primitivism and Expressionist art, especially African, favoured by Omega artists and contemporary potters alike. From 1931 to 1940 the department was run by Bernard Adeney. Michael Rothenstein's decorative lino and woodcut style owed much to Adeney's design concepts.[28]

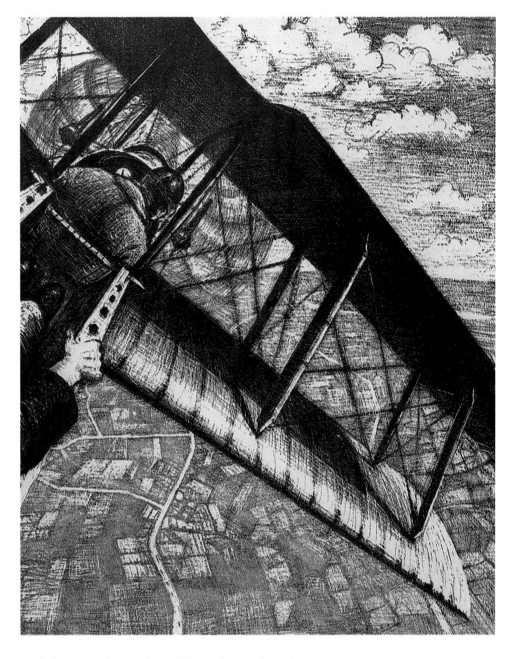

C.R.W. Nevinson
'In the air'
From the series 'Britain's efforts and ideals', 1917
Lithograph
400 × 317 mm
© Imperial War Museum

Woodblock printing not only helped to bridge the gap between art and craft, it also did much to erode barriers between art and industry. As Morley Fletcher percipiently remarked in his influential Artistic Crafts series book, *Wood-block printing* (1916),

perhaps no work goes so directly to the essentials of the art of decorative
designing for printed work of all kinds. The wood blocks not only compel economy
of design, but also lead one to it... The craft has thus not only its special interest as
a means of personal expression, but also a more general use as a means of training
and preparation for the wider scope and almost unlimited resources of modern
printing.[29]

Morley Fletcher's observations on the importance to designers of understanding how to handle simple blocks of colour were especially valid for poster design which, from 1913, was taught first by Rooke in his book illustration classes. It was lithography students,

however, who were best able to apply these lessons commercially, since the ease of repro-duction and its relative cheapness made lithography the favoured print medium for publicity purposes, particularly advertising.

In a competitive post-war environment the need for firms and organisations to promote their products accounted for the vast expansion in advertising. In 1925 the Advertising Association was formed to raise the status of the profession. The relatively new sciences of market research and behavioural psychology were eagerly pursued. Their lessons mean-while impacted on Central teaching, where in typography, lettering and printmaking classes, especially, the significance of marks as symbols and instantly recognisable message-bearers was emphasised. Indeed one contemporary psychologist maintained that 'different types of lines are associated with certain feelings, and may thus be used to lend atmosphere to the product advertised'.[30] The surface, line and colour of lithographic impressions possessed an intrinsic and aesthetic design value which appealed to a vast public.

If Rooke and Mason played a major role in the revival of wood-engraving and the growth of the private press movement, the teaching of F. E. Jackson and his successor, A. S. Hartrick (1921–30), was fundamental to the development of lithography in Britain. Both attracted excellent students. The distinguished war artist, C. R. W. Nevinson, for instance, sought Jackson out as the best teacher,[31] while Henry Trivick, in his manual on autolithography acknowledged his debt to Hartrick, whose own *Lithography as a fine art* (1932), was a well-used handbook.[32] Jackson firmly believed that the printing of a lithograph should contribute to its design and that, with intelligent handling of roller and inks, the artist was capable of producing a print 'which has quite a character of its own and does not resemble work in any other medium'.[33] To this end pupils were greatly aided by the skill of lithographic printer, T. R. Devenish, and his son. By exposing pupils to the lithographic process and demonstrating its versatility and potential both as a means of original artistic expression and for commercial purposes, Jackson and Hartrick generated widespread inter-est in the medium as a marketable commodity. This led to many fruitful collaborations between artists and printers, publishers and advertising firms.

During his 1907–8 session Jackson worked on a journal, *The Neolith*, which he produced entirely lithographically and which included illustrations by him and his students, and a

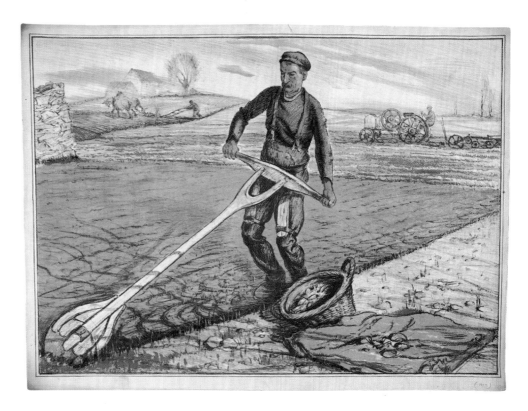

A.S. Hartrick
'The breast plough', 1919
Colour lithograph
560 × 750 mm
Central Saint Martins Museum
Collection

number of well-known artists. Together with fellow contributors Hartrick and Joseph Pennell, Jackson founded the Senefelder Club in 1908. With its aim to promote artists' lithography, print editions were limited to 50, and lay members' prints were shown at the annual exhibitions held at both the Twenty-One Gallery and the Central School. Under Jackson's secretaryship, the Club was immensely influential, with many former Central members contributing to its success.

In the early years various projects based at the School gave students a headstart over their contemporaries at other art schools, and established it as the centre of excellence for lithographic art. With the backing of the Advisory Council and Board of Education, Jackson was made technical advisor to a research project to produce the best type of school picture. In the 1917–18 session three lithographs in the School Picture series, Jackson's 'Lambeth Palace', Rooke's 'Mountain scene' and F. S. Unwin's 'Stirling Castle', were produced, followed the next year by fifteen more, some by Central artists. In 1918, with Jackson's persuasion, the Ministry of Information published a series of portfolios of lithographs on 'Britain's efforts and ideals' from established lithographers including Jackson, Brangwyn, George Clausen, Augustus John, William Nicholson and William Rothenstein. Hartrick produced six prints under the heading 'Women's work'; those of Nevinson are particularly compelling. The large format of 'Ideals' set a precedent for large-edition colour lithography that was to become prevalent from the late 1930s onwards.

The changing taste for decorative wall prints was the motivation behind a number of initiatives in the 1930s and 1940s. The pioneer contemporary lithographer scheme (1937–8), run by Robert Wellington of the Zwemmer Gallery, with John Piper as technical advisor, was the first attempt to publish and retail artistic lithographs to schools on subscription. Lynton Lamb and Vincent Lines contributed to the second series. In 1941 the National Gallery and the War Artists' Advisory Committee collaborated in the production of large-scale colour prints for exhibition in public spaces, as did the new government agency, the Council for the Encouragement of Music and the Arts (CEMA) for touring exhibitions. Edward Ardizzone and James Fitton were among the chosen artists. An ambitious School Prints scheme drew on a number of Central artists, notably Michael Rothenstein, John Skeaping, Edwin la Dell, Phyllis Ginger, Clarke Hutton,[34] and Hans Feibusch. Over three thousand of these cheap, colourful images were sold to subscribers. Two enterprising schemes after the Second World War gave further opportunities to poster artists: forty prints for Lyons Coffee House (1947–55) and two series for Guinness (1956–7) for display in pubs and bars. Central artists included Anthony Gross, John Minton, la Dell, Lamb, Rothenstein, and Feibusch. The last artistic venture in this tradition, the images were printed by the Baynard and Curwen Presses, well-regarded commercial printers.

Like many other printing firms, the Curwen Press drew its apprentices from Central.[35] Before joining the family firm in 1908, Harold Curwen had attended Johnston's classes. From him he learnt the importance of legibility and of bringing simplicity and beauty into everyday printing. Under Curwen's management, and aided by publisher, editor and designer Oliver Simon, new standards of jobbing printing developed.[36] With the aid of clever lithographic craftsmen, the firm worked in close collaboration with artists, among them Farleigh, Lamb, Ardizzone, and Enid Marx. Curwen encouraged autolithography, throughout the 1930s producing magnificent posters,

Clare Leighton
'Hampstead Heath', 1929
Wood engraving, one of a set of six made for the London General Omnibus Company
148 × 106 mm
Central Saint Martins Museum Collection

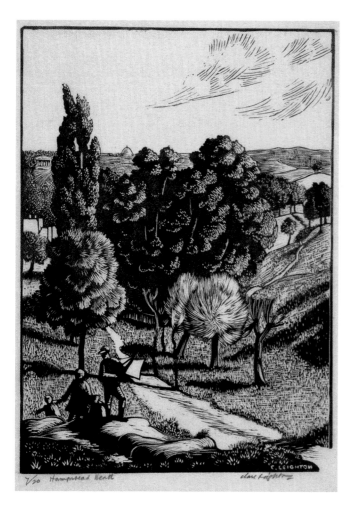

book illustrations, book jackets, and so forth. Likewise the Baynard Press, under the foremanship of Thomas Griffits, printed some of the more memorable posters of the time.

Much of the finest publicity material was produced by women, a number of whom founded their own Advertising Club in 1923. As Rooke noted, advertising was one of the few areas, together with interior design and women's clothes designing, where women had high status and good pay.[37] Most probably this was because they had shrewd insight into female psychology and, at the time, were the main consumers of advertised goods. Ethel Gabain, Elsie Henderson, Dorothy Hutton, Dora Batty, Margaret Calkin-James and Clare Leighton are just a few Central poster artists remembered today, while others such as Herry Perry, Mary Wright, and Doris Carter, whose work was admired by contemporary critics, have been largely forgotten.[38] Ethel Gabain was among the most respected lithographers. A pupil at the Central in 1906, where she met her future husband, John Copley,[39] she was one of the first women printmakers in this country to own her own studio and press. Some of her most interesting work was for Ministry of Information official wartime publications, counterparts to the First World War 'Efforts and ideals' scheme. Eleven prints in two portfolios, *Children in wartime* and *Women's work in the war, other than the Services* (1940), were supported by a further four by Hartrick for his *Land work in wartime* series.

If government departments looked to Central artists for propaganda prints, the London County Council (LCC) School 'was for a time the unwitting sponsor of some of Britain's most mordant political propaganda of the period'.[40] From within James Fitton's lithography evening class a number of students were recruited to the Artists' International Association (AIA) (1933–53), an anti-Fascist, pro-Soviet organisation, many of whose members were Communists. Founders included Fitton,[41] James Boswell, James Holland, Edward Ardizzone, Pearl Binder and James Lucas. The AIA derived much of its vitality from poster and

Ethel Gabain
'Sandbag workers', 1940
From 'Women's work in the war other than the services', 1940
Lithograph
330x460mm
©Imperial War Museum

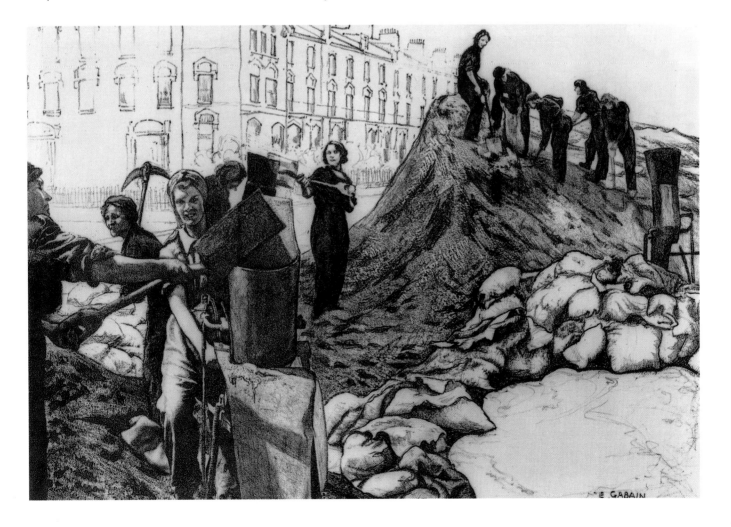

advertising campaigns. Its ambition to democratise the consumption of art resulted in schemes such as mural decoration, and touring exhibitions to libraries, factory canteens and retail outlets, particularly Marks and Spencer. Of the twenty-one prints sponsored jointly by the AIA and School Prints for the Festival of Britain in 1951, Central artists were responsible for almost half. The most significant initiative undertaken by the Association, however, was the Everyman Print scheme. First issued in January 1940, the unlimited edition of prints (priced at one shilling plain and one shilling and sixpence coloured), with examples by Boswell, Holland, Binder, Binyon and Ginger were shown in London, Bristol and Durham among other places. Over three thousand prints were sold within the first three weeks, but the scheme foundered in 1942, partly due to poor quality offset printing and the perception among collectors that these were not 'original' works.

The AIA's production of inexpensive prints expressing socialist views was influenced to a certain extent by *New Masses* (an American magazine with lithographic illustration), and to German political caricature. In the British tradition of Hogarth and Cruikshank, 'The three Jameses', Fitton, Boswell and Holland, created a new style of satirical art with their biting imagery for magazines such as *Left Review*, and *Lilliput* for which Boswell acted as art director. His own work, predominantly an attack on the ruling classes, recalls the work of George Grosz and Otto Dix both in its subject matter and its style of outlining and stippled and scratched markings. He also pursued a successful career in advertising, as art director for Shell Petroleum, and later editor of the house journal of J. Sainsbury. Apart from his contributions to magazines and other publications, Holland did some attractive lithographic illustration for Puffin Picture Books. Fitton's commercial work was extensive, including book jackets, and posters for London Transport, the Empire Marketing Board, the

James Holland
'The quick-starting pair', 1930
Advertisement for Shell
Colour lithograph
762 x 1143 mm
© Shell Art Collection at the National
Motor Museum, Beaulieu, Hampshire

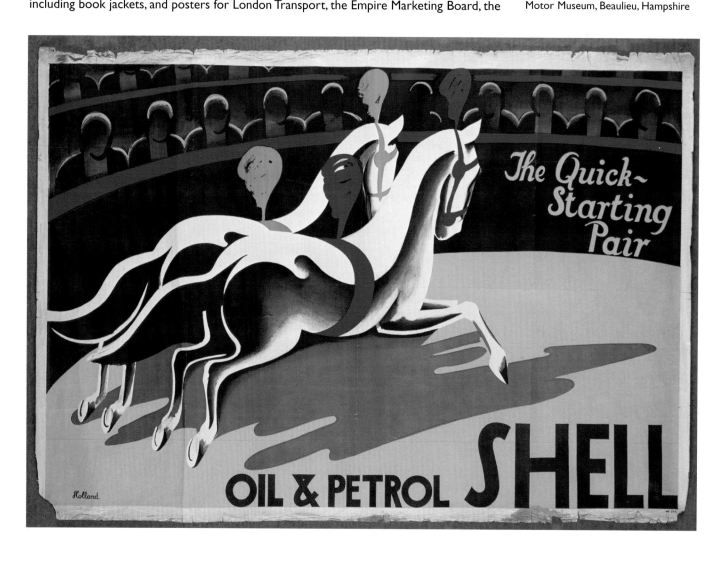

Pearl Binder
'Open-air concert at workers'
collective', 1933
Private collection

Ministry of Information, the Ministry of Food, and Ealing Studios (including one for the film *Kind Hearts and Coronets* in 1949). He was also a prolific painter and produced designs for textiles. Some of Binder's works of the mid-1930s were early examples of social realism in British printmaking. She was among a number of artists who visited Russia, where her drawing and prints based on life in London's East End and in the theatre world were successfully exhibited in Moscow. She contributed occasionally to the *New Left*, as did Clare Leighton, and to glossier magazines such as *Vogue* and *Harper's Bazaar*. Francis Klingender recognised the social importance of these artists' work when he commented in 1943 that 'the essential basis for popular art... is only now beginning to re-emerge'.[42]

After the foundation of the Royal Society of Painter-Etchers and Engravers in 1880, etching in particular was perceived as an original rather than a reproductive art, achieving phenomenal popularity. Indeed, from 1907 the subject was taught in Central's School of Book Production more with artists' prints in mind than for illustrative purposes. Etching's status as a fine art was fully recognised in 1946 when classes were moved from the School of Book Production and incorporated within the School of Drawing, Painting, Modelling and Allied Subjects. The first teacher, Luke Taylor, was followed by F. V. Burridge, F. L. Emmanuel, Malcolm Osborne, A. K. Middleton Todd and Paul Drury. The most influential was W. P. Robins (1920–49), whose practical handbook, *Etching craft* (1922) became a standard manual. Post-war staff up till the 1960s included James Grant, Blair Hughes-Stanton, Merlyn Evans, and Anthony Gross,[43] inspiring teachers who, with the help of the publishing ventures of entrepreneurial galleries, such as the St George's Gallery and the New Editions Group, brought etching to the forefront once again. Its popularity waned somewhat in the 1960s and 1970s when the more highly mechanised techniques of screen-printing and mixed media became popular, commissioned and produced on an international scale by the professional printing studio-galleries, Editions Alecto, the Curwen Studio, and Kelpra. Such work was exemplified by that of pre-second world war students, Michael Rothenstein and Richard Hamilton, both of whom advocated the use of new technical processes.

Despite the move away from traditional printmaking methods, the primacy of mark and pattern making was retained in the 1950s with the teaching of Basic Design. Indeed, one linocut exercise devised by Hamilton and illustrated in 'The developing process' (Institute of Contemporary Art, 1959) shows a remarkable resemblance to Rooke's repeat pattern design method.[44] Contemporary artists, John Lawrence and Sarah van Niekerk, pupils of Gertrude Hermes, found her sculptural use of tools profoundly affected their way with wood-engraving, much of it commissioned for illustrative or publicity purposes.

The expressive quality of tool marks – so much the focus of Central teaching – is today apparent in prints generated from computer programmes in which linear and tonal schemes relate to traditional graphic techniques. Paradoxically, the computer offers similar challenges to modern-day graphics and textile students as conventional printmaking techniques did in earlier years.

In 1947 James Boswell advocated the type of training that gave students

a solid basis of judgement and ability which are today used as propaganda methods for government policy or commercial purposes. Even if these are derivative in character... their creation would not have been possible if the artists had not by virtue of their

early training reached an understanding of what the craftsmen of the past or the innovators of today were trying to do. The revolution which they wrought in the presentation of ideas was the outcome of this understanding. Had their training been of a specialised nature their outlook would never have acquired the flexibility and catholicity necessary to make the changes.[45]

The wide-based teaching methods of the Central School produced artists who, through the application of their design and technical skills, reinstated prints as 'powerful tools of modern life and thought'. Boswell's perceptive views precisely embody the Central School ethos and its cultural significance.

1　William M. Ivins, *Prints and visual communication*, Harvard University Press, 1953, p. 3.

2　See list of manuals, p.156.

3　Letter to Sidney Cockerell, n.d. Cited in Priscilla Johnston, *Edward Johnston*, Faber & Faber, 1959, p. 88.

4　In 1959 Ruari McLean wrote 'Practically all lettering in Europe today is being taught by people taught by people taught by Johnston'. Cited in Francis Meynell, *My lives*, Bodley Head, 1971, p. 62.

5　John Farleigh, *Design for applied decoration in the crafts*, G. Bell & Son, 1959, p. 9.

6　W. R. Lethaby, 'Modern Design', unpublished lecture [c.1901]. Cited in Justin Howes, ed., *Craft History*, 1988, 1, pp. 133–42.

7　Peter Dormer, 'The art of the maker: skill and its meaning in art', *Craft and Design*, Thames and Hudson, 1994, pp. 7–8.

8　Eric Gill, 'The Society of Wood Engravers', *The Architect*, 1920, 104, p. 300.

9　Robert Gibbings, 'Thoughts on wood', *The Saturday Book*, 1957, 17, 207–13, reprinted in *Matrix*, 9, 1989, pp. 8–19, p. 9.

10　Simon Brett to the author, 14 June 1999.

11　Noel Rooke, *Woodcuts and wood engravings*, London, Print Collectors' Club, 1926, p. 27.

12　'The qualifications and experience of Noel Rooke', n.d. Cited in Justin Howes, 'Noel Rooke: the early years', *Matrix*, 1983, 3, pp. 118–23, p. 121.

13　Charles Pickering to the author, 20 October 1985. He taught part time at the Central School (1935) and in Guildford and Kent before his appointment as Head of Mid-Kent Region Printing Department. He became the first HM Inspector to be appointed as a national specialist for printing subjects.

14　Initially women were not allowed to set and print type as the trades did not admit them to the profession.

15　Fry most probably learnt wood-engraving from Eric Gill whose lettering classes he attended in 1908.

16　See Joanna Selborne, 'An adventure of re-discovery: lesser-known pre-war students of wood-engravings at the Central School', *Matrix*, 19, 1999, pp. 165–78.

17　He taught punch cutting at Central in 1914 and also worked for the Doves Press.

18　L. T. Owens, *J. H. Mason 1875–1951, scholar-printer*, Frederick Muller, 1976, p. 81.

19　J. H. Mason, *Notes on printing considered as an industrial art*, British Institute of Industrial Art, 1926, p. 12.

20　Her manual, *The way of wood engraving*, was published by Studio Publications in 1953.

21　Founded in 1947 by Charles Ede to produce beautiful but affordable books, the Society continues to employ wood-engravers.

22　Both artists wrote practical handbooks: Leighton, *Wood engraving and woodcuts*, Studio Publications, 1932, and Farleigh, *Engraving on wood*, Leicester, Dryad Press, 1954.

23　Simon Brett, *Mr Derrick Harris, 1919–1960*, Denby Dale, The Fleece Press, 1998, p. 7.

24　Monica Poole, *The wood engravings of John Farleigh*, Henley-on-Thames, Gresham Books, 1985.

25　The Colour Woodcut Society was founded in 1920 and the Society of Graver-Printers in Colour around 1931.

26　See Paul Nash, 'Modern English textiles', *Artwork*, Nov–Mar 1926, 6, p. 84.

27　For further discussion see Mary Schoeser, *Bold impressions: block printing, 1910–1950*, Central Saint Martins College of Art & Design, 1995.

28　Rothenstein's *Linocuts & woodcuts*, Studio Books, 1962, was written while he was teaching at Camberwell Art School.

29　F. Morley Fletcher, *Wood-block printing: a description of the craft of wood cutting and colour printing based on the Japanese practice*, London, John Hogg, 1916, pp. 86–8.

30 H. E. Brutt, *The psychology of advertising*, Boston, Houghton Mifflin, 1938. Quoted in Clive Ashwin, compiler, *History of graphic design and communication: a source book*, London, Pembridge Press, 1983, p. 54.

31 C. R. W. Nevinson, *Paint and prejudice*, New York, Harcourt Brace, 1938, p. 113.

32 Henry L. Trivick, *Autolithography*, Faber and Faber, 1960, p. 7. Trivick taught lithography at the Regent Street Polytechnic from around 1946.

33 Quoted from J. G. P. Delaney, 'F. Ernest Jackson, draughtsman and lithographer', *Apollo*, May 1987, pp. 338–43, p. 340.

34 He taught lithography from 1930, replacing Hartrick in 1930 and running the class from 1944.

35 See Sylvia Backemeyer, 'The School of Book Production and its influence', in Sylvia Backemeyer, ed., *Object lessons*, Lund Humphries, 1966, pp. 38–41, p. 40.

36 Two seminal publications emanated from the Curwen Press: Harold Curwen, *Processes of graphic reproduction*, Faber & Faber, 1934, and the influential magazine, *Signature, a quadrimestrial of typography and the graphic arts* (1935–40 and 1946–56). The Double Crown Club, a dining club for artists, printers, and publishers, was founded by Simon in 1924. Invitations and menus for the dinner were originally designed by the speakers.

37 Noel Rooke, *The Royal Society of Arts Journal*, 1931. Cited in Jill Seddon and Suzette Worden, eds., *Women designing: redefining design in Britain between the Wars*, University of Brighton, 1994, p. 13.

38 See note 16.

39 Lithographer and etcher, Copley was the first secretary of the Senefelder Club.

John Lawrence
Illustration for *Rabbit and pork, rhyming talk*, written and illustrated by John Lawrence, Hamish Hamilton, 1975
Wood engraving and colour
160 x 190 mm
Central Saint Martins Museum Collection

40 Robert Radford, *Art for a purpose: the Artists' International Association, 1933–1953*, Winchester, Winchester School of Art Press, 1987, p. 21.

41 Fitton studied under Hartrick in 1925 where he met his wife Margaret, a successful lithographer and painter. He took over from Hartrick's successor, Spencer Pryse, in 1933.

42 Francis Klingender, 'Hogarth and English caricature', *Transatlantic Arts*. Cited in Lynda Morris & Robert Radford, *AIA, The Story of the Artists' International Association, 1933–1953*, Oxford, The Museum of Modern Art, Oxford, 1983, p. 71.

43 Gross's *Etching, engraving and intaglio printing* was published by Oxford University Press, in 1970.

44 Reproduced in Tanya Harrod, *The crafts in Britain in the twentieth century*, Yale University Press, 1999, p. 232.

45 James Boswell, *The artist's dilemma*, Bodley Head, 1947, p. 40.

'Visual Language':
the growth of graphic design

Sylvia Backemeyer

Jesse Collins
Label for Martins Virginia cigarettes,
1945
Published in *Designers in Britain*, vol 1,
SIAD, 1947
Central Saint Martins Museum
Collection

It was in 1935 that the changes taking place in the department were acknowledged by a change of title. The 'School of Book Production' became the 'School of Book Production including Printing, Posters and Advertisements'. The Head of Department at that time was Noel Rooke, who ran it until he retired in 1950 and was succeeded by Jesse Collins. Collins had been teaching on a part-time basis in the department since 1936, as well as at Camberwell. He was one of the members of the Industrial Design Partnership (IDP) which was founded in 1935 by Milner Gray and Mischa Black and set a prototype pattern for the Design Research Unit (DRU), which came into being in 1943. As Britain's first multidisciplinary design consultancies, the IDP and DRU made a strong impact on graphic design in this country.

Collins produced a range of graphic designs for the DRU including posters and packaging. One former student remembers his pleasure in discovering that Collins was the designer of the Martins cigarette pack, a design he had long admired.[1] He is now remembered more by those he knew and taught in the 1940s and 1950s as an outstanding and inspiring teacher, remarkable for his ability to spot talented staff and students, and to help all students by his caring attitude to individuals and their needs. He was an idealist and believed passionately in the contribution graphic design could make to improving the environment.[2]

Collins was one of the few staff who seemed to be aware of the Bauhaus and was influenced by it in his teaching. He started a Basic Design course at Camberwell in the 1930s and developed Basic Design as an element of the graphic design course at Central, with the support of William Johnstone, who thought very highly of him. Basic Design, often taught by fine artists, became a part of all courses while Johnstone was Principal.

As head of department Collins was responsible for drawing up the programme for every student individually. Ivor Kamlish, a student in the 1950s, remembers that Collins agreed that he could work across two schools, Book Production & Printing and Interior Design, as he was interested in both interior and exhibition design, as well as typography, drawing, illustration and basic design. He and other students remember the easy flow between departments and courses. 'It was easy to take extra classes and work across disciplines.'[3]

Collins felt it was essential to get the balance right in terms of individual students attending the course. He chose students from a mixture of races and a cross-section of backgrounds, knowing that the right mix of students was an important ingredient for a stimulating course. Another source of stimulation was the physical arrangement of the class. In the 1950s two or three different groups would work in one studio: Collins teaching graphic design with Gertrude Hermes and Laurence Scarfe teaching illustration. Although an atmosphere of quiet concentration prevailed during teaching, in the breaks the students from the three groups would mingle and discuss each other's work.[4]

Collins showed great sensitivity towards individual students and their needs. Derek Birdsall remembers Collins seeing he was struggling with a project and needing a break, saying, 'Why don't you go to the park and read John Donne, or go along to the Academy cinema this afternoon? There's a very good film you ought to see.' Recognising Birdsall's wish to concentrate on typography towards the end of his course Collins allowed him to have a free-ranging timetable.[5]

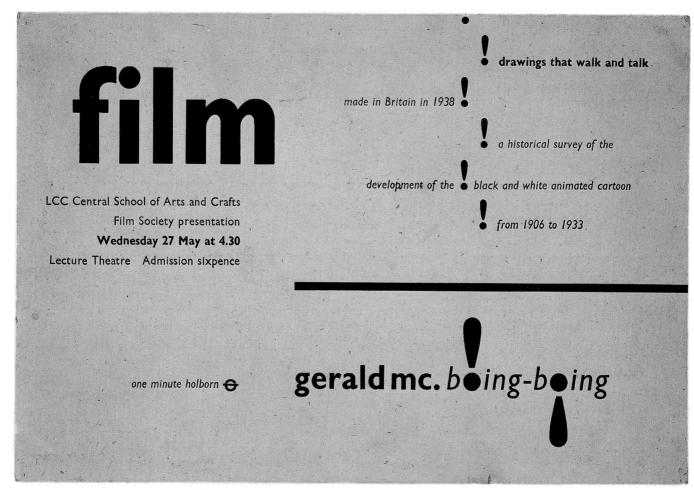

Derek Birdsall
'Gerald Mc Boing-Boing', 1953
Poster for the Central School film
society
Private collection

The great affection felt by his former students is palpable. They quote with pleasure some of his many memorable remarks: 'out there are the Philistines', 'this place is like a cathedral', 'something will occur', 'this is a chapel of good taste'. Birdsall compares him to a 'Welsh shepherd' guiding his flock. He is remembered for his calm reassurance at times of stress, like when they were setting up a show: 'Just use Gill type and you'll be all right'.[6]

Not only students remembered Collins with affection and respect. Roderic Barrett who taught from 1947 to 1968 remembers the lunch-time gatherings. 'Keith Vaughan, Laurence Scarfe, Hugh MacKinnon, Anthony Froshaug and others, going on with fervour about religion, politics, poetry and painting. At the centre Jesse Collins, full of vitality, ideas, good humour and affection. We loved him. Nothing was good enough. Bad design was wickedness, only partly forgiven if the maker was an idiot.'[7]

One of Jesse Collins' most inspired appointments was Anthony Froshaug. Froshaug had been a student of drawing and wood-engraving at Central from 1937 to 1939. In a memoir he describes how he encountered Collins in the street outside Central one day in 1948. ' "I was wondering if I couldn't persuade you to come and teach." To teach; I'd never thought of it. Had no idea how to I told him. "No, no. You're just the person. You see you have authority." Authority? I always felt so uncertain about my ideas: they were never quite right, but incredibly interesting to me to pursue. But to teach? "Yes, I'd like you to do a day a week, starting this September, Tuesdays." '

Until his death in 1984 Froshaug taught at the Central for several periods: 1948, 1952–3 and 1970 to 1984. He also taught at Watford College of Art, the Royal College of Art and from 1957 to 1961 he was Professor of Graphic Design at the Hochschule for Gestaltung, Ulm. A witty and imaginative designer Froshaug produced early British examples of progressive European typography influenced by Jan Tschichold, in his own printing workshop. Considering the limited period he taught at Central, Froshaug had a tremendous influence

on his students, remaining in touch with many of them until his death. Derek Birdsall describes him as 'an immensely attractive personality', 'a poet and a prince' elegant, charismatic and aristocratic. Philip Thompson has said that when he arrived at Central it 'was like the coming of the messiah'.

Froshaug taught his students clarity of thinking. He was very rigorous and insisted that they justify their statements. He taught a logical way of looking at things which could be applied across the board. In his obituary of Froshaug, Ken Garland, a student of his in 1952–3, wrote:

> Most exciting of all, his teaching was never dogmatic; all propositions existed to be examined, challenged, fought over if necessary, but not to be taken for granted, so that we felt like valid participants in an ongoing debate, rather than humble acolytes unquestioningly accepting the eternal truths.[9]

Discussing progressive influences on post-war graphic design in Britain, Garland wrote of the work of Collins and Froshaug at the Central that

> it formed the true focus of teaching and thinking on graphic design in the vital five-year period from 1951 to 1956… it attracted the most forward looking and stimulating teachers on the subject, including, as well as Collins and Froshaug themselves, Spencer, George Mayhew and Edward Wright… it produced within a short period an extraordinarily talented bunch of designers.[10]

In 1949 Jesse Collins was impressed by the newly launched *Typographica* and invited Herbert Spencer, its founder and editor, to teach one day a week at the Central School. Spencer was only 24 years old. In an interview in the 1980s Spencer said

Herbert Spencer
Cover for *Typographica* number 10,
Lund Humphries, 1964
275 x 218 mm
Central Saint Martins Museum
Collection

because some of my students were older than I was, I suddenly found myself faced with the need to analyse what I was doing… I had 22 students for five hours one day a week, and I used to go round and sit next to each one of them every time I went there. Because I wouldn't see them again for a week, I really had to concentrate my ideas. So at the end of the day I had learned a great deal myself.[11]

He added that it was as a direct result of his experience with Central students that he developed his first book *Design in business printing*, published in 1952.[12] This recognised that the needs of business printing are substantially different from those of the traditional book. It became a standard reference book for a generation of graphic designers. Spencer got Central students to design an exhibition at the publisher's for the book launch.

It must have been tremendously exciting for the Central students Spencer taught from 1949 to 1955. Throughout this period he was editing the first series of *Typographica*, a ground-breaking British typographic journal published by Lund Humphries from 1949 to 1967. Well designed and printed, it provided an informed and sympathetic assessment of modern European typographic developments. It was virtually the only place where students could find avant-garde material.

Spencer's Central students were very involved in both series of *Typographica*. In the first series *Typographica* 3 has an

article on Central School experiments with the photogram, showing the work of students in the creative photography class. In *Typographica* 9 an article, 'Pattern, sound and motion', describes some typographical experiments by Central School students working with Edward Wright, with illustrations by John Wallis, Germano Facetti, Derek Birdsall and Ken Garland. In the second series one of the articles which caused most interest was in *Typographica* 4 for December 1961, devoted to street signs and lettering. In his article 'Mile a minute typography', a brilliant *tour de force*, Spencer describes a journey taken by himself and Brian Little, a former Central student, between Marble Arch and London Airport, with photographs of every road sign along the route.

In 1952 Edward Wright was brought into the department by Anthony Froshaug to teach an evening class. Wright was a designer of environmental graphics, architect, painter, constructivist typographer and much more. He taught in several art schools and eventually became head of Graphic Design at Chelsea College of Art in 1970. At Central he taught experi-

mental typography, one of a number of part-time evening courses run at the college at that time. Another part-time course especially pertinent to graphic designers was Nigel Henderson's experimental photography. Wright's part-time students included the architect Theo Crosby, and Germano Facetti who became art director of Penguin Books in 1961. Many full-time students also took the opportunity to attend Wright's and Henderson's courses. Some were so enthusiastic that they deliberately got locked in the building overnight so that they could go on using

the equipment. In a memoir Wright noted that 'Froshaug gave me the idea and opportunity to try out what Lawrence Gowing has aptly called "extempore typography". The method was to arrive at a design or typographic statement by moving units around on the bed of an Albion press, while making a series of impressions from wood letter and other type-high printing units. Ken Garland, who was a student then, produced some remarkable results in this way.'[13]

Because this was an evening class it was agreed that Wright and his students would be granted access to one of the printing presses. Ironically, full-time graphics students were not allowed to use them. F. C. Avis, the head of the Day Technical School for Printers, would not allow anyone access to the printing presses except his own students, the printer apprentices. The graphic designers produced their layouts and the printers would set them. Some students were so frustrated they bought their own Adana hand press. It must have been very difficult for the traditional printers, whose right to sole use of the presses and other printing facilities had been unquestioned for nearly fifty years, to take these 'graphic designers' seriously. William Johnstone and Jesse Collins did their best to change attitudes. From 1953 with the change of the title to the School of Book Production and Graphic Design, the official School policy was to encourage working across what Johnstone saw as artificial boundaries, by both the graphics students and the printers. He outlined his policy in an article in the *Penrose Annual*.

For a long time it seemed to me that in this school where one had the most distinguished artists of the country there was not a sufficiently close contact between these and the printers. It is important that the printer become an artist rather than merely a specialist in specialisation and limitation… To change and alter the basic training provided by the department required serious thought, but to continue indefinitely along one path, however successful, tends to create a false notion that tradition is a thing of continuity and growth. The curriculum based on the needs of pre-apprenticeship training and to some extent the day-release system have their limitations. The hope is entertained that the day-release student may not only become a fine printer, but a creative person and designer.[14]

Unfortunately he failed to move the old-style traditional printers who were backed to the hilt by the unions and mostly refused to co-operate. Eventually the Day Technical School closed. In spite of the problems with the printers the graphic design students got their training in typography and became familiar with typefaces which they used throughout their working lives.

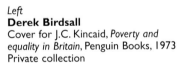

Alan Fletcher
Pirelli Bus poster, 1965
For Crosby, Fletcher and Forbes
Courtesy of Pentagram Archives

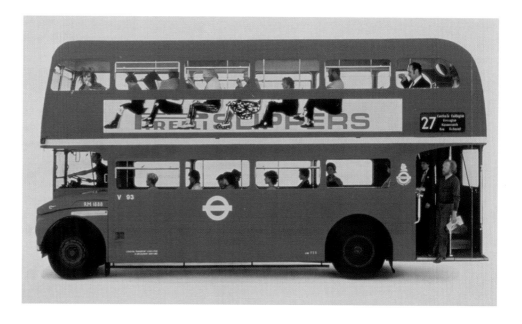

Ken Garland
Cover for *Design* magazine, issue 171,
March 1963
280 x 210 mm
Private collection

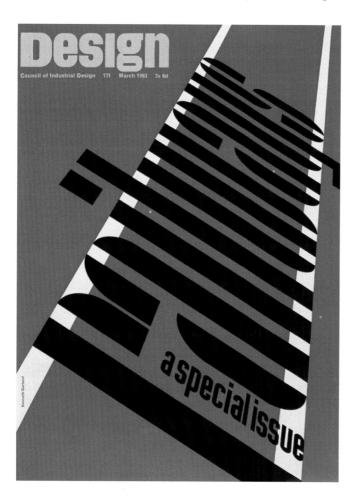

All in all this was an immensely productive time. The first generation of professional graphic designers graduated from Central in the mid-1950s and launched themselves on London. Some went freelance right away. Colin Forbes, Peter Wildbur and Harold Bartram formed the FWB Partnership, subsidised with some part-time teaching. In 1962 Forbes co-founded Fletcher, Forbes and Gill which ultimately was absorbed into the newly created Pentagram of which Forbes was a founder member, with Alan Fletcher, another Central student. Derek Birdsall, George Daulby, George Mayhew and Peter Wildbur formed BDMW associates in 1960. Ken Garland was art editor of *Design Magazine* from 1956 until 1962 when he established Ken Garland & Associates, Ken Briggs designed publicity and signage for the National Theatre and the Barbican and Bill Slack became editor of *Architectural Review*. As ever, Jesse Collins kept a watchful eye, helping students find jobs and inviting others to stay on and teach, spreading the word to the next generation.

Eventually many students went on to teach at other colleges. Harold Bartram taught full-time at the London College of Printing; others taught part-time at Central, London College of Printing, the Royal College, and other colleges across the country. Derek Birdsall became Professor of Graphics at the Royal College in 1987.

Idealism was in the air. Ken Garland published 'First things first: a manifesto' in 1964. Signed by twenty-one other designers and photographers, it appeared in the *Guardian*, the *SIA Journal*, *Ark* and *Design*. He was concerned that the talents of graphic designers were mainly devoted to consumer advertising ('cat food, stomach powders... roll-ons, pull-ons and slip-ons'). They should be redirected towards other, more worth-while enterprises: street signs, books, instructional and educational aids, 'more useful and more lasting forms of communication'. Much of his working life reflects this belief. Between 1962 and 1966 he produced striking posters for the Campaign for Nuclear Disarmament (CND).

Students who subsequently became teachers themselves have spoken with appreciation not only of the thorough grounding in techniques they received at Central, but also of

the inspirational teaching methods, methods which they were able to draw upon in their own teaching later.

In 1963 *17 graphic designers*, a book by seventeen graphic designers then working in London, eight of them former Central students, was published by Balding and Mansell. It examined attitudes and approaches to graphic design current in England at the time. A number of Collins' students also produced books, arising in the main from ideas they experienced in their time at Central. These included *Art without boundaries 1950–1970* in which Philip Thompson collaborated with two other designers in an exciting and influential discussion of the erosion of traditional boundaries between the arts.[15] He followed this in 1980 with *The dictionary of visual language*.[16] Ken Garland published *Graphics handbook* in 1966 and *Illustrated graphics glossary* in 1980. Peter Wildbur published several books on logos and other aspects of information graphics.

Most if not all of the students mentioned in the preceding paragraphs would have studied illustration as part of their portfolio of subjects. At Central both book jacket design and book illustration were a major part of Book Production. Noel Rooke started book illustration with his wood-engraving classes in 1905 and continued until his retirement in 1947. John Farleigh, probably his most gifted pupil, worked very closely with Rooke teaching the wood-engraving classes until 1948, when he left rather suddenly after falling out with William Johnstone when Johnstone became Principal.[17] Farleigh was a charismatic character, a talented artist and teacher and champion of the crafts in general. Students adored him. One of them from the 1940s said 'when he praised your work, you were up in the clouds'.[18] From the late 1940s until the late 1960s the staff teaching illustration changed very little: Roderic Barrett, Keith Vaughan, and Laurence Scarfe were the core staff.

Roderic Barrett was a contemporary of Margaret Till[19] and was a talented wood-engraver although later primarily a painter. He taught illustration from 1947 to 1968, initially teaching two classes, one with John Farleigh, the other with William Roberts. Keith Vaughan taught illustration from 1948 to 1957. In 1946 he was put in charge of design and production for John Lehmann, and designed many book jackets, including some for the New Writing and Daylight series. He was succeeded in this role by Val Biro, a student of Vaughan's at Central from 1939. With John Minton, also a teacher at the Central School, he was one of a group of neo-romantic lyrical painters. Students remember him as a serious and brilliant teacher. Vaughan's students had to learn to work in ink because reproduction from pencil was difficult.[20]

Laurence Scarfe taught part-time at the Central School from 1945 to 1970. He also worked as a freelance artist, contributing to several magazines, including *Radio Times*, and designing for the BBC, GPO, Central Office of Information, London Transport and the Curwen Press. Typical of the staff employed at Central, Scarfe brought with him a range of contacts and experience of the real world which were invaluable to his students.

From time to time other part-timers joined the little band of

Ken Garland
'Aldermaston to London, Easter 1962'
CND poster
Private collection

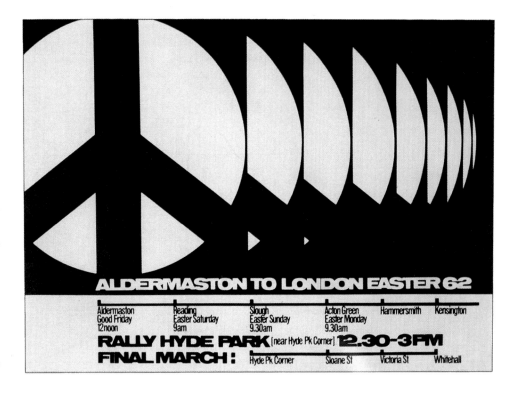

illustration staff. Paul Hogarth was one of these and taught from 1951 to 1954. In between sessions of teaching he would go off on one of his trips behind the 'Iron Curtain'. Students were fascinated by his traveller's tales. Jesse Collins did his best to accommodate Hogarth's frequent absences by bringing in substitute staff; Johnstone was less accommodating. Hogarth was given an ultimatum:' "Either y'arrange for me to be invited to China or any of those damned countries, or I'll have to ask ye to resign." I did my best, but without success, so my days at Central ended'. [21]

Because of the flexibility of approach, students could attend classes in the School of Fine Art in Life Drawing. A number chose to work with Anthony Gross who was known for his 'classical approach'. He surprised students by using a plumb line, something he considered an essential tool in the business of learning to draw. Like other staff teaching at the time Gross would make perceptive comments that made students look at things differently. Derek Birdsall remembers him saying one day when they were drawing from life 'That's not a pencil, it's a surgical instrument', and 'that is not a model, she's a woman'. [22]

Illustration students benefited from Farleigh and the relationship he and his staff had with the commercial publishing world. All the staff were personally engaged in designing and drawing for books, magazines, posters and other advertising, which meant they knew it from the 'inside'. Clarke Hutton was

THE BETHNAL GREEN MUSEUM has a famous collection of toys, dolls and all the varied appurtenances of childhood, mainly from Georgian, Regency and Victorian nurseries. Many are important social documents. Inspect the fine Dorset House. Its furnishings and occupants reflect carefully fashion's progress between 1760 and 1830. Lovingly created and preserved, these playthings evoke unfailingly the authentic savour of childhood.

Underground to Bethnal Green

often in touch with Noel Carrington, a governor of Central who was involved in a range of innovative and imaginative projects, including Puffin Books and Transatlantic Arts. He invited many Central students to participate, including Kathleen Hale and Pearl Binder.[23] Farleigh had extensive and valuable connections with the book trade and helped his students get work. It was departmental policy to get all leaving students their first commission, often a book jacket.[24]

In May 1940 *The Bookseller* published a discussion on the subject of illustration in books.

It was held at the Central School in Southampton Row and was attended by, among others, Basil Blackwell, Richard Church, Robert Gibbings and representatives of publishers including Macmillan and Bumpus. The notes on the discussion published in *The Bookseller* were followed by an open letter from Farleigh to book publishers.

> This is quite frankly a begging request. I have in my class at the Central School ten students fully trained and as capable as any professional of doing a job. They under-stand methods of reproduction, and know the costs. They have specimens ready. All they need is a 'first job', the most difficult of all to get. I know the value of a first job myself and remember with affection the men who, here and there, have given me a start in different directions. They had plenty of gambling instinct as well as discern-ment. I want ten jobs (or more) to be sent to me at the Central School of Arts and Crafts, Southampton Row, WC1 and I will guarantee to supervise ten students and get the work done. I want publishers to know about us, that they can come to the school for talent and efficiency. Is the publishing world prepared to gamble, ten jobs, how-ever small, in the whole of London?

This was the first year of the War, a time of great uncer-tainty all round, but particularly in the publishing trade where paper was scarce and sales uncertain. A number of

Anthony Gross
Frontispiece to John Galsworthy,
The Forsyte saga, Heinemann, 1950
Six colour lithography
230 x 160 mm
Central Saint Martins Museum
Collection

Kathleen Hale
Cover for *Orlando's home life*, written
and illustrated by Kathleen Hale, Puffin
Picture Book, 1942
175 x 235 mm
Private collection

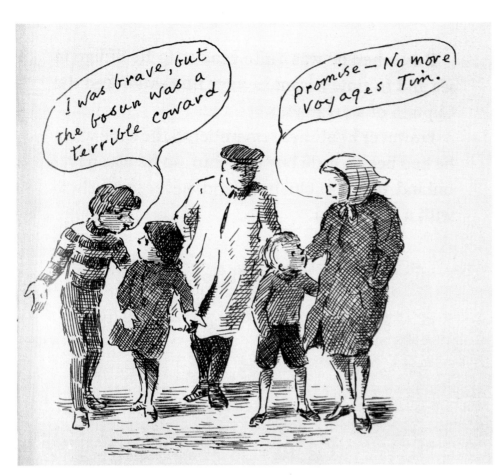

Edward Ardizzone
Drawing for *Little Tim's last sea voyage*,
written and illustrated by Edward
Ardizzone, Bodley Head, 1972
Pen and ink
255 x 180 mm
Central Saint Martins Museum
Collection

Below left
Susan Einzig
Jacket design for Philippa Pearce, *Tom's
midnight garden*, Oxford University
Press, 1958
Pen, ink and watercolour
220 x 160 mm
Central Saint Martins Museum
Collection

Below
Brian Cook
Jacket design for Clive Rouse, *The old
towns of England*, Batsford, 1948
220 x 180 mm
Courtesy of the Royal Society of Arts

publishers came up trumps; Margaret Till remembers receiving a commission from Macmillan as a result.

Many of the graphics students went into book illustration or undertook this and a range of commercial design. Susan Einzig, Lynton Lamb, Edward Ardizzone and Val Biro all did work for *Radio Times*, as well as book illustration and other design work. Outstanding children's book illustration was undertaken by Kathleen Hale *Orlando the marmalade cat*, A. E. Bestall *Rupert Bear*, John Burningham, John Lawrence, John Vernon Lord, Hilary Stebbing, and John and Isobel Morton Sale. Penguin employed a number of Central staff and students including Paul Hogarth, Derek Birdsall, George Daulby, Alan Fletcher and Peter Wildbur. Peter Harle, an ex-Central student was art editor of *Radio Times* from 1959 to 1969. Hans Tisdall, Brian Cook, Enid Marx, Lynton Lamb and many more all designed book jackets for a range of publishers. All the major advertising concerns commissioned Central students. Around twenty were engaged in designing posters for London Transport over a period of sixty years. Others did posters for the GPO, Shell, the Empire Marketing Board, Guinness, and film companies, such as Ealing Studios.

After Jesse Collins retired, William Johnstone appointed Colin Forbes in 1958 as his successor. Forbes was a former student of Collins and among other jobs, had worked as an assistant to Herbert Spencer after completing his course. Although he was exceptionally young, only thirty, he was a great success for the two years he held the post. He left in 1961 to work full-time in his own design consultancy, and later became one of the founder members of Pentagram.

In 1963 the Day Technical School for Printers finally closed down. This was a reflection of the advent of the new Dip. A.D. qualification and the establishment of graphic design as a profession. In the Central School Prospectus for 1966, Brian Yates, the head of the new Department of Graphic Design, wrote

> The course is conceived as a broad education in art and design. It is concerned with the personal development, artistically and intellectually, of each student. At the same time it leads progressively to specialisation in one or more of the professional fields of graphic work – illustration, publicity, publishing and designing.

Some of the old faces still remained, but by the end of the 1960s a complete new staff, mainly practising graphic designers, had replaced them.

1 Interview with Philip Thompson, 17 September 1999.
2 Ibid.
3 Interview with Ivor Kamlish, 2 July 1999.
4 Ibid.
5 Interview with Derek Birdsall, 6 August 1999.
6 Interviews with former staff and students, from 2 July to 17 September 1999.
7 Roderic Barrett, letter to Joanna Selborne, 1987.
8 Anthony Froshaug, 'Memoir of Jesse Collins'. In Robin Kinross, *Anthony Froshaug*, Hyphen Press, 1999.
9 Ken Garland, 'Obituary of Anthony Froshaug 1920–84'. In *The Designer*, Journal of Society of Industrial Artists and Designers, October 1984, p. 6.
10 Ken Garland, 'Graphic design in Britain 1951–61: a personal memoir'. Paper given at a seminar on Post-war Design History, Kingston Polytechnic, March 1983. In Ken Garland, *A word in your eye*, University of Reading, 1996, pp. 62–9, p. 64.
11 Herbert Spencer, 'Getting going', *The Designer*, January 1980, pp. 6-8.
12 Herbert Spencer, *Design in business printing*, Lund Humphries, 1952.
13 Edward Wright, 'The Central School of Arts and Crafts'. In Edward Wright, *Graphic work and painting*, The Arts Council, 1985, p. 47.
14 William Johnstone, 'Graphic design at the Central School', *The Penrose Annual 1953*, pp. 58–60, p. 60.

A.E. Bestall
'Rupert gets his present'
From *More Rupert adventures*,
Daily Express Publications, 1943
240 x 175 mm
Central Saint Martins Museum
Collection

Rupert and Golly

RUPERT GETS HIS PRESENT

Then Bill says, "I would like to see
That bramble patch. Do come with me."

But when they get there—what a shock!
There are no brambles round the rock.

They find two parcels hidden there,
One each for Bill and little bear.

Then Rupert proudly shows his plane,
And tells the strange tale once again.

Their footsteps lead them up to the higher part of the rocky hill, and Bill suddenly points. "Let's go and see what it looks like now that Christmas has gone." Rupert tries to hold him back. "You know where our inquisitiveness led us before," he says. But Bill insists. There is no sign of any bramble having been there at all. "They must have been Santa Claus's own magic brambles," gasps Rupert. "I'm going to see if that crack in the rock really does lead to the toy store," declares Bill.

Rupert and Bill soon see that the crack in the rock is shallow and leads nowhere. Then their eyes fall on two parcels labelled one for Rupert and one for Bill. Grasping the presents Rupert and Bill run back to Mrs. Bear's cottage in triumph. Then they open the boxes and disclose the parts of two lovely model airplanes. "Don't you recognize them, Bill?" he cries. "These are the two best planes which we painted while we were in the toy store. Golly must have chosen them for us."

85

15 Gerald Woods, Philip Thompson and John Williams. *Art without boundaries 1950–70*, Thames and Hudson, 1972.
16 Philip Thompson and Peter Davenport, *Dictionary of visual language*, Bergstrom and Boyle, 1980.
17 William Johnstone, *Points in time*, Barrie and Jenkins, 1980, p. 222.
18 Interview with Joan Pilsbury, 11 July 1999.
19 Margaret Till, 'A student at the Central School, 1936–40'. In this volume, p. 120.
20 Interview with Ivor Kamlish, 2 July 1999.
21 Paul Hogarth, *Drawing on life: the autobiography of Paul Hogarth*, David and Charles, 1997, p. 54.
22 Interview with Derek Birdsall, 6 August 1999.
23 Conversation with Joe Pearson, 15 October 1999.
24 Interview with Margaret Till, 16 March 1999.

Following the thread: textiles

Mary Schoeser

Mary Schoeser is a consultant archivist specialising in textiles. She has curated a number of exhibitions including, in 1999, Decadence: views from the edge of the century, *for the Crafts Council. Her most recent publication is* The Watts Book of Embroidery: English Church Embroidery, 1833-1953, *in 1998*

The textile department was typical of the entrepreneurial spirit forged by the interdisciplinary approach at the Central. As will be seen, its students and staff combined art and industry in ways that contributed significantly to stylistic and technical developments in embroidery, hand weaving and hand-block printing, as well as in the ways these products were made available. The complexity of Central's textile programme – day school and evening classes, trade school, special lectures, and the incorporation in 1908 of the Royal Female School of Art (founded 1842–3) – is expressed in an annual report of 1921–2 which concluded it 'is difficult for anyone who is not closely in touch with the School to realise the scope of its work'.[1] This feature makes it difficult to reconstruct a full picture, or to trace more than a handful of students, particularly from the earlier years. Only a proportion of staff can be identified from the prospectuses, which give but a brief description of the courses. What they *do* show, however, is how, from its foundation, Central was both responsive and innovatory in relation to textile crafts and industry. Constantly changing, the textile courses nevertheless can be viewed as falling into three periods: 1897–1915, 1916–33 and 1934–66.

1897–1915

In the first period the emphasis was on embroidery, a principal expression of the avant-garde in limited edition hand-crafted textiles. Embroidery as an art form had numerous supporters, but Central had May Morris, who first directed and then 'visited' the School's embroidery classes from 1897 to 1910. Otherwise, embroidery was taught by Maggie Briggs from 1897 to 1899 and by Ellen Mary Wright from 1899. In 1908 the latter was joined at Central by her sister, Fanny Isobel, and both remained (Fanny Isobel listed as Mrs Beckett) in the prospectuses from 1916 until 1936–7. All were active as designers as well as practitioners and Ellen Wright had connections with Morris & Co. from about 1890, as an embroiderer trained by May Morris herself. This link gave students access to embroiderers whose knowledge not only embraced the artistic traditions of the Arts & Crafts Movement, but also included the demands of clients and the commissioning process, as well as practical details, such as costings.

While from the outset the needlework and embroidery lectures focused on the practical aspects of technique, students were encouraged to select from the other courses offered. Most pertinent in 1897 was the drawing class which included aspects of wallpaper and textile design, then at the peak of their importance as British exporting industries, and many still of a craft nature despite their scale of operation. In

1907 drawing incorporated carpet and linoleum design too, perhaps in anticipation of the arrival of the Royal Female School of Art, by 1860 'acknowledged as producing female designers of carpets'.[2] With the new building in 1908 came reorganisation: the strengths of the practical training were clarified by the creation of the School of Needlework, Embroidery and Lace. The inclusion of lacemaking, first noted in 1905 (when dressmaking and costume design were also introduced), befitted its rebirth as an artistic form over the previous decade or so.

Design remained in what became the School of Drawing, Design and Modelling, where it had passed from the hands of the likes of Archibald Christie, author of the influential volume, *Traditional methods of pattern designing*, 1910, and known to have designed silks at the turn of the century for the English Silk Weaving Company, Ipswich,[3] and Robert Catterson-Smith, to Bernard Adeney. Adeney taught drawing from 1904 to 1908, design from 1908 to 1914–15, and the museum studies course in 1914–15, a responsibility that seems to have been shared among many staff in something like rotation, and evidence of a long and cordial relationship with the Victoria & Albert Museum, the site of many classes. Within Central itself, was 'a considerable collection of fine examples of needlework', first noted in the 1897 prospectus: on the main staircase were cartoons for Burne-Jones tapestries. All presumably came under the care of the curator, Charles William Beckett, who was to become Fanny Isobel's husband. From 1908 to 1915 John M. Doran and G. E. Kruger taught drawing, and Katherine M. Wyatt, from the Royal Female School of Art, design. Doran and Kruger were in the School of Drawing, and Wyatt in what was, for a brief time, known as the Day School for Women. All three, with Adeney, were ultimately to become part of the School of Textiles and Costume, as it was renamed – and reorganised – in 1919.

Up until that time the conjunction of art and craft was expressed in the sharing of students between departments. The relationship between the engraver's use of tools and the embroiderer's use of stitches has already been mentioned (see chapter 'Making an impression'). Equally complementary to embroidery were the book production, calligraphy and lettering classes, and furniture, which included instruction in upholstering. Indeed, in the prospectuses for the years around 1910 it was urged that 'students of design unattached to any craft might find it useful to join [the embroidery] class as a corrective and practical outlet for their work'.[4]

Tapestry and hand-loom weaving were emerging courses in 1908. The prospectus for that and the next ten years noted that they would be taught, quite probably by Luther Hooper, 'if enough applicants' came forward. Hooper came from outside the Morris circle, although his training as a book illustrator and wood-engraver made his involvement with Central seem inevitable. His first commercial designs were for wallpapers, but in 1890 he had joined a silk weaving concern, probably the same Ipswich firm that wove Christie's designs, and, acquiring skills in tapestry weaving along the way, in 1901 he had his own looms in Haslemere (a thriving centre for the revival of textiles as crafts) and by 1910 a studio in London.[5] In 1920 Hooper appeared for the first time on the list of staff teaching textiles, and in this capacity he passed on his expertise until 1922 when, owing to age regulations, Central was 'deprived of [his] exceptional knowledge and skill'.[6] But long before his official entry into the department he was providing lectures: in 1909, for example, he gave a series of six talks on the history and techniques of weaving with special reference to design and drawlooms, and in 1913 contributed to a series of twelve talks, including a lecture on embroidery given by Mary Newill.[7]

1916–1933

Although it was in 1919 that the School of Textiles & Costume was created, bringing together all the staff necessary to teach 'all forms of surface design for furnishing and dress materials, and their uses in decoration and costume',[8] it is from 1916 that change was apparent. In that year Lindsay P. Butterfield began teaching design, a role he maintained until 1934. He brought with him twenty-two years' experience and wide commercial contacts as

Left
Archibald H. Christie
Example of floral work, published in his book *Pattern design: an introduction to the study of formal ornament*, New York, Dover Publications, 1969. Reprinted from the first edition published by the Oxford University Press in 1929
215 x 135 mm
Private collection

a freelance designer of wallpapers, prints and weaves, his wholesale textile-manufacturing customers including G. P. & J. Baker; Liberty & Co.; Alexander Morton; Newman, Smith & Newman; Thomas Wardle; Warner & Sons; and Turnbull & Stockdale. Also added in 1916, at the age of sixty-seven, was Professor Selwyn Image, lecturing in the history of art. Image had designed the majority of the repeating patterns sold by the Royal School of Art Needlework in the 1880s and 1890s, and from 1888 had produced designs for embroidery and stained glass under his own name. Textile and costume students attended his course; it was recommended to all students and 'day students are expected, and day scholarship holders required to do so'.[9]

Finally, a new course was added, Instruction of Salesmen and Saleswomen in the Wholesale and Retail Textile Distributing Trade, reflecting the close eye kept by Central on aspects of the trades which it supported.

The formation of a course on distribution had been mooted on the grounds that with the near demise of the old apprenticeship system and enough

> educational provision of a suitable character. . . for producers, the like education of distributors has been almost entirely neglected. The public in satisfying their needs can only choose from what the suppliers offer, and as the makers reach the public through the salesmen the importance of the latter is obvious. They are directly in touch with the consumer, and upon the judgement they use in stocking their shops depends the choice open to the public.[10]

Proposing in 1917 the creation of a Learner's Agreement (in lieu of an apprenticeship) to facilitate two to three years of study, it was reported that the scheme, under the guidance of Luther Hooper and G. H. Wadsworth, 'has already been satisfactorily tested by the arrangement under which young assistants from certain drapery houses attend the LCC Central School of Arts and Crafts on two mornings a week during business hours'.[11] The course covered a range of topics still relevant today: textile manufacture and the impact of art, technology and science; fibres, design, sketching; shop architecture and window dressing; advertising, publicity and modern trade; the distributor, producer and consumer. In this form it was offered for a further two years, 1917–18 and 1918–19, with Hooper assisted by a Miss C. Brock. Some indication of the commitment of Central to this course is suggested by the additional staff granted to it – respectively Noel Rooke and the principal, Fred Burridge.

The timing of the development of this course was undoubtedly allied to the same motives that prompted the creation of the Design and Industries Association (DIA) in the previous year.

Both were framed against the concern for standards of industrial design that also promoted a joint scheme, sponsored by the Board of Trade and the Board of Education from 1914, and led to the creation of the British Institute of Industrial Art (BIIA) in 1920. From the DIA's first council, Charles Sixsmith of Bentinck Cotton Mills gave occasional lectures[12] and Frank Warner of Warner & Sons was on Central's advisory council from 1919–22. Warner, as a member of both boards that had mooted it, had also been instrumental in the formation of the BIIA and undoubtedly numbered among the members of the advisory council who ensured that, 'with the Principal and several of his colleagues, the School is in useful contact with learned societies, educational bodies and Government Departments. Also, certain of them serve on the Board of Governors of the British Institute of Industrial Art'.[13] As a result, with the reorganisation of schools in 1919, the 'new' School of Textiles & Costume brought together the teaching skills required to sustain the thrust of the course for textile retailers. By 1921 it was also taking part in the collaboration between Central and the London School of Economics to provide a degree in commerce from London University.

There were other signs of the times in the textile department, not least the creation of a Disabled Soldiers' Class in which, among other things, kelim (tapestry-technique) rugs

Lindsay Butterfield
Eight colour block print design, 1905-20
This is typical of his work when he taught at Central
Private collection

were made.[14] The provision of tapestry and weaving tuition was solidified with the appointment in 1919 of Walter Taylor, born about 1876 and apprenticed to Morris & Co. as tapestry weaver from the age of 14.[15] But it was with the arrival of Hooper as a permanent member of their staff that the thrust of this period, from 1916 to 1933, became clear. In the prospectus for 1920–1 the description of weaving is for the first time comprehensive, covering all aspects of tapestry, carpet and cloth weaving and 'suitable for those who wish to practise hand-loom weaving as a home industry, and for those who intend to design for the textile trade'. Behind this description was Hooper's long and varied experience, which included his development of a 20th-century drawloom, which went all over the world once he eventually perfected it in 1928.[16] In it the machine, the loom, was embraced as a tool, just as a graver was for the block cutter, and many students, still encouraged to follow courses across the five schools, learned wood-engraving to lasting effect. Among these was Alice Hindson, who was taught by Hooper during her studentship of 1920–2 and became both a major proponent of the drawloom's capabilities and active in the Guild (later Guilds) of Weavers, Spinners and Dyers, as a founder and member of the editorial board. She also became an accomplished wood-engraver and, in particular, a calligrapher. Others whose wood-engraving skills contributed to the new style in hand-block printed textiles were Elspeth Ann Little and Joyce Clissold, both entrepreneurial in their approach. Calkin-James's interwar Rainbow Workshop, set up in her own home, is another example of the application of printing skills to a range of end products, which in her case also included block-printed textiles.

Entwined throughout this period at Central were the focus on retailing as a means of shaping the activities of both consumers and manufacturers, and the interdisciplinarity of the training both within and across schools.[17] The smallest school, Weaving, Embroidery and Dress Design, had only forty-four 'industrial' students in 1921–2, but it nevertheless contributed with lasting impact to the slowly growing number of galleries and shops which supported the work of craftsmen (see chapter 'Spreading the word'), among them Theo Moorman, a student of Taylor from 1925 to 1928. Later, seemingly unaware of the Central Diploma, offered in textiles from 1919, and of the rich provision of drawing and engraving courses, she found the tuition in weaving narrow in scope and her social life was among circles outside the Central. Nevertheless, while she later

regretted her lack of academic training in drawing or aesthetics at the Central School... the practical training she received was the best available and from that

Luther Hooper
Reversible tapestry rug
Designed by Hooper, worked by
E. Roe-Barnett, T. Cattermole,
E.F. Tredray and F.J. Hall in the disabled
soldiers' class at the LCC Central
School of Arts and Crafts
Published in *The Studio year book of
applied art*, 1921
Central Saint Martins Museum
Collection

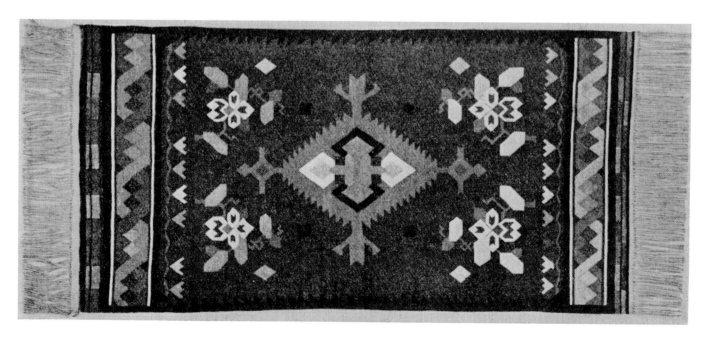

grounding she was able, much later, to make the series of technical departures which liberated her creativity. 'Basic skill is the gateway to freedom' she was to write many years later. It also enabled her to earn her living in her first job at Heal's, as a weaver of rugs. Theo described Heal's as 'a green and fertile oasis in an aesthetic desert... At Heal's we were surrounded by everyday things of good contemporary design'.[18]

From 1930 embroidery was taught in the School of Costume, separated in that year from the School of Textiles, with heraldry and theatrical design part of it until the second half of the 1930s, when the latter was moved to the School of Costume. Textiles now had a designated head, Bernard Adeney. Butterfield taught design in both schools until 1934; Wyatt retired in the same year and Doran, Taylor and the Wright sisters, in 1936–7. Although this suggests the maintenance of the status quo, the early 1930s were a time of change in fashions, fibres, printing techniques – in society generally – and so at the Central too.

Bernard Adeney
untitled, mid 1930s
Linen and rayon cretonne, hand-screen printed
Undocumented design, probably for Alan Walton
Central Saint Martins Museum Collection

1933–66

In acknowledgement, perhaps, of the impact during the 1920s of hand-block printed textiles on both the public's and manufacturers' views of modern textile design, to a large degree initiated by Noel Rooke's autographic approach to wood-engraving, in 1930 textile block cutting and printing began to be listed in the prospectuses, and taught by Adeney. Such textiles, 'a radical and unanswerable challenge to the dogma of modernism',[19] had since the 1920s become highly graphic in content – full of man-made and increasingly abstracted objects (or people) in preference to the flowing vines and stems of yesteryear. In the same years, due to a combination of factors – taxes on foreign designs, the recognition of the marketing value of artist-designed textiles and economic necessities – a significant number of graphic and fine artists produced textile designs.[20] These graphic tendencies were further enhanced, within the department, by the appointment of Dora Batty in 1932. She already enjoyed a reputation as an interdisciplinary designer of posters for London Transport, song sheets and leaflets for Curwen Press, ceramics for Poole Pottery, textiles for Barlow & Jones, advertisements for MacFisheries, and illustrations. She remained until 1958, for most of the post-war years as head of department.

Weaving, however, was not overlooked. Cyril Kisby, appointed in 1934, underpinned the growing technical aspects of the course, but also introduced spinning classes, in keeping with both the craft traditions of Central and the importance of characterful yarn in the colour-and-texture cloths in interiors and furniture of this period. In 1948 he was succeeded by Mary Kirby, who in addition was a printer, and lecturer on the history of textiles. She inspired a number of students. Mary Oliver recalled her as an inveterate traveller who came back with 'paper all over, notes chaotic, but fantastic information'. Eight years later Kirby was appointed to teach at Achimoto College, Ghana. Her role as the enthusiast for

history was taken up by Mary Harper whose study collection and notes now reside in the Central Saint Martins Museum & Study Collection. For weaving, Kirby sought out Marianne Straub. Having turned down offers to teach before, Straub already knew Batty, and accepted, teaching from 1956 to 1964, because the latter was 'an excellent teacher who had all her priorities right'.[21] Later, Batty recruited Peter Collingwood. Linda Parry, who in the mid-1960s trained in art history and criticism at Central and is now the leading authority

on William Morris and textiles of the Arts & Crafts Movement, has written that the Central School's 'teaching of embroidery and hand weaving in the late 19th and early 20th centuries became legendary, as students who had attended the classes of Maggie Briggs, May Morris, Ellen Wright, Walter Taylor and Luther Hooper went on to become influential designers and craftsmen in their own right and the teachers of future generations'.[22] That list could be extended, and it illustrates how weaving gradually replaced embroidery as a vehicle for individual expression in the later half of this period: Hindson, Moorman, Kirby, Straub and Collingwood were to write standard texts on hand weaving.[23]

In the mid-1930s the number of staff increased from five to eight. Clissold was among those who joined the staff, from 1936 to 1940, during the period when her enterprise, Footprints, was a thriving hand-block printing and custom dress-making business, employing some forty people. At the same time the reputation of Central for its training in both printing and weaving was consolidated. In 1939, for example, when Hayes-Marshall published *British textile designers today*, of the seventy-seven designers whose work he illustrated, over 10% had trained at Central.[24] One, Hans Tisdall, then known as Hans Aufseeser, was to teach there from 1948 to 1962. He was one among a number of painters in the department over this period.[25] The trend towards more staff continued after the Second World War and into the 1950s, when they numbered fifteen or so. Among other artists joining the staff were Eduardo Paolozzi, Hugh MacKinnon, Alan Reynolds, and Walter Hoyle. Counterbalancing them during the post-war years were Mary Yonge, a dress-fabric designer for Courtaulds, and ex-students, often invited to teach for a year or two: so arrived Robert Addington, Gordon Crook, John Drummond, Wanda Garland, Ruth Harris, Mary Oliver and Roy Pasano, among others. As in days of old, there were still evening classes and visiting lecturers. Notable among the latter in the mid-1950s was Jean Lurçat, the French tapestry artist who did so much to encourage the revival of autographic tapestries, a field in which Tisdall, Crook and Harris became known.[26]

Mary Harper
'Pallida', 1963-5
Screen printed cotton chintz for
Edinburgh Weavers
146 x 127 mm
Central Saint Martins Museum
Collection

These were lively years in which the principal, William Johnstone, 'allowed all sorts to wander in and out'.[27] Enriching this mixture were constant debates among staff and students. As in other departments, Batty often paired staff, for example in about 1950 putting Oliver, a recent but already successful graduate, together with Crook, an 'eccentric chap, ex-army, told marvellous tales and made very original and unusual drawings'. She also put McKinnon and Yonge together, one idiosyncratic, the other very commercial. 'They didn't always agree, but it was all very useful.'[28] Many in the college at large participated in the philosophical discussions in the dye room, where Anton Ehrensweig held court with students and staff, including Alan Davie (jewellery) and Robert Adam (a sculptor in the furniture department). Meanwhile, Paolozzi spent time in the ceramics and photography departments. Screen-printed designs by him and Nigel Henderson, the photographer, found their way onto both fabrics and tiles. The cacophony of conversation seemed to find its way into designs. Paolozzi-designed ceiling papers, printed by Ehrensweig with ever-varying overprints from a group of screens, were left to the workmen to put up in any order they chose. The department encouraged experimentation and invention.

When Audrey Levy arrived as head of department in 1960, Crook having been acting head for two years, she found it international in its student intake and fascinating for its staff –

Kestelman kept a chilled bottle of wine suspended by a string outside his window – and 'it was an education for *me* ...'. As many in the industry were protesting that fashion fabrics should be as well-served by graduates as one-offs and furnishings were – including wallpaper and decorative paper products, the latter most notably by Ian Logan – under her guidance, the textile department became more focused towards studio practice. Levy developed a major final project and introduced study trips to Paris, formalising the encouragement to travel that students had been given since at least the 1920s.

But it was Adeney and Batty who set the tone of the department for the bulk of this period. Adeney had already established a reputation among students as a sympathetic teacher, a painter who 'taught us to get it balanced [and] minded very much about decoration, good design and colours – helped enormously, produced good examples'.[29] Mary Oliver, from her student days in the late 1940s, summed up Adeney as having gathered 'a collection of stars'. She found Batty warm and understanding ('looking like Mrs Noah'), giving very personal, friendly teaching – possible with only 30 to 40 students in the entire three-year course. Later, with the generation gap beginning to tell, Batty was perceived by Wanda Garland as 'wise and powerful', and so she was. When an organiser had been sought by the committee that initiated the influential Exhibition of Modern British Crafts, which travelled to the United States and the Dominions from 1942 under the aegis of the British Council, 'apparently the ideal dedicated Dorcas was a Dora Batty'.[30] Batty declined and it was at her suggestion that Muriel Rose was appointed. Both she and Adeney had wide-ranging contacts and interests; Adeney and his wife Noel Gilford Adeney, for example, were long-time friends of Phyllis Barron and Dorothy Larcher; while Batty had insight into policy making, as well as the ear of a key policy maker, her long-time associate Sir Thomas Barlow, the director of Barlow & Jones, was, among other things of influence, Director of Clothing at the Board of Trade during the Second World War, active on the Cotton Board, and chairman of the Council of Industrial Design from 1944 to 1949.[31] From the 1930s to the 1960s, it 'all seemed to turn on tough-minded individuals'.[32] Batty, undoubtedly, was one, and one suspects she was not alone.

Wanda Wistrich
'Toriello', 1950s
Roller printed glazed cotton
The design was exhibited at Wanda's diploma show where it was seen and bought by Gayonne's Ltd
186 x 118 mm
Private collection

That characteristic did not dent the tradition of helping students. Apart from those who were given some teaching for a year or two, others were helped to find jobs, or helped to place designs.[33] There was also a growing tradition of exchange with the Royal College of Art (see chapter on Enid Marx). Mary Oliver and John Drummond both went on to teach there. Levy had trained there. By the early 1960s these two institutions were dominant in supplying the most fêted young British textile designers of the period, many of whom had studied at both. Althea McNish, who later taught at Central, was spotted by Crook in an evening class and went on to the RCA; so did many others, including Eileen Ellis. Her design consultancy, Weaveplan, today employs five people; three of these are ex-Central students and, in a continuation of a Central tradition, in the 1980s one was taught by another.

The legacy

Throughout its first seventy years, certain themes intertwined through the changes in departmental structure, staff and textile curricula: the importance of making; sustained contacts with certain associations, shops and manufacturers (and the creation of workshops and retail outlets); interdisciplinarity and debate. With regard to maintaining interest in the

tool, just three post-war examples must suffice. Straub and Collingwood, weavers from very different backgrounds and points of attack, had finely honed their understanding of materials and looms by the time they were teaching at Central. Collingwood wrote later that only those having a brief encounter with weaving would

> find a loom a dominating machine, rather than a useful tool. Being more mechanical [than a potter's wheel], it needs little skill to work it, but a great deal of time to *understand* it. And it is only with understanding that the 'damned thing' reveals that it can confer freedom as well as speed.[34]

Several students recalled that Batty 'wanted us to make marks' and that 'the *really* interesting thing was that Dora organised things so that you were kept constantly busy. No faffing around, no loose organisation. Our time was kept full and everyone appreciated that.'[35] Drummond was taught by her, and his students used the graver to design on the block and then converted these to the 'coming' process, hand screens.[36]

Through staff, governors, advisors and students' later employment, sustained commercial contacts were maintained for over seventy years with a number of manufacturers and retailers, including Liberty, Heal's, Warners, and Morton Sundour/Edinburgh Weavers. Other avant-garde firms whose ranges were at various points through the middle decades of the 20th century shaped by Central designers, freelance or employed, included Donald Brothers, Gayonnes, and David Whitehead. Footprints was just one example of workshops large and small. There was also, for a short time after the Second World War, Armfield-

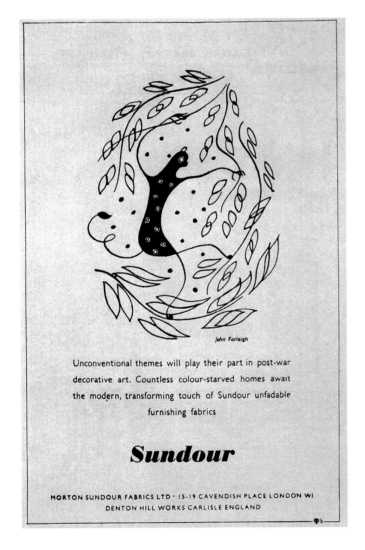

John Farleigh
Advertisement for Morton Sundour
Fabrics, 1947
Published in *Designers for Britain*, vol 1,
SIAD, 1947
Central Saint Martins Museum
Collection

John Farleigh

Unconventional themes will play their part in post-war decorative art. Countless colour-starved homes await the modern, transforming touch of Sundour unfadable furnishing fabrics

Sundour

MORTON SUNDOUR FABRICS LTD · 15-19 CAVENDISH PLACE LONDON W1
DENTON HILL WORKS CARLISLE ENGLAND

Pasano (Diana Armfield and Roy Pasano) whose hand-block printed textiles were shown at the Festival of Britain. As for creative retailing, there is Terence Conran, a student of the department in the late 1940s and recommended to the course by his school, Bryanston, where his tutor in pottery, sculpture and metalwork was Don Potter, a former pupil of Eric Gill. Given these non-textile interests, Conran was amazed when Batty accepted him, but it is indicative of Central's 'talent spotting' abilities, of both students and staff.[37] He returned to teach an interior design evening class and among his students in 1957 were Min Hogg, later editor of *World of Interiors*. This connection with journalism was not new, for Audrey Whithers, the most influential fashion journalist of the 1940s and 1950s and one-time editor of British *Vogue*, served for many years on the Central School Consultative Committee for Woven and Printed Textiles, as did Hans Juda, founder of the magazine *Ambassador*.[38] Other interdisciplinarians have already been mentioned and the output from illustrators and painters associated with Central, as staff or advisors, include textiles by Farleigh, Ashley Havinden, Juda, Paolozzi and Alan Reynolds, and wallpapers by Gwyther Irwin. The freedom to cross boundaries meant, too, that among the small number of students trained in the post-war years as painters, at least one, John Laflin, became a textile designer, for Liberty.

From its antecedents in the Art-Workers' Guild to the mid-1960s, debate was cherished as a vital part of the Central ethos. It was constantly fed by what Mary Banham, a student in the 1940s, described as Central's knack for getting people in; Ruth Harris called it fluidity. Because Central had so many passing through its doors, its history provides a glimpse of the attitudes of practitioners, both there and elsewhere. In the

debate that still continues concerning who should make (or design) everyday objects, the answer from Central was the well-rounded designer with workshop-based training, familiar with the tools *and* the trade. In addition, it was 'always understood, and taught by the School, that the training up to that point is only a beginning and a preparation for the real test that comes in the studio or factory'.[39] But much of its history is invisible, hinted at through texts but largely preserved in individual heads, in hands and in countless textiles and wallpapers, both hand and machine made. This is perhaps more than anything the result of the lasting legacy granted to the Central by Lethaby. It was a place that could satisfy the urges summed up by one student who said 'I wanted to *do*, so I wanted to go to the Central'.[40]

1 G. S. C. Swinton (Chairman), *Annual Report: Session 1921–22*, Central School of Arts & Crafts, 1922, p. 12. In researching this essay, I have become personally aware of this fact, and would like to express my gratitude to Mary Banham, Sir Terence Conran, Eileen Ellis, Wanda Garland, Ruth Harris, Mary Oliver and Linda Parry for sharing their recollections with me.

2 Cynthia Weaver, 'My life is an embroidery'. In Mary Schoeser, *The Watts book of embroidery: English Church embroidery 1833–1953*, Watts & Co. Ltd, 1998, p. 29.

3 Published by Oxford at the Clarendon Press. Christie substantially revised the work for its second edition in 1929. In 1969 this edition was republished as *Pattern design: an introduction to the study of formal ornament*, New York, Dover Publications.

4 Students of embroidery during the first years of World War I included May Seddon Kück, Frances Channer and Millicent M. Jackson, whose work was illustrated in 'Central School of Arts and Crafts', *Arts and Crafts: a review of the work executed by students in the leading art schools of Great Britain and Ireland*, Studio, 1916.

5 Linda Parry, *Textiles of the Arts & Crafts Movement*, Thames & Hudson, 1988, p. 128.

6 Swinton, op. cit., p. 5. Other accounts give his retirement as in 1923.

7 Newill (1860–1947), trained at Birmingham School of Art and taught there from 1892–1920. Others who gave lectures in the same series were C. T. Lindsay (printed dress fabrics), Talbot Hughes (costume) and Alan Cole (lace).

8 *Prospectus 1919–20*, p. 17.

9 *Prospectus: School of Drawing and Painting*, from 1916 to 1930.

10 *The Training of salesmen & saleswomen…* , London County Council, Education Offices, 1918, p. 1. Issued by The Provisional Consultative Committee of the LCC Central School of Arts & Crafts to advise on the instruction of salesmen and saleswomen in the wholesale and retail textile distributing trade, which included Burridge and representatives from Central's advisory committee (including Selwyn Image), the Wholesale Textile Association, the Drapers' Chamber of Trade and the National Amalgamated Union of Shop Assistants.

11 Ibid., p. 7.

12 For example 'Some modern cotton prints', March 1921, at which he exhibited a collection of cotton textiles and discussed their production. *Prospectus 1920–21*, p. 26. Others who contributed to this series of nine lectures included Luther Hooper, A. F. Kendrick, and Grace Christie, then in her last year as embroidery lecturer at the Royal College of Art, where she had been the first to do so, in 1909.

13 *Annual Report: 1921–2*, p. 7. Warner had also been a founder of the Textile Institute, in 1910, and was actively involved with the Royal Society of Arts, initiating their national student competition in 1924.

14 For an illustration of a 'reversible tapestry rug' designed by Luther Hooper and made by R. Roe-Barnett, T. Cattermole, E. F. Tredray and F. J. Hall see: *The Studio Yearbook*, 1921, p. 94. Also illustrated are designs for printed cottons by D. A. Fitch and R. M. Levett.

15 Taylor may well have also taught at the Central prior to this. Another candidate is Fred Owen, described by Ursula Brock, who studied in Hooper's studio and worked with his student, Alice Hindson, as, in the 1920s, 'an eighty-five year old Spitalfields weaver, who taught at Central for a time'. See Ursula Brock, 'Silk weaving – I: Jacquard silk weaving', *Quarterly Journal of the Guilds of Weavers, Spinners and Dyers*, December 1955, no. 16, p. 529.

16 Hooper's private students, as listed by Hindson, were Mrs May M. Cooper, Miss Marion Ford Anderson, Miss Christine Hunter, Aristide Messinesi, Miss Dorothy Wilkinson, Ursula Brock, Hindson herself, and Lois Clarke, from the United States. See Alice Hindson, *The Designer's drawloom: an introduction to drawloom weaving and repeat pattern planning*, Faber & Faber, 1958, p. 176. See also Luther Hooper, *The new draw-loom*, Sir Isaac Pitman, 1932.

17 Both Burridge and Jowett were to comment on the number of times they recommended students to consider careers in sales. See, for example, P. H. Jowett 'Royal Society of Arts Annual Competition of Industrial Designs 1931', *Journal of the Royal Society of Arts*, December 1931, p. 76.

18 Hilary Draper (ed.), *Theo Moorman 1907–1990: her life and work as an artist weaver*, Leeds, The University Gallery Leeds, 1992, p. 71. Moorman was taught 'the antique' by Farleigh.

19 See Alan Powers, 'Blocked out', *Crafts*, March/April 1996, no. 130, pp. 34–7.

20 Among those associated with Central are James Fitton, who trained as a textile designer prior to studying at Central.

21 Marigold Coleman, 'A weaver's life', *Crafts*, May/June 1978, p. 41. Batty had supplied designs to Helios, an avant-garde subsidiary of Barlow & Jones that existed from 1936 to 1950, with Straub as head designer, and later managing director, from 1937 to 1950. See Mary Schoeser, *Marianne Straub*, The Design Council, 1984.

22 Linda Parry, *Textiles of the Arts and Crafts Movement*, Thames & Hudson, 1988, pp. 95–6.

23 Mary Kirby's book, *Designing on the loom*, London and New York, Studio Publications, 1955, contains illustrations of work by Central students Elisabeth Bierrum, Doreen Cottell, Ann Cuthill, Eileen Davis [Ellis], Ruth Drori, Lindsay Fortune, Mary Middleton, Lillian Wilsdon and Gwen Smith; her colleague Claire Chapman and the weave technician, Elizabeth Hardie, Marianne Straub, and Cyril Kisby who had gone on to teach at Leeds. Ann Bristow (née Whitehead) was also a Kirby student.

24 H. G. Hayes Marshall, *British textile designers today*; Leigh-on-Sea, F. Lewis Ltd., 1939. Stated as Central-trained are E. V. Borton, Lt-Col. Barry Costin-Nain, Barbara Hayes, Elaine May, Barbara Pile, Winning Read, Helen Sampson and Stephen Smith. Those listed in the end-matter as members of the National Register of Designers are Adeney, Batty, Enid Marx and Cedric Morris.

25 Tisdall was in the Fine Art department from 1951 to 1962.

26 Tisdall designed numerous tapestries for the Edinburgh Tapestry Company. Crook, in New Zealand from 1960, set up a still-active and influential tapestry studio, and Harris exhibited at the V&A in the 1960s with Collingwood, and sold many tapestries to Arts for Offices. Reynolds and Paolozzi also designed tapestries for them.

27 Interview with Ruth Harris, September 1999.

28 Interview with Wanda Garland, September 1999.

29 Interview with Casty Cockerell, 1995. See also Diana Armfield's recollections, in Julian Halsby, *The art of Diana Armfield*, David & Charles, 1995, pp. 24-5.

30 James Noel White, 'The unexpected Phoenix I: The Sutherland tea set', *Craft History*, 1988, vol. 1, Bath, Combined Arts, p. 52.

31 For a discussion on the impact of Barlow see: Mary Schoeser, 'Fabrics for everyman and for the élite', in *Design and popular politics in postwar Britain*, Leicester University Press, 1977.

32 Conversation with Ella McLeod, September 1999.

33 For instance, Straub at Warners commissioned Fern & Leaf, by her student Andrea Mossiman-Grass, 1956. Oliver, while a student, sold to Barlow & Jones via Batty.

34 Peter Collingwood, 'Letter responding to O'Casey (1978)' in *Craft classics since the 1940s*, Crafts Council, 1988, p. 108.

35 Interview with Sir Terence Conran, November 1999.

36 Examples of such work by Drummond and students are in the V&A. William Johnstone was to argue that this was how it should be done in all cases. See typescript of lecture by William Johnstone, 'Textile Design: the real essentials in training', National Art Education Archive, Bretton Hall, p. 3.

37 Interview with Sir Terence Conran, November 1999.

38 For Min Hogg's recollections, see Nicholas Ind, *Terence Conran: the authorised biography*, Sidgwick & Jackson, 1995, p. 115. For Conran's two years at Central, see pp. 33–44.

39 Jowett, op. cit., note 14, p. 73.

40 Interview with Ruth Harris, September 1999.

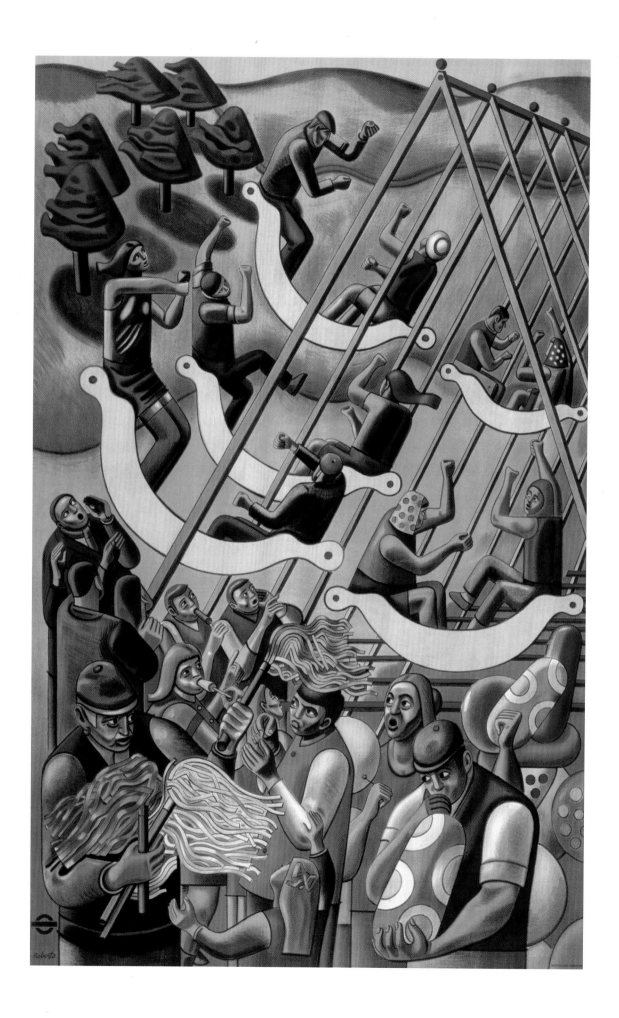

Morris Kestelman and Fine Art teaching at the Central School

Sylvia Backemeyer

Morris Kestelman's long association with the Central School started in 1922 and lasted for almost 50 years. He won a scholarship and enrolled as a student just a few weeks before his seventeenth birthday. His teachers numbered many of the best artists and draughtsmen of the day including A. S. Hartrick, Bernard Meninsky, Ernest Jackson and William Roberts. He taught drawing from 1936 and in 1951 became head of department.

A. S. Hartrick began teaching at the Central School in September 1914 when he taught life drawing and then, some years later, lithography. During the First World War, while working at Central, he produced his famous lithograph series *Women's work* and *British work and ideals*. Students were rather in awe of Hartrick who had trained in Paris and worked with Gauguin and Van Gogh. William Roberts, the Vorticist painter, taught drawing at the Central School from 1925 to 1960. His drawing demonstrations have been remarked upon by many students including Kestelman for their logic, clarity and confident technique. Students learned a great deal just by watching him.

Bernard Meninsky came to Central in 1913. He was one of the first appointments of E. V. Burridge, Lethaby's successor as principal of the Central School. Meninsky had been the prize pupil at Liverpool School of Art when Burridge was principal there. He was immediately at home at Central, revelling in its lively and enlightened atmosphere. At 21 he was a young and inexperienced teacher but he took to teaching (and to the Central School in particular) and remained there until his tragic suicide in 1950.[1]

As a teacher he made a great impression on many students, for he was gifted with brilliant powers of demonstration accompanied by lucid exposition of what he was about. What held me was the intensity of his concentration in the act of drawing, remarkable feats of improvisation from the model. It was a fascinating exercise to watch, and it related to you as a student... He talked very well, constructively and clearly, and would establish a strong personal relationship, watching your reaction. Then he would produce a stub of a pencil... and with extraordinary directness proceed to produce, on a corner of your sheet one of those remarkable drawings which students would later cut out and mount. As he drew, he talked.[2]

When Kestelman became a teacher himself at Central in 1936 his friendship with Meninsky developed and they became very close. They had much in common: both were the sons of Jewish émigré parents, both were involved with the London Group, and both took inspiration for their work from the warmth and light of the Mediterranean, especially the south of France.

Bernard Meninsky
'Figure in a landscape', 1946
Gouache on Ingres Paper
480 x 870 mm
Central Saint Martins Museum
Collection

At that period there was no separate painting school at Central. 'Drawing and painting' were part of Ancillary Studies, a department which included subjects taught across the college, such as anatomy, natural history study (taught at the Zoological Gardens), architectural study (held at the Victoria and Albert Museum on Saturday mornings) and drawing and painting. There was also a course of fifteen fortnightly lectures on the history of art given to all students by Selwyn Image. At that time students who wished to study painting would have gone to the Slade or the Royal College of Art. Sculpture was only taught as modelling and casting in relation to architecture. The School of Painting and Sculpture was not formed until 1940. The strongest subject in the fine art area was drawing which was seen as underpinning all subjects taught at Central, including the crafts. After the First World War the high reputation of the drawing classes attracted many students. In order for students to gain promotion to the life drawing class they had to spend many hours drawing casts. In common with most art schools of the period Central had a huge collection of casts, Greek, Roman, mediaeval and Renaissance, including, unusually, casts from English cathedrals. At that time Kestelman's programme of study was put together by the principal, E. V. Burridge, who was responsible for organising a programme of study for all the students individually. He also taught on the drawing and painting course.

> In this first year I drew endlessly – the Ulysses, the boy and the duck, Michelangelo's slaves, Venus of Milo, innumerable heads, the Discob … all well known to earlier

generations of art students. I loved this studio and drew endlessly. My programme also put me in the lettering classes where I studied Roman letter forms as well as lettering with a quill pen, perspective and some furniture design, a little painting from still life groups. In my second year I was promoted to the life drawing classes and some poster-design or composition. In the evenings I was introduced to etching under W.P. Robins and lithography under Hartrick and Spencer-Pryse. The drawing classes in particular were crowded with men in their middle twenties who had lately been demobilised. The atmosphere was lively and tense and… those of us who were still in their teens were given an additional stimulus from men who had been out in the world.[3]

Fellow students included James Fitton, Victor Pasmore, Edward Bishop, Herry Perry, Joyce Clissold, Celia Fiennes, John Farleigh and Margaret Lisle. The group had an active social life. They looked forward to the annual Chelsea Arts Ball held in the Albert Hall – students in costume were allowed in at half price. Central students who were trained by Jeannetta Cochrane excelled in the making of all manner of exotic costumes to a professional standard. In 1925 the students decided to form a dramatic society and put on 'Twelfth Night'. Kestelman had always had a special interest in all aspects of the theatre and regularly attended performances at the Old Vic. He was chosen both to produce the play and act the part of Malvolio. Costumes were designed by Nancy Warry and made by students of the costume classes under the supervision of Jeannetta Cochrane. Sets were made by the furniture and interior design students. The play was staged at the nearby YMCA and was a great success.[4]

Kestelman was also one of the group of students who helped organise summer camps for boys from the slums of Bloomsbury during the Depression years. Students would make

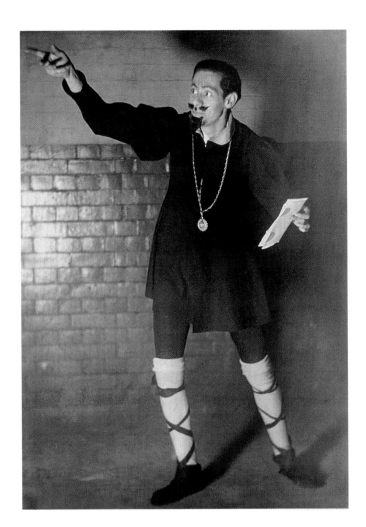

Morris Kestelman as Malvolio in the
Central Dramatic Society's production
of Shakespeare's 'Twelfth Night', 1926
Photograph
Private collection

and sell work and use the proceeds to finance holidays in the countryside for groups of deprived boys.

From 1926 to 1929 Kestelman continued his studies at the Royal College of Art. This was where his interest in theatre design first developed. He designed productions for Sadler's Wells and the Old Vic in the late 1930s and 1940s, including Olivier's 'Richard III'. His own interest in theatre design made him very sensitive to those students who were having difficulty finding themselves as artists. When head of fine art at Central he remembers suggesting to Ralph Koltai that his talents lay in the area of theatre design, for which Koltai was very grateful.[5] Kestelman was also fascinated by the circus. In 1937 Noel Carrington commissioned him to do a book on the circus for which Kestelman spent many hours drawing at Bertram Mills. Unfortunately because of the war the book never materialised, but in 1997 a limited edition of four of his favourite images was published.

In the 1930s, before his marriage and the need to support a family, Kestelman spent as much time as possible painting in the south of France. For three months in 1931 he had the use of Soutine's old studio in Cagnes-sur-Mer. He taught drawing at Central from 1936 and became head of painting and sculpture in 1951.

Kestelman's full-time appointment as head of department gave him two opportunities: to spend more time teaching; and to use his contacts to make a number of key appointments to his department. He had been trained initially by Ernest Jackson, known for his exacting standards of draughtsmanship, and later by Meninsky who Kestelman said taught him all he knew about drawing. With his years of experience as a draughtsman Kestelman 'exerted enormous influence on two generations of artists and was also greatly respected as an authority on painting'.[6]

As a teacher of drawing, Kestelman was unsurpassed. Not only could he draw supremely well, but also he could explain exactly what he was doing as he went along, and this is not easy as I later discovered. He would sit down on the 'donkey', look searchingly at the model, and then take out of his breast pocket a pencil carefully sharpened to a chisel point, so that it could be used endways for a fine line – 'a line is like a melody to me' he once explained – or sideways for broad tones. He began drawing, lightly but unerringly, putting in shaded areas as he went along, often using his thumb to rub in the soft pencil tones, so that his rather bony hands became quite black by the end of the day, and since he had fast-growing black hair, his chin also darkened as the hours went by. It was easy to see where one's drawing had gone wrong, and Kestelman's cheering encouragement buoyed up one's hope that the next drawing would be better. Most of us watched and listened carefully, and tried to follow his example. Some did not. There was a very talented but wayward youth who... produced a curiously angular design with hard outlines. 'Well, Mr Wyndham Lewis,' said Kestelman good-naturedly, 'let's see what you've been doing'... In spare moments while the model rested, Kestelman would show us reproductions of work by great draughtsmen, analysing their construction and explaining how effects had been achieved.[7]

In the period 1951 to 1971 when he was head of department at Central, Kestelman was able to choose a range of talented staff to teach at the college. His contacts with the

Morris Kestelman
'Circus clown', 1940s
Wood engraving
245 × 120 mm
Central Saint Martins Museum
Collection

London Group in particular gave him the entrée to a wide circle of talent. Additionally this period coincided with the appointment of William Johnstone as principal. For the first time Central had a principal who was a fine artist himself and took a considerable interest in its teaching. He also employed a number of fine artists to teach basic design to students across the college (see 'William Johnstone at the Central School'). Adrian Berg, Cecil Collins, Merlyn Evans, David Haughton, Mervyn Peake, Thelma Hulbert and William Turnbull were all appointed in this period. Hans Tisdall, another lover of France and the Mediterranean, whose value to students was immediately recognised by Kestelman, was appointed in 1948.

> Three or four generations of students may find their approach to life and art a little different to what it might have been without Tisdall's quizzical presence, partly rather grand, faintly dandified, and amused.[8]

Tisdall was a cross-disciplinary artist who used his talents as a fine artist to design textiles and illustrate books as well as painting murals.

Cecil Collins was encouraged to teach at Central by William Johnstone in the early 1950s. Initially Collins shared a post with Mervyn Peake. Peake was teaching at Central in 1951 when he won the Heinemann award for literature for *Gormenghast*. He suffered from Parkinson's disease for many years and could be a difficult colleague but Kestelman, recognising his talent, did his best to support Peake and employed him for as long as possible.[9]

Cecil Collins was a sensitive artist with an idiosyncratic vision and probably one of the most original teachers ever employed at the Central School. Mark Tobey initially encouraged him to teach, and, like him, Collins was very much influenced by eastern philosophy. The basis of his teaching has been described as 'stripping down, seeking the "real self"... True education is based on self-knowledge, and education not based on self-knowledge is based on self-deception'.[10] Collins used a number of simple but effective methods in his teaching to provide freedom within structure. He used music to help students focus on the present moment; sometimes they would lie on the floor or use the left rather than the right hand. Collins said about his teaching 'My own classes are highly technical, they are all about technique, but not as a mechanical technique. What they are really about is the nature of creativity'.[11]

Hans Tisdall
'Pace: doves of peace', signed
Aufseeser, undated
Mixed media
530 × 720 mm
Central Saint Martins Museum
Collection

As a full-time member of staff with all the responsibilities of head of department, Kestelman had less time for his own work than he would have liked. However the security of a full-time post possibly freed him to make the fundamental change from figurative to abstract which took place in his work in the 1950s. He declared: 'I take the greatest delight in painters whose work revels in the sunny side of life'[12] and this is reflected in his own work, both figurative and abstract.

Throughout his time at Central Kestelman battled to improve the working conditions of part-time staff. In 1939 at the outbreak of war the college closed without warning, leaving many of the part-time staff without an income. Kestelman took on the role of spokesman, writing to the principal and the LCC, to state their case. He also fought for many years to enable all head of department posts to be eligible for a pension. He finally succeeded in 1966, only six years before his own retirement although sadly he never benefitted himself. His memory lives on at Central in the work and memories of his students.

Mervyn Peake
'The pied piper', undated
Pen and ink
252 x 198 mm
Central Saint Martins Museum
Collection

It could truly be said he taught Life as well as Drawing: his compassionate and deeply thoughtful reactions to world events and the human situation must have influenced all who were fortunate enough to have known him. In between sessions of drawing, and during 'rests' in the life class, he would encourage discussions on many subjects, always listening courteously to other people's views, and expressing his own with quiet wisdom. [13]

1 John Russell Taylor, *Bernard Meninsky*, London, Redcliffe Press, 1990, p. 33.
2 Morris Kestelman, 'Reminiscences'. In *Bernard Meninsky, 1891–1950*, Museum of Modern Art, Oxford, 1981, pp. 18–23, p. 18.
3 Morris Kestelman, unpublished memoir, copyright the Kestelman Estate. I am grateful for the help and information provided by Sara Kestelman.
4 Interview with Margaret Stavridi (née Lisle), 17 December 1999.
5 Interview with Morris Kestelman, June 1992.
6 'Morris Kestelman', obituary, *The Independent*, 18 June 1998.
7 Margaret Till (née Levetus) 'Remembering Morris Kestelman', unpublished memoir, December 1999.

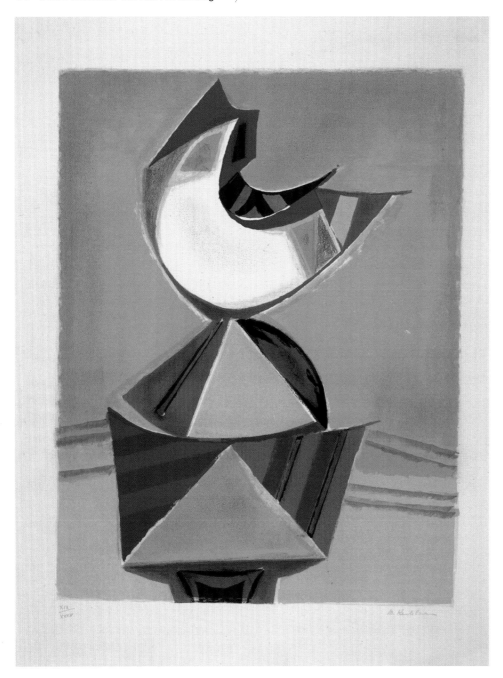

8 Bryan Robertson, 'Introduction'.
 In *Hans Tisdall: paintings
 1960–1990*. Exhibition cata-
 logue, Albemarle Gallery,
 London, 12 September–5
 October 1990, pp. 4–5, p. 5.
9 Interview with Morris
 Kestelman, June 1992.
10 Helena Drysdale, 'Portrait of
 Cecil Collins', *Matrix*, Spring
 1983, no. 16, pp. 4–5, p.5.
11 Brian Keeble, 'Theatre of the
 soul: a conversation with the
 artist Cecil Collins', *Temenos*,
 1981, no. 1, pp. 59–85, p. 65.
12 'Morris Kestelman', obituary,
 The Jewish Chronicle, 24 July 1998,
 p. 21.
13 Margaret Till (née Levetus)
 'Remembering Morris
 Kestelman', unpublished memoir,
 December 1999.

Morris Kestelman
'Bonjour', 1975
Lithograph
550 x 390 mm
Central Saint Martins Museum
Collection

William Johnstone and the Central School

Alan Powers

Alan Powers is a historian and curator specialising in twentieth century English art, architecture and design. He has organised a number of exhibitions and was a consultant curator for Modern Britain 1929-39 *at the Design Museum in 1999. He is a Senior Lecturer in the School of Architecture and Landscape, University of Greenwich.*

William Johnstone has been described by some as looking like Picasso, by others as more like James Cagney. He was principal of the Central School from 1947 to 1960, when he retired from teaching to return to his native Scotland as a sheep farmer and painter. This gives some indication of the variety of his talents, and perhaps some explanation why he has not yet been accorded a secure place in the history either of 20th century painting or of art education. His time at the Central was nonetheless arguably as important as the reign of Robin Darwin as rector of the Royal College of Art (1948 to 1971) in making the transition of an important school from pre-war Arts and Crafts-based work to a form of modernism encompassing abstraction in painting and training in industrial design.[1]

Johnstone himself studied at Edinburgh College of Art in the years immediately after the First World War on an ex-army grant. His autobiography, *Points in time*, 1980, gives a lively account, particularly the influence on him of lectures on the history of art by George Baldwin Brown whose specialisms were Celtic, Scandinavian and Anglo-Saxon art. These enthusiasms returned in Johnstone's book *Creative art in England*, 1936, where he showed how modern art – such as Picasso and Matisse – resembled Celtic carvings and medieval wall-paintings. The creative force of modernism, he claimed, was a perfectly natural and indigenous quality when modernism was frequently condemned as foreign.[2] The other influential moment he recalled was a lecture by Walter Sickert who emphasised the dynamic and kinetic quality of all visual experience.

> We were dealing with movement – the earth rotating round the sun gives continuous change, but no matter how you looked at light or shade the effect was momentary. It was the moments of movement that were so important – a revelation… It was this eye, this seeing eye, impregnating the subject with an intensity of movement, which mattered. The artist should always be looking for some experience, some revelation.[3]

Time became one of his themes and Mary Banham remembers as a student at Camberwell before the war how Johnstone would strike up a conversation about J. W. Dunne's recent book *An experiment with time* with whichever bemused student was closest to the Life Room door. In addition, the head of the College, Frank Morley Fletcher, a former teacher of wood engraving at the Central School in London introduced Johnstone to the writings of W. R. Lethaby, founder of the school, to which he responded warmly.

Points in time reveals Johnstone as an angry young man of the 1920s, becoming concerned with politics and literature through friendships with Christopher Grieve (Hugh MacDiarmid) and others, but out of step with the successful art of the time. Going to Paris in 1925, Johnstone decided to study with André L'Hote, hoping for an improved sense of grammar and discipline within a modern context, since the teaching was based on the analysis of the old masters in relation to cubism, a method that preserved much of French academicism but gave it extra freshness. This was a lasting influence on Johnstone's concept of teaching. Returning to Scotland, married to the American painter Flora MacDonald whom he had met in Paris, Johnstone worked on abstract paintings drawn from the subconscious. Later in California, he made friends with Charles Roberts Aldrich, author of a Jungian study, *The primitive mind and modern civilisation*, 1931, who complimented him on his

intuitive understanding of psychology. Frank Lloyd Wright tried to persuade him to stay and work at Taliesin. On the point of returning to Scotland, still to a large extent confused as to what direction to take, Johnstone had an insight that the primitive art of Scotland and the north of England might be the key to giving modernism a local and authentic grounding. This was the second point of origin for *Creative art in England*. Working as a school art teacher in slum areas of north London, Johnstone developed a sense of mission that linked these various activities. He felt that he could give his pupils a sense of creativity and critical judgement, while they in turn had the benefit of an innocent eye. He continued his own work as a painter, finding a loose abstract way of working with paint, through which he tried to communicate his interest in time and change. His large painting, 'A point in time', 1929–37, (National Gallery of Modern Art, Scotland) is probably his best-known work.

Creative art in England draws a parallel between the evolution of a child into an adult, commonly involving a loss of creativity during adolescence, and the evolution of Britain, which he believed had entered an analogous phase of materialism as a nation in the 18th century from which modern art offered a means of escape. Industrial design was a popular theme of the 1930s, and Johnstone believed that its improvement could only come with a widespread rebirth of creativity that would affect producers and consumers alike. His book offers a useful background to understanding his motives as an art educator, concerned with process and personal development rather than product.

Johnstone's second book, *Child art to man art*, 1941, was an extension of the same argument. He made the case for the general value of a visual training at any age.

William Johnstone
'A point in time', 1929-37
Oil painting
1372 x 2438 mm
© The Scottish National Gallery of
Modern Art

> A particularity of good art training is that it is probably the most easily transferred of all possible kinds of skill, and its usefulness extends probably further than training in any other skill. That is one reason why those artists, admittedly few, who feel their art medium as plastic, contradict the common slander about them by making successes of themselves when circumstances turn their attention to other fields of activity than art, and why men who are successful in other fields of activity are so continuously interested in art.[4]

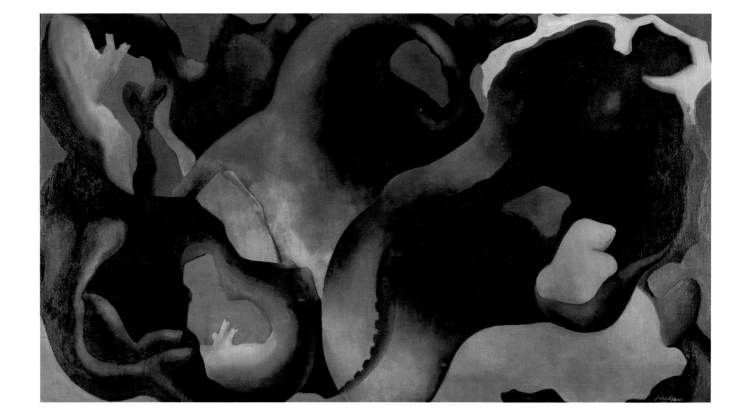

A teaching job at the Regent Street Polytechnic brought Johnstone into contact with students of architecture and car body building. For the latter, in place of the conventional drawing course he was meant to teach, he devised a course based on 'flat patterns and solid forms, with design in relation to engineering'. This was probably the basis for the design exercises given in the fourth chapter of *Child art to man art*. He also introduced a greater element of creativity into the teaching of drawing for architects, and was complimented by Eric Mendelssohn who compared the work favourably with the Bauhaus where he felt there was too much rigid, formal scholasticism.

Through these jobs, and a further appointment to the Royal School of Needlework, where, by his own account, he introduced the concepts of the School of Paris to delighted astonishment, Johnstone developed a good relationship with the liberal minded LCC Chief Inspector of Art, R. R. Tomlinson, who was acting principal of Central before Johnstone. He became head of Hackney School of Art before getting the appointment as Principal of Camberwell in 1938.

Camberwell was representative of LCC art schools in its combination of trade training and art training. The cross-fertilisation which W. R. Lethaby hoped for when setting up these schools in the 1890s had seldom occurred, although the teaching of the painter A. S. Hartrick had given Camberwell and later Central (where Victor Pasmore was one of his pupils) a reputation for fresh ideas. The pottery department at Camberwell, famous under W. B. Dalton, was in a trough, as was the well-known if rather unimaginative printing department. Johnstone decided to bring artists into the technical departments 'so that sparks would fly off to give a new life-enhancing environment'.[5] Among the teachers whom Johnstone recruited were the painter Vivian Pitchforth, the illustrator and graphic artist Eric Fraser, the textile designer Ronald Grierson, and the sculptor F. E. McWilliam. He also engaged Victor Pasmore in 1943 for the painting department, explaining in his memoirs 'Victor was essentially a purveyor of good taste, an ideal person for my Painting Department which had to begin from the phoenix state'.[6] Pasmore was the first of several key members of the Euston Road School to join the Camberwell staff, establishing its long-lasting character as a school of painting in both senses.

On the recommendation of his friend Norman Dawson, a specialist in child art, Johnstone engaged A. E. Halliwell who had been teaching at Beckenham. Alongside a successful and precocious career as a poster artist he had pioneered a basic design course in 1933, based partly on the work of the Bauhaus, and continued this in both the junior and senior schools at Camberwell, finding that it gave students the qualities wanted by employers. Halliwell urged Johnstone to allow him to expand it into three-dimensional teaching for industrial design just before the war, an experiment which came to fruition after 1945.[7] When Johnstone was appointed to the Central School in 1947, Halliwell moved with him, becoming vice-principal, as he had been at Camberwell. Johnstone admired him greatly and credited Halliwell for laying the foundations for modern industrial design teaching while at Camberwell. This contrasted with the difficulty experienced by the RCA and its Civil Service masters in shifting the orientation towards industry.

Halliwell's method was pragmatic, in that it required no special equipment, and at the same time was more genuinely educational than the 'hands-on' activity often recommended. As David Thistlewood pointed out in a paper on Halliwell, he

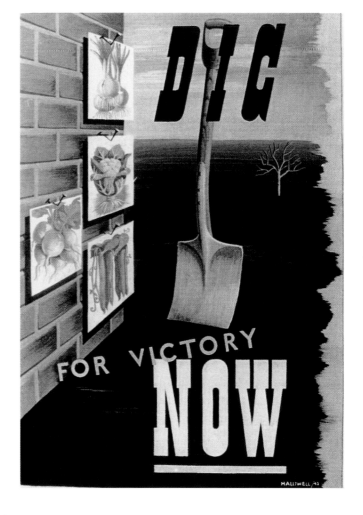

A.E. Halliwell
'Dig for victory', 1942
Design for poster
Acrylic colour
355 x 518 mm
A.E. Halliwell Collection, National Arts
Education Archive, Bretton Hall

took his own independent line, akin to Johnstone's philosophy of art and the early 'Expressionist' Bauhaus, which

> stressed not only 'learning by doing' and the fullest exploitation of material properties, but also the importance of 'doing' in order to realise what one already knows and unconsciously feels.

Halliwell helped Johnstone to bring his ideas to fruition at the Central School. Sharing an underlying affinity with the founding purposes of the School under Lethaby allowed for a relatively painless transition to modernism, in which each of the School's departments made pragmatic decisions about the appropriate balance between hand and machine work. While painting and drawing were accepted as self-sufficient skills, the policy of employing creative artists in all departments was followed.

In 1948 Halliwell took over the existing department of industrial design from A. R. Emerson, the head of silversmithing, and began to appoint new staff, who, in the succeeding ten years, included the ex-Bauhausler Naum Slutzky, the painters Victor Pasmore and Alan Davie, the design theorist Bruce Archer, the photographer Nigel Henderson, the sculptor William Turnbull, Douglas Scott, famous for the design of the London Transport Routemaster bus, and the stained glass artist Keith New. The prospectus for 1948 states:

> This department deals with the application of contemporary design to the needs of industry, the major stress being on design of those articles of everyday use which are mass-produced. It is essentially a basic course in the theory of design and the technology of machine processes.

The introduction of new methods of design teaching was not restricted to this department. Textiles, headed from 1950 to 1958 by Dora Batty, included in its staff the painter and designer Hans Tisdall, first appearing in 1948, who shifted after two years to the School of Painting and Drawing, Eduardo Paolozzi, Marianne Straub, and Anton Ehrensweig, the Austrian émigré whose Freudian book, *The hidden order of art*, 1967, was an important text for the wider dissemination of the Basic Design movement, even if a problematical one. Ehrensweig, who joined the staff in 1949, was a textile designer by profession and began his teaching at Central with a fabric printing class. The tendency of the course, judging from the prospectuses, was a gradual shift from hand-production methods to machine, but with an even-handed professionalism.

The School of Interior Design staff included, variously, Denys Lasdun, Naum Slutzky, Peter Smithson, Trevor Dannatt, William Turnbull and Reyner Banham, the latter teaching art history from 1954 onwards. In typography, the legendary figure of Anthony Froshaug stayed long enough to redesign the

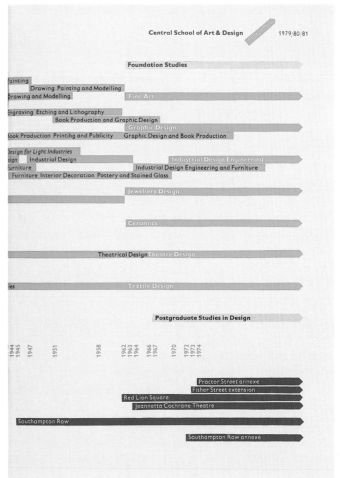

Left
Alan Davie
Cover design for *Motif* 7, summer
1961, Shenval Press Ltd
Silk-screen print
310 x 240 mm
Private collection

prospectus in Bodoni, in a typical Festival of Britain style, expelling the hand-lettered map which had given a rustic Arts and Crafts character in earlier years. In furniture design, the classes remained largely craft-based and excellent of their kind, with the addition of Clive Latimer, a former student of Central, who in 1949 won one of two prizes out of three thousand entries for low-cost furniture design in the Museum of Modern Art, New York, with a design for sectional unit storage pieces.

Silversmithing and jewellery were necessarily craft-based, continuing the existing work-shop traditions with some invasion by new design ideas from Alan Davie and others. Perhaps the most significant event in Jewellery was the exhibition of American jewellery in the autumn of 1950 which Gerda Flockinger, passing by on a bus, stopped to look at, and which made her determined to study at Central in order to be able to produce similar pieces.

The activity of different departments seems to have achieved a connection with the core activities of painting and drawing, if only through the interest which individual teachers such as Pasmore, Alan Davie and Tisdall had in the questions of design. Their several pathways towards abstraction were typical of the trend of the time, but it is easy to lose sight of the dimension of outward direction towards practical application which they saw as implicit in their work. Tisdall's training in Munich in the 1920s had included sign-writing, and he hand-lettered the covers for books published by Jonathan Cape. Johnstone, who lived across the road from Tisdall in Royal Avenue, Chelsea, and regarded him as an ally and confidant, recalled in his memoirs that Ernest Hemingway insisted on having Tisdall's lettering on his books. Tisdall was also much involved in mural painting and textile design, and was one of forty staff and students who contributed work to the Festival of Britain in 1951.

Johnstone's interest in the subconscious as the source of creativity endeared him to Alan Davie, and as Duncan Macmillan writes

Left
Anthony Froshaug
Design for Central School
Prospectuses, 1978-85
Each 210 x 145 mm
Central Saint Martins Museum
Collection

> Davie's personal link with Johnstone is… also a link to a distinctive and developing tradition of the appreciation of the importance of the unbroken chain of human experience as it is preserved in the subconscious.[10]

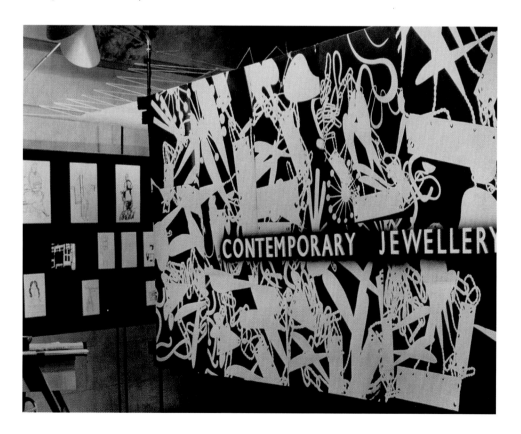

Central School Contemporary
Jewellery Show, 1951
Photograph
Central Saint Martins Museum
Collection

Cecil Collins who began his long teaching career at the Central in 1951 was an artist admired by Johnstone from the 1930s onwards. Following his inner convictions, he aimed to take the students out of their normal state of consciousness through various structured forms of reorientation and to develop the sense of group effort. Collins's work might appear in retrospect to have been even further removed from the concerns of industrial design than that of the Euston Road artists, but these divisions are deceptive. John Plumb, a Central student in the later 1950s, told the historian Margaret Garlake that he saw

painters in a school of applied art as the 'leaven in the dough', while Johnstone told him personally that he did not believe in painters, presumably meaning that he did not believe in painting as a self-sufficient activity.[11]

Johnstone was thus able to offer students contact with a wide range of artistic personalities and, in contrast to the dominant Euston Road character of the Slade under Coldstream, and the tendency to abstraction in his own work, maintained an interest in pictorial content within Modernism.

During Johnstone's time, Central nurtured teachers who transmitted the idea of Basic Design which was one of the most important developments of the post-war period in

Hans Tisdall
Jacket design for Carson McCullers, *Clock without hands*, Cresset Press, 1951
Mixed media
190 x 270 mm
Central Saint Martins Museum Collection

Cecil Collins
'By the waters', 1980
Gouache on paper
460 x 590 mm
© Peter Nahum at the Leicester Galleries

Britain. In 1959, Roger Coleman stated that 'most of the subsequent basic design courses in British art schools owe something of their character to work done at the Central'.[12] The architect Theo Crosby, in his profile of William Turnbull in the magazine *Uppercase*, commented that

> for the past years Turnbull has taught basic design at the Central School, introducing students to the problems and themes of modern art: movement, light, space, and his work here might merit another volume.[13]

As Turnbull stated in 1961, his teaching aspired to be academic, meaning that it addressed structural issues in a systematic way, rather than the accepted meaning of academic as conventional and unadventurous. He also insisted that it was never meant to be dogmatic, nor to lead automatically to the production of abstract art. Richard Hamilton commented at the same period that, since Basic Design had yet to be made the foundation for fine art as well as design, it had so far had its greatest effect in the latter domain. He too was wary of its becoming formulaic.[14]

Hamilton and Victor Pasmore were key figures in the introduction of Basic Design at Newcastle University after moving there from the Central in 1953. Basic Design was closely allied in its methods and intentions with the activities of the Independent Group, whose members were well represented at Central, including Banham, Hamilton, Henderson, Paolozzi, Smithson and Turnbull. In such a large and diverse institution as the Central School, they were less visible than at the ICA and in their publications and exhibitions at the Whitechapel Gallery, but the School will doubtless always be remembered during the 1950s for its association with them. As Margaret Garlake has written

Victor Pasmore working on the design of a ceramic mural for a restaurant in the Festival of Britain, 1951. The completed mural was 32 by 28 feet.
Photograph © Hulton Getty

> The close links between the School, the I.C.A. and the Independent Group underline the pivotal position of the Central School at a point when artists were reaching out for conceptual tools to explore modernism.[15]

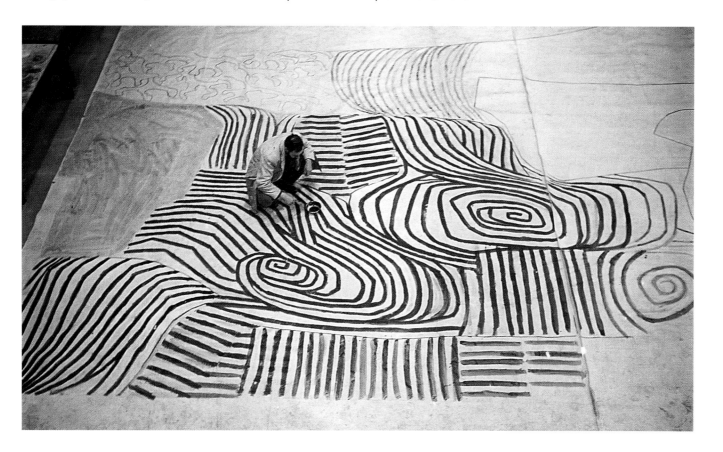

How much was this due to Johnstone? As we have seen, he had been working towards such an outcome all his life, mostly against the grain of both the traditional and modernist art establishments until finally a younger generation came round to his way of thinking. The theory of Basic Design, and even some aspects of its practice, can be dated to the 1930s and even though Johnstone was not unique in his line of thought, he combined creativity with sufficient administrative skill to achieve the difficult balancing act of running a major institution.[16] When he organised a centenary publication on W. R. Lethaby in 1957, he quoted his predecessor in terms that might equally apply to himself.

A prophet, however much he may appear to be in opposition to his age, yet in a peculiar way represents that particular time. He is the antidote, the balance, the complement, and his is the voice which awakes all those who are ready to be like-minded. If he is wholly successful, and his teaching is absorbed, it may hardly be understood how anyone might ever have believed otherwise. The flashing inspiration becomes a commonplace. It is the prophet's aim to be thus abolished in absorption, to be lost by diffusion.[17]

1 William Johnstone's papers are held at the National Archive for Art Education, Lawrence Batley Centre, Bretton Hall, Wakefield. I am grateful to Leonard Bartle, administrator at the Centre, for his assistance, and Sylvia Backemeyer for providing additional information.

2 The second edition of Johnstone's book, published by Macmillan in 1950, was titled *Creative art in Britain*.

3 William Johnstone, *Points in time*, Barrie & Jenkins, 1980, pp. 63–4.

4 William Johnstone, *Child art to man art*, Macmillan, 1941, p. 79.

5 *Points in time*, p. 183.

6 Ibid. p. 185.

7 See William Johnstone, 'Training students in Commercial Art and Industrial Design', *Art & Industry*, April 1945, pp. 116–22.

8 David Thistlewood, 'Albert Halliwell: educationist in contemporary design', *National Association for Education in Art Papers*, Vol. 1.

9 See Julian Satterthwaite, 'The origins, development and endemic failure of basic design', MPhil thesis, University of Liverpool, Department of Architecture and Building Engineering, 1993.

10 Duncan Macmillan, 'Magic pictures'. In *Alan Davie, works on paper*, Edinburgh, Talbot Rice Gallery, 1990, unpaginated.

11 Margaret Garlake, *New art new world*, Yale University Press, 1999, p. 245, n.142, and interview 18 January 1990. Garlake quotes a contrary view from an MA report (J. Morgan, 'Basic Design, pedagogy or aesthetic', Courtauld Institute, University of London, 1992) that the painting school remained firmly academic and separate from the design departments (p. 7).

12 R. Coleman in *The developing process*, exhibition catalogue, ICA, 1959, p. 1.

13 'Introduction', in *Uppercase* 4, 1960, unpaginated.

14 'A visual grammar of form' in *Motif* 8, Winter 1961, pp. 7–8 (Turnbull) and p. 17 (Hamilton).

15 Garlake *op. cit.* p. 30. See also David Thistlewood, 'The Independent Group and art education in Britain 1950–1965'. In David Robbins, ed. *The Independent Group and the aesthetics of plenty*, MIT Press, 1990, pp. 212–20.

16 In *Points in time*, Johnstone claimed that his skill in writing budgets, learned from his father, brought approval from the bureaucrats of County Hall.

17 William Johnstone, 'Introduction'. In *William Richard Lethaby, 1857–1931*, Central School of Arts and Crafts, 1957, p. xi.

From three-dimensional craft to industrial design

Stuart Evans

Stuart Evans is a designer and design historian. He teaches at Central Saint Martins specialising in research studies. He organises conferences, including, in September 2000, Ruskin and the Arts and Crafts Movement. *His publications include studies on architecture, furniture and the Arts and Crafts movement.*

Central Saint Martins has an enviable reputation for its courses in design, aimed at students who wish to work within the design profession and those industries which depend on design to attract the consumers' attention. Its undergraduate course Product Design and the related postgraduate course in Industrial Design[1] might be singled out for their role in educating those who give form to consumer products, while those familiar with the field will be aware of the major role the college has taken in shaping and re-shaping education for these designers. Indeed, it can legitimately claim to have pioneered this discipline in Britain.

With this emphasis on design for consumer goods the inscription over the entrance to Central Saint Martins' Southampton Row building might seem anachronistic. The cast-bronze door lintel bears the legend 'L.C.C. Central School of Arts and Crafts'. The arts and crafts, though dear to British hearts, are usually seen as concerned with the individual maker, with personal skill and creativity and the one-off artefact — all a little cosy. Yet this essay argues that the college was founded to help develop a new type of practice, with a new type of education to serve it; subsequently, at critical points, the college has redefined both practice and education. These developments will be explored by examining some of the staff and students associated with the college, especially in the areas of three-dimensional work 'from craft to design'.

When the LCC Central School was founded in 1896, the Arts and Crafts was a new, vital and innovative movement in Britain. As a movement it does not lend itself to precise definition. Its date of commencement is often formalised as the foundation of the Arts and Crafts Exhibition Society in 1888, a body set up to promote public exhibitions of craftwork in which the executive craftworkers were named, as well as the artist or designer. In the range of its interests and organisation its background lies with the Gothic Revival of the mid-nineteenth century, and its ideology with John Ruskin's influential book *The Stones of Venice*, published in 1851-54.[2] William Morris's 'firm', Morris and Company, is often seen as an important precursor not only for the remarkable artists who contributed designs, such as Philip Webb, Dante Gabriel Rossetti and Ford Madox Brown, but for having brought together design and production in several crafts within an architectural context, while at the same time emphasising the creativity of the artisan craftworker who executed the designs, and his or her potential to influence the artistic quality of the finished work. An image used by the Arts and Crafts was of architecture as the 'mother art'; the others, painting and sculpture as well as ceramics, metalwork, textiles and so on, were 'handmaiden arts'.

The LCC chose to adopt Arts and Crafts tenets for its new Central School less than a decade after the founding of the Arts and Crafts Exhibition Society. The LCC Technical Education Board's emphasis on art for its new vocational crafts school may at first seem curious. Art education had separated training in the technical skills from training in 'design', which was taught as precise drawing for the development of ornament from familiar models, without context. The School's joint principals were the artist-architect W.R. Lethaby and the sculptor George Frampton, while John Singer Sargent, the virtuoso portraitist, and Harry Bates, also a sculptor, were appointed as Visitors. The role of the Visitor was unclear. In a schematic proposal for the administration of the school, written before it was established,[3] the Visitors were to be responsible for design teaching and were to co-ordinate the

practical teaching given by craftworkers. But they appear to have acted as advisors on curriculum and standards. All were active practitioners, as were the other staff, although some specialised in design and others in the physical realisation of craftwork. For example, the architect Halsey Ricardo taught architectural design while the sculptor E. Roscoe Mullins taught modelling and ornament 'hands on' with a course aimed at architects, gold and silversmiths, decorators, cabinet makers and carvers. The class in lead work was aimed at both architects and plumbers and covered external functional-decorative leadwork such as cisterns and downspout hoppers, as opposed to sanitary plumbing, and was taught by the architect and author F.W. Troup, assisted by Mr Dodds, a registered plumber: plumbers joining this class were advised to also join classes in drawing, decoration and elementary modelling. Cabinet design was taught by Archibald Christie, and in the first prospectus his name is bracketed with that of William Margetson and Robert Catterson-Smith as teaching courses in 'Drawing, colour and decoration, design for cabinet makers, metal workers etc.'. Robert Catterson-Smith is known as a metalworker and later as Head of Birmingham School of Art.

The Central School of Arts and Crafts was to provide a practical-based training in the crafts for men and boys from the LCC boroughs. Its students were drawn from the trades associated with architecture and included mature journeymen-craftsmen as well as apprentices and improvers, plus architectural trainees. It took as the basis for its curriculum the idea of the 'arts supporting architecture', and hoped to re-integrate them through a shared sympathy; it also gave its students access to a network of contacts in different crafts. Nowhere at that time was there a full-time formal training in architecture, nor, indeed, in design for the craft industries which served the matrix of architecture. Most architectural students gained an education by joining an architect's office. This could be as an articled pupil, who paid a fee and would enjoy some tuition, or as a paid assistant, a draughtsman or improver. (W.R. Lethaby, Central School's first principal, received his training as a pupil of Norman Shaw, becoming his chief assistant.) Artisan craftworkers gained their training by a trade apprenticeship, which could provide a positive, supportive experience, but which by the end of the nineteenth century was likely to be exploitative. The School intended to educate and encourage a new type of architect, one aware of the practical requirements of crafts, and a new type of craftworker who matched practical skills with creative independence and was used to working alongside other crafts. This is manifest in the insistence on staff with practical experience of craftworking or designing for crafts, or both, plus the care with which courses were cross-referenced in the prospectus, with recommendations regarding which practical classes architecture students should attend and which drawing and design classes craftworkers should go to.

In 1896 the first prospectus listed twelve teachers and lecturers between them offering classes in eleven skills areas; a decade later the prospectus listed forty-five staff and thirty-nine classes. The staff included many famous Arts and Crafts practitioners whose roles at Central can surprise. Henry Wilson was an architect and a designer for silver work (the author of *Silverwork and jewellery: a text book for students and workers in metal*, in 'The Artistic Crafts Series of Technical Handbooks', edited by Lethaby and published by John Hogg), a pupil of J.D. Sedding, later his chief assistant, then partner and finally the successor to their practice. After Sedding's death Wilson completed Holy Trinity, Sloane Street, London (built 1888-1890), which contains a remarkable body of Arts and Crafts work, including metalwork by Wilson. From its introduction in 1899 a life drawing class for men was taught by Henry Wilson. Although life drawing was seen as an academic pursuit, the ability to draw freehand was just as important when composing designs, as orthographic conventions were for manufacture. Wilson's design drawings are characterised by a seductive fluidity and expressiveness. At the turn of the century his designs for architecture and silver work were proto-Art Nouveau in style in the way Charles Rennie Mackintosh's was.[4] His designs for additions to St Martin's Church, Marple, Cheshire (of 1895-1896, original design by Sedding in 1869-1870) include an aisle and chapel and various fittings, a font cover

with a pierced sphere in its suspending chain, and a wagon-vaulted ceiling of modelled plaster with a flight of swifts describing the arch. The design for this project is clearly informed by Lethaby's design 'A beryl shrine', published in 1888.[5] Marple also has some exceptional silver by Wilson. His ecclesiastical silver has a strong architectonic, sculptural quality, close in spirit to his architectural designs.[6] This quality is also seen in Wilson's design for the stage set for the Art Workers' Guild masque of 'Beauty's awakening' (1899), performed at London's Guildhall, with its heavy Byzantine arch and colonnade.

George Jack taught woodcarving from 1908.[7] Like Wilson, Jack was an architect and had been senior assistant to Philip Webb, the hardest of the hard architects,[8] who designed the Red House for William Morris in 1857-60. From 1890 Jack was also the chief furniture designer for Morris & Co., a prestigious position. His designs are characterised by a fineness of detail and finish only possible when the work is executed by skilled craftsmen. Many used inlays and contrasting veneers in bold repeated patterns. The most highly wrought pieces, such as the inlaid mahogany secretaire, are positively lush. Here the cabinet is carried on an open stand. All surfaces are slightly domed, and all are decorated with veneers, a geometric counterchange to the sides and back panels, a stiffly-treated swirling pattern of boughs and leafage to the front and apron. This is a tour de force of furniture making, priced, in the 1900s, at 98 guineas. It is not difficult to imagine what an impact this sort of work would have on the men and boys at Central School. It embodies the sort of high skills of design and making which were part of what the School sought to show its students.

However at Central Jack taught carving. As a craft, woodcarving is characterised by 'risk'[9] and the clarity with which the craftworker's artistic and technical skills are expressed. An architect or designer making a design for freehand carving is dependent on the technical skill of the carver and on his expressive skill in interpreting it sympathetically. However, to accord with Arts and Crafts theory, the carver, ideally, should have been responsible for both the creative composition and the execution of the carving. In fact, at Central a clear divide between the design and executive skills was recognised, as the prospectus makes clear, and the syllabus was intended to help bridge them. This was a result of the School being an LCC institution, open only to those engaged in the trades, artisan craftworkers, which specifically excluded amateurs. However its syllabus must have attracted amateurs who wanted an education in craft with a view to practising as creative rather than artisan craftworkers, those who wanted to be the designer-makers of the time. Policy on what was taught, and to whom, was gradually broadened. For example in 1906 a class in china painting was started and the entry in the prospectus for 1908 noted, 'the attention of designers wishing to get in touch with a craft is directed to the facilities offered for turning their designs to account'. The class were taught techniques of

George Jack
Inlaid mahogany secretaire for Morris and Company, 1905. It was priced at 98 guineas.
Private collection

decoration using ceramic whiteware blanks which had been bought in. Here there is a clear signal of a different approach, one which seeks to harness existing skills to develop the making side of design.

The class in china painting was run initially by Alfred Powell who could serve as a model for the creative craftworker side of the Arts and Crafts movement. He was firmly of the middle classes, a public schoolboy, and was articled as a pupil to the architect J.D. Sedding, Henry Wilson's partner.[10] His friends were among that group of young idealistic architects whose pursuit of Arts and Crafts ideological perfection led them to retire from London professional life to engage with craft production, often in the Cotswolds, as he did. He was an environmentalist and conservationist with a strong social commitment who made furniture and took occasional architectural commissions. From 1903 he worked on commission for Wedgwood designing some shapes and producing underglaze enamel decoration. In 1906 he married Louise, grand-daughter of Wedgwood's Art Director Émile Lessore. Louise Powell was a craftswoman in her own right. Together they fielded a formidable range of skills. They shared a studio in London, partly funded by Wedgwood, and made their living designing, making and decorating craft items. These were craft wares of a creative significance which would appeal to an informed middle class audience and commanded a good price, hand-painted ceramics and furniture with gesso or painted decoration. This suggests an enterprise more on the lines of the Omega Workshop than the artisan skills of the metropolitan craft industries.

Following the School's move into its new purpose-built accommodation in Southampton Row in 1908, further types of courses were added with the arrival of the Day School of Art for Women and the Technical Day School for Boys which again broadened the range of students who had access to Central School. The former was 'intended to train young women who wish to become art teachers or to earn their livelihood in some branch of Art or Art Craft',[11] and the latter included general academic subjects and gymnastics in addition to the training in vocational skills.

W.R. Lethaby left Central in 1911 to take over at the Royal College of Art, then devoted to training art teachers. He was replaced as principal by F.V. Burridge and under his direction Central continued to broaden its access policy. The addition of subjects like book production and decorative needlework and embroidery had already undermined the logic of the original organisational framework in which architecture had been dominant, and under Burridge the organisation was re-jigged. 'New' subjects were introduced. In 1912 a special lecture on Business Organisation was included, to be given by 'a

Alfred Powell
Wedgwood pottery charger, designed and painted, c. 1920
410 mm in diameter
© Cheltenham Art Gallery and Museum, and Woodley and Quick, photographers

lecturer... provided by the National Cash Register Co.'.[12] By that date N.C.R. was a leading supplier of business machines for financial and stock control.[13] A specialist course of 'Lectures to Furniture Salesmen' was also started that year, which in addition to a stylistic history of furniture and decoration, modern methods of production and distribution, soft furnishings, colour, and proper methods of arranging furniture, also included the 'science of salesmanship' and 'principles governing the science of negotiating'.[14] This was the first of several such courses aimed at different branches of design-led retail trades, such as textiles.[15]

Such innovations reflect contemporary developments in business and management practices as well as indicating a shift in the potential audience Central addressed, now to include not only the designers and makers of artefacts but also the distributors and retailers, and the consumer. The original student audience of artisan craftsmen continued to be served by evening and day release courses which, although an awareness of design was encouraged, were vocational and based in the materials, processes and skills of a particular medium and a particular craft industry. To these had been added day and evening courses aimed at people with design skills, like that in China Painting which by 1912 was run by Miss M. Hindshaw, a former pupil of Powell's. These courses were design-led, orientated to help students attain sufficiency through sales of designs or on a design-and-make basis, as the Powells did. Teaching methods were varied, architecture and the building crafts acquiring a thematic course on the design and building of a small house to act as a focus for the courses on materials, structure, design and theory. The next development, fostered by changes under Burridge, was to be full and part-time design-led courses to train designers for manufacturing industry. Public lecture courses addressed to a wider audience were held. University Extension Course lectures in the history of art were started, given by Selwyn Image, Slade Professor of Fine Art at Oxford and past Master of the Art Workers' Guild, and in the history of architecture, given by Banister Fletcher, architect and author of the compendious *History of architecture on the comparative method*, first published in 1896 and in its updated form today still an indispensable text book. A series of lectures and visits on 'Art and the community' was also directed at the public, covering the house, its decoration and furnishing, the garden, and urban and rural amenities.[16]

As well as the important contribution it made to art and design education in emphasising project-based activity in studio or workshop, as a movement the Arts and Crafts had a significant role in re-affirming the creative integrity of the individual craftworker. The industries Central School originally served were based on craft skills, as indeed were most industries at that time. A high level of artisan skill was essential even for the manufacture of large mechanical products. For example the motor industry engaged in series production of vehicles to a standard design but for the most part still relied in the 'fitter' to mate components individually. In Britain the development of mass production industries using automatically operated machines to make a product of a standard design to a consistent quality was only gradual. In 1922 the first Year Book of the Design and Industries Association[17] illustrated luxury cars by Daimler, Lanchester and Rolls-Royce as representing good modern design, all built to order in small numbers, not Ford's mass-produced Model T.

The DIA with its call for 'fitness for purpose' was a British response to the German Deutsche Werkbund, founded in 1907, which led the development of design for a modern industrial age in Germany. One of its leading figures was Walter Gropius, the founding head of the Bauhaus in Weimar, who was associated with the Central when in Britain in the late 1930s. Another refugee from the Bauhaus was Naum Slutzky, a well known goldsmith and jeweller who also taught industrial design. He taught both subjects at Central from 1946 to 1950.

However the impact of continental European developments, in particular that of the Bauhaus, was felt only in the late 1930s. During the 1920s and most of the 30s the Central School was chiefly concerned with courses of two different types: a range of full-time four-year courses which led to a Diploma of Craftsmanship assessed by examination, and then

Naum Slutzky
Pendant, silver pipes and sticks , 1961
Courtesy the Worshipful Company of
Goldsmiths

the original part-time courses for men and boys from the craft industries, including furniture-making, printing and silver-smithing. The courses for printers and silversmiths had rigid guide-lines imposed by their trade organisations. These were intended to train artisan craftworkers. The other courses were more open and experimental, aimed at developing students' creative skills to work as designers or designer-makers. In 1938 came another type of course, Design for Light Industry, set up by H.G. Murphy, silversmith and Principal of Central, who died suddenly and unexpectedly in 1939.

In post-war Britain design received more attention than it had previously, with greater government support. The Council for Industrial Design, later the Design Council, promoted awareness of the importance of design to manufacturers and to the public, helping the manufacturer to find designers and the consumer to identify products considered to be well designed. In 1946 the Central School established a Department (later renamed School) of Industrial Design and emphasised an education to design articles for everyday use which would be mass produced.[18] This stood alongside the more traditional craft-based courses where design was focused through an intimate familiarity with a particular medium. Unlike them, industrial design addressed the design of complex products, locating them in relation to the consumer's preferences as well as the manufacturer's. It focused on developing a familiarity with principles of design and a knowledge of a wide range of materials and production processes (based on theory as much as hands-on experience), and an analytical problem-solving approach. This represents a considerable shift. Theorists of both Arts and Crafts and industrial design approaches would recognise that an object must be practical, although Arts and Crafts might refer to 'fitness for purpose' while industrial design claims 'form follows function', and both would recognise the primacy of materials and tools or processes in determining appearance, but at that point they diverge. Arts and Crafts would encourage individuality in design and expression of the craftworker's skill and delight in the making process, whereas industrial design would encourage abstract and universal design qualities and expression of zeitgeist in design for mass-produced objects made by automatic machines to a consistent standard.

In addition to purist influence from the Bauhaus there was another equally powerful and for some a possibly more attractive influence from the USA where a new type of design consultant had emerged, typified by the French-born Raymond Loewy, who gave exciting and attractive expressive form to designs for mass production, such as Studebaker cars. From 1936 Loewy's London office included the designer Douglas Scott who had been a student at Central from 1926 to 1929 where he trained as a silversmith. Thus he was familiar with the complexities of designing smooth compound-curved surfaces and punctuating them with applied details, as well as the use of refined and controlled handling of the junction of surfaces and around openings. These skills are apparent in his subsequent career as a designer across a wide range of products, which included the London bus. In his design for the London Transport Routemaster bus he succeeded in 'endowing a massive public service vehicle with graceful curves and civic manners'.[19]

The Routemaster was not radical in the way that the almost contemporary Daimler designs were. Daimler introduced the now familiar model of a rear-engined bus, which permitted a low floor, with forward control and front entrance, which made one-man working possible. But the design concept of the Routemaster can be traced back to the

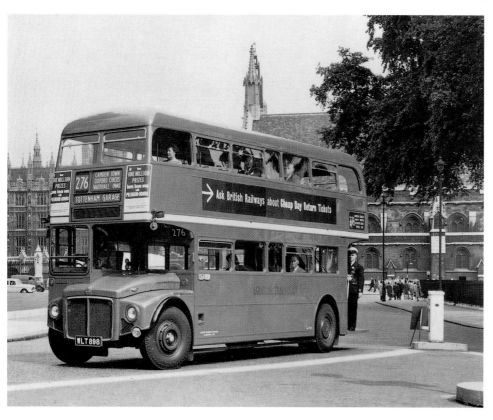

Douglas Scott
The Routemaster bus, designed for
London Transport, 1956
Photograph
© London Transport

earliest motor buses, with a front-engined, rear-wheel drive chassis and open rear entrance, which in turn derived from the horse-drawn buses of the nineteenth century. However, the design is beautifully refined and controlled inside as well as out. It is comfortable and has proved reliable, and it is no surprise that people think of this design as the London bus, rather than the more radical one. It seems appropriate that Loewy is credited with the concept of MAYA, 'most advanced yet acceptable', to control the degree of innovation in any design. arguing that however good, a design too radical for the public to recognise and identify with must fail. The consultancy Loewy established offers a model for the subsequent development of the design industry, and through Scott this had considerable influence at Central School. In the post war period the industrial design course at Central was restructured and expanded to give students a broad experience in design and a working knowledge of the multiple contiguous disciplines, electrical engineering or plastics for example, which the designer needs to be aware of. The course rapidly became recognised as a leader in the field.

A remarkable group of staff was assembled to teach the new Industrial Design course. This included the silversmith and industrial designer Robert Welch who trained at the Royal College of Art where he explored the use of stainless steel which was then still a 'new' and rather exotic material. He worked as a consultant designer to the Old Hall company, producing designs for stainless steel which are distinctive of the 1960s, such as a coffee service with abbreviated spouts and side handles in teak which was included in the Design Council's Index. Welch also worked as an industrial designer, responsible for cult products such as the range of lamps with smoked acrylic shades he designed for Lumitron in 1964, and as a silversmith producing designs for domestic silver for Heal's, ceremonial silver for embassies and livery companies, and ecclesiastical silver. Robert Welch taught on the industrial design course at Central School from 1957 to 1962, specialising in the application of stainless steel for domestic and contract holloware and cutlery. His role was to introduce students to the characteristics of stainless steel and how it is worked in manufacture. He did this by setting them simple projects to design and make in stainless steel, such as a tea strainer.

In coverage his work focuses mainly on wares for the kitchen

Tea strainers, designed by students in stainless steel as an exercise set by **Robert Welch** at the Central in 1961
Photograph
Courtesy of National Arts Education Archive, Bretton Hall

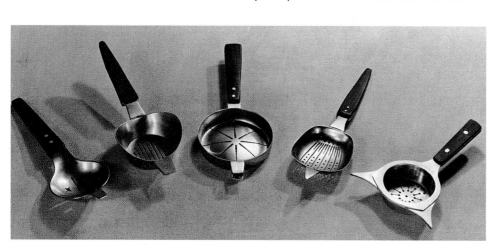

and table while in materials used he is an all rounder and can also lay claim to be among the first of a new generation of designers who were recognised by name for their distinctive designs by the design generation that started with the 1960s. The cast iron range of domestic table items with deeply undercut stems were featured in the new design boutiques which sprang up in the 1960s, Primavera being among the first, Habitat becoming the most prominent. Welch has also been innovative in the marketing of his designs through his own shops in Chipping Camden and Warwick and a mail order catalogue, which continue to flourish. In a curious way Welch links back to the Arts and Crafts revolution in which Central School was started. His shop is in the charming Cotswold village of Chipping Camden, and

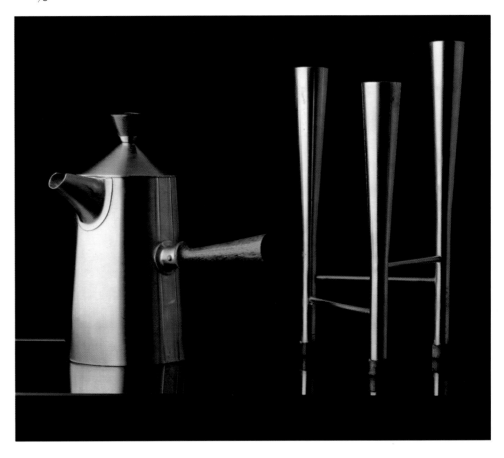

Robert Welch
Stainless steel coffee pot with handle, and candle holder, designed for Old Hall tableware, 1950s
Photograph
© Camberwell College of Arts

his base there is the Old Silk Mill which was taken over at the turn of the century by the pioneering Arts and Crafts group the Guild and School of Handicrafts when it left East London for this rural Elysium, so there is a continuity in craft skills, in designing and in making.[20] There is also that other quality of the entrepreneur craftworker who is as sensitive to his market as to the materials and processes of his craft, and who matches the products and marketing methods to his public.

In 1982 the Department of Industrial Design at Central produced a book entitled *Central to design, Central to industry*, with an explanatory subtitle *Seventy-eight past students in industrial design from the Central School of Art and Design: a look at who they are working for and at the products they have developed*.[21] The book is in part celebration, part guide to the profession, for the former students formed a substantial proportion of the profession at that time, and the products illustrated include some very familiar ones: televisions, radios, motorcars, electric ovens and other domestic appliances.

Twenty-nine of these had completed their training between 1949 and 1966 and achieved distinction. David Carter and Bill Moggeridge, like Douglas Scott and Robert Welch, became Royal Designers for Industry. Martyn Rowlands was the first industrial designer to become a Fellow of the Plastics Institute. Richard Farrell joined the Raymond Loewy design practice in New York and became the owner of Loewy International in 1979, counting among his commissions the design of the NASA Skylab. In total ten RDIs practising in industrial design and product design were trained at the Central.

Robin Sandberg who formed Thornton Sandberg Brockbank in 1974 with two fellow students Vernon Thornton and Roger Brockbank captured the spirit of the department in the late 1950s, when recalling the visit of Charles Eames.

The noted art historian, Reyner Banham, during one of his teach-in tea time treats, brought Charles Eames to the Central to meet us. Challenged – inevitably – to define

'good design', Eames gave us all the lesson of the year, if not the course: 'good design is the best you can do between now and Tuesday'... Eames also said he reckoned good design is just 'common sense made visible'. We liked that too.[22]

By the 1980s the LCC Central School of Arts and Crafts had become the Central School of Art and Design. Along the way it had shed its furniture design course and its architecture course, and the others became first Dip. A. D. (Diploma in Art and Design) or H. Dip. Des. (Higher Diploma in Design) courses, later BA and MA courses. What has remained is the regular updating of not only the course syllabuses but also the approach they take, keeping the important balance between aesthetics and the advances of technology.

1 Honours degree courses in Product design, Ceramic Design, Arts and Design, and masters degree courses in Industrial Design and Design by Project in Ceramics or Jewellery.

2 See Evans, 'Teaching collections then and now'. In S. Backemeyer, ed., *Object lessons*, 1996, pp.15-20.

3 Quoted in Godfrey Rubens, *William Richard Lethaby: his life and works, 1857-1931*, Architectural Press, 1986, p.187.

4 See Nicholas Taylor, 'Byzantium in Brighton'. In Alistair Service, ed., *Edwardian architecture and its origins*, Architectural Press, 1975, pp. 280-88.

5 See Godfrey Rubens, op. cit.

6 Victoria and Albert Museum, *Victorian church art*, 1971, pp. 125-30, items M12, 13 & 14.

7 Jack was the author of *Wood carving, design and workmanship* in The Artistic Crafts Series of Technical Handbooks, edited by Lethaby and published by John Hogg.

8 Using the standard suggested by H.S. Goodhart-Rendell, *English architecture since the Regency*, Constable, 1953

9 Risk as 'the workmanship of risk' is discussed by David Pye in *The nature and art of workmanship*, Studio Vista, 1968.

10 Biographical information on the Powells is taken from Jacqueline Sarsby, 'Alfred Powell: idealism and realism in the Cotswolds', *Journal of Design History*, 1997, vol.10, pp. 375-97.

11 *Prospectus* etc., 1908, p.28.

12 *Prospectus* etc., 1912, last sheet (not numbered).

13 See I.F. Marcosson, *Wherever men trade: the romance of the cash register*, New York: Dodd, Mead, 1945.

14 *Prospectus* etc., 1912, pp.19-20.

15 London County Council, 'The training of salesmen and saleswomen', (reprint of a memorandum), 1918, attached as an appendix to *Prospectus* etc, 1919.

16 *Prospectus* etc, 1919, p.24.

17 *Design in modern industry: the Year Book of the Design and Industries Association*, Benn Brothers, 1922.

18 This essay is informed by an unpublished thesis written for the MA History of Design course at Middlesex Polytechnic: Teal Triggs, *Central School and Industrial Design in post-war Britain, 1945-57*, 1990.

19 Jonathan Glancey, *Douglas Scott*, Design Council, 1988, p.12.

20 Colin Forbes, ed., *Robert Welch: design in a Cotswold workshop*, Lund Humphries, 1973.

21 The Central School of Art and Design, Industrial Design Department, *Central to design, central to industry*, The Central School of Art and Design, 1982.

22 Ibid. p129.

David Carter
The Stanley knife, designed for Stanley Tools, 1960s
Private collection

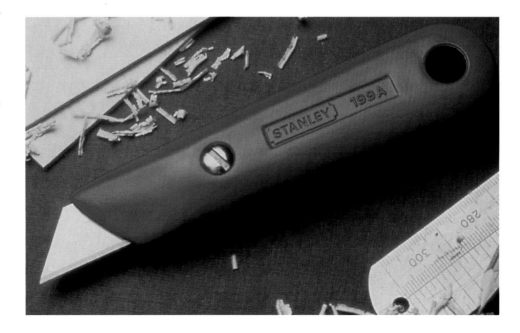

Central Ceramics: Dora Billington and Gilbert Harding Green

Alison Britton

Alison Britton is a potter and lecturer who has exhibited widely and is represented in many international collections. She also writes on the applied arts and curates exhibitions, including The raw and the cooked: new work in clay in Britain, *1993, for MOMA, Oxford. She studied ceramics at Central from 1967-1970 and was awarded an OBE in 1990.*

After a survey of the progress of the potter's craft throughout the ages one turns anxiously and critically to its position today to find that, while the mass production of pottery tends through its very efficiency to a more and more mechanical result, an entirely new type of 'Studio Potter' has arisen in our time, with aims and ideals that are primarily aesthetic. For many of these, pottery is a medium which gives scope to combine painting and sculpture, form and colour, without necessarily having any utilitarian value whatever, being in fact a species of so-called fine art; it has even been described as one of the purest forms of art through having little or no representational value.

In this way Dora Billington began the last chapter of her small but incisive and enlightening book *The art of the potter* published in 1937.[1] She acknowledges the new idea of the sphere of meaning of pottery and echoes some comments of Herbert Read. I want to quote more of this passage because it sums up so accurately the breadth of the underlying philosophy of the pottery department at the Central School in the middle decades of the 20th century.

Allowing for their different purposes when considering modern pottery, mass production and studio production must at present be viewed as two separate things which although not necessarily conflicting are doing no better than running parallel. The world has use for them both, but as co-operative forces. At no time has either art or industry profited by standing aloof from the other; and it must be recognised that an economic condition has now been reached when the two must work together for the advantage of themselves and in the service of the community.

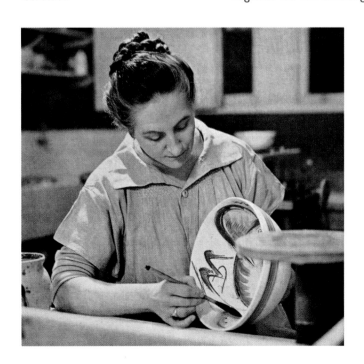

Dora Billington
Decorating the inside of an earthen-ware bowl, c. 1940s
Photograph
Central Saint Martins Museum Collection

Miss Billington steered the pottery from being a sub-section of various generalised art and design schools, towards having an entity as a department, which ran both evening classes and a three-year full-time day course called the Central Diploma Course. By the late 1940s under the new and reforming energies of the principal William Johnstone, the college was dominated by returning ex-servicemen and women taking the opportunity of an art education. In this ebullient and expansive post-war period, the pottery courses at the Central School came to represent the most progressive front of the art and craft of ceramics.

Miss Billington was in her middle years by this time. She was born in 1890 in Staffordshire, and for at least three generations her family had been involved in the pottery industry of Stoke-on-Trent. She was very familiar with all aspects of industrial production. This is clear from the beautifully concise way in which she describes processes in the earlier technical chapters of *The art of the potter*. As a child she was surrounded by the discussion of production and by the pots themselves

'and at a very early age I saw that they were not all they should be'. A crusading spirit took her to the local Hanley School of Art and she recalled 'getting hold of some Japanese prints and handing them over to one of my father's gilders, hoping that they might prove to be a good influence'.[2] For a couple of years after art school she worked in the small studio pottery of Bernard Moore, famous for his glazes, and gained decorating experience, and then in 1912 she got a scholarship to the Royal College of Art in London, where they put her in the Design School. But in London she also met Bernard Leach, Michael Cardew and William Staite Murray, and began to realise that the potential for the individual production of the 'artist-potter', and the craft of throwing in particular, was of great importance.

During her time as a student at the RCA she also became a teacher there, the wealth of her practical experience in Stoke enabling her in 1915 to take on the running of the pottery, for the few students who worked with clay, when Richard Lunn died.[3] She continued to teach there until 1924 when the more elevated job of instructor in Pottery at the RCA was offered to William Staite Murray, a post he won in competition with Leach, in 1925. Dora Billington went to work at the Central School.

When she left the RCA it appears that specific knowledge of the nuts and bolts of ceramics left with her. Oliver Watson says of the new Staite Murray ethos 'while the atmosphere he created was certainly an artistic stimulus, most of his students had to resort to Dora Billington's evening classes at the Central School of Art to learn the technical basis of their subject'.[4]

It is not clear which department of Central the pottery belonged to in 1925, but the *Pottery Gazette* for August of that year notes that

> The record of the Pottery Section at the Central School is distinguished, and its equipment has recently been increased by the installation of high temperature kilns which make possible the production of stoneware. Very interesting results have already been obtained. It is inevitable, perhaps, that the younger generation should be influenced by the work of Mr Bernard Leach and Mr W Staite Murray, but there is little evidence of indolent plagiarism.

Dora Billington
Earthenware decorated casserole, undated
Photograph by Bonnie van de Wetering
Private collection

Whereas in the early years of the century 'pottery' had been only a china painting class taught by the famous Stoke decorator Alfred Powell, by 1937, when Miss Billington was publishing her book, pottery was part of the 'School of Painted and Sculptured Architectural Decoration'. A range of forming, decorating and glazing processes were taught, including mould-making, casting, and the jigger and jolly machine, which were industrial rather than craft processes, and ceramic chemistry lessons. Other classes in the department were in studies from the figure, draped and nude, composition, lettering, casting in plaster and metal, and carving in wood, stone and ivory. There was also a mosaic and mural decoration class.[5]

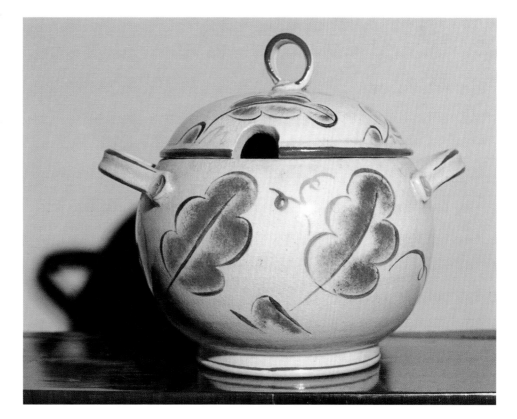

By 1940 Miss Billington had been joined by Gilbert Harding Green as an assistant teacher. London born in 1906, as a very young man he lived abroad for some years in Brazil and Italy. He came back to England to study, attending painting classes at Chelsea, and modelling classes at Central with Frank Dobson and John Skeaping, (who appears with Dora Billington on the staff listing for the Architectural Decoration department in 1937). Harding Green presumably found his way into Miss Billington's class on clay modelling, and thereby embarked on a long and close collaboration with her, and an engagement with the continuing evolution of the ceramics course which was to preoccupy him for the rest of his career. He exhibited quite frequently before the war 'decorated pottery and modelled heads which owed nothing to the oriental traditions of Leach, the work of Staite Murray or the English traditions of Stoke on Trent'.[6] But by about 1950 Gilbert Harding Green, or HG as he was known, devoted himself to teaching, taking over the leadership of the department in 1956 when Miss Billington suffered a stroke and retired. Her second book, *The technique of pottery*,[7] was written after the stroke. She died in 1968.[8]

It is interesting to note, from changes apparent in successive prospectuses, that however the philosophy of the pottery department itself was crystallising, its status in the college as a whole was less clear.

The college was evacuated to Nottingham during the War and part of the London building was destroyed. The prospectus for 1940 reveals that the department responsible for the pottery had shifted its scope more towards what we would now call Fine Art, and was called the 'School of Drawing, Modelling, and Allied Subjects'. Central also had a new School of Painting and absorbed courses from the Westminster and Chelsea Schools of Art.

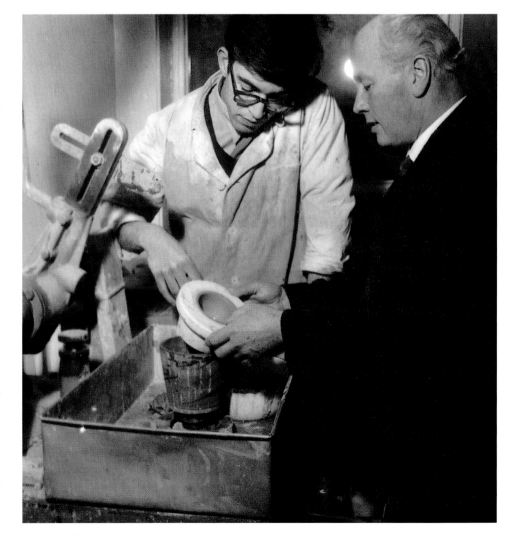

Gilbert Harding Green working with a student on the 'jigger and jolly' machine in the early 1960s
Photograph
Central Saint Martins Museum Collection

In 1945 the pottery was included in a new category, the School of Furniture and Interior Decoration. Applicants were told that they could specialise in either furniture or interior design, and it would seem that the broad range of experiential, practical, technical, theoretical, and aesthetic understanding of the ceramic medium that HG and Miss Billington were offering was tangential to these main aims.

However in 1947 the school is retitled 'Furniture, Interior Decoration, Pottery and Stained Glass'. The prospectus notes that pottery students are now taught to pack and fire the kilns for high and low temperature firings; and in addition to the lectures given by Miss Billington on simple Pottery Chemistry, there will be lectures on the appreciation of pottery 'from time to time'.

Her aptitude for this is clearly shown in *The art of the potter* where she gives a comprehensive history of the medium, starting with primitive hand-built pottery, and proceeds, largely through a

straightforward discussion of methods, to illustrate the key achievements in ceramic history. The chapter on 'Glazed and painted pottery' culminates in the story of tin-glazed wares and the way in which that important, painterly technique travelled with the conquering Moors from the Islamic Empire into Spain and thence to the rest of Europe, inspiring Italian Majolica, and Dutch and later English Delft.[9]

Her account of the history of pottery is significant for the times in that she gives a very rounded world view, with no trace of an orientalist bias. This compares interestingly with Bernard Leach's *A potter's book*,[10] in which his quintessential chapter 'Towards a standard' emphatically locates Chinese pots from the Tang and Sung dynasties as the supreme models. A sentence on the world's best pottery does however include 'early Persian, Syrian, Hispano-Moresque, German Bellarmines, some Delft and English slipware'.[11] He also commends Miss Billington's book in a footnote.[12] She devotes a later chapter of her book to Chinese ceramics starting in 3000 BC, but the longest chapter in the historical section is on 'Pottery in England', and includes Wedgwood and the Industrial Revolution. But as John Colbeck remarks, the idea that there was antagonism between the ethos of the Central School pottery and that of Bernard Leach is a distortion: why else would she have used a photograph of a Leach lidded jar as her frontispiece?[13] Perhaps the position is well summed up by a reflective comment much later from her pupil William Newland: 'It is not that we were anti-Leach – but there were other things to do.'[14]

I want now to look in more detail at the years just after the War. Billington and Harding Green both worked part-time. Other staff came and went for certain classes, such as Mr Bateson for large-scale throwing. About ten students could be accommodated in the pottery on the ground floor of the Lethaby building, which Miss Billington ran from a desk in the corner of the room. There were kilns and glaze rooms in the basement. Industrial aspects – casting, jigger and jolly – were still mentioned as in earlier prospectuses, but no one I have interviewed can remember them being taught at this time. David Queensberry, who began the diploma course on the same day in 1951 as Gordon Baldwin, left before the end of the course to study in Stoke because he felt Central didn't know enough about the industry.[15] It was now quite definitely a Studio Pottery course, with throwing at its heart. Students who didn't show interest in throwing were encouraged to leave in the Billington-HG era.

Kenneth Clark and William Newland were both New Zealanders out of the forces and getting an art education in London. Both made the transition from being Billington's pupils to being her colleagues. Kenneth Clark recollects that in Miss Billington's approach skill was the first consideration. The course structure followed a historical and grammatical logic, starting with pinch pots and red clay. White clay, the wheel, and stoneware temperatures were goals for the more advanced students, and Clark doesn't remember that porcelain was ever reached. One day a week was spent on decoration. He thought that Harding Green complemented Billington in a very effective way, being liberal, highly supportive of creative students, and encouraging experiment. His cultured and well-travelled background in Europe and South America, and his high aesthetic standards and 'taste' in Italian architecture and gardens were also inspirational.[16]

Newland's main teaching job was at the Institute of Education, but he gave classes in throwing at Central from 1949 to 1960. Newland became the focus of a new direction in studio pottery, with his wife Margaret Hine, James Tower, and Nicholas Vergette, who was the department technician prior to Ian Auld. Billington thoroughly supported the work that they were doing with thrown and assembled sculptural form, and painterly press-moulded dishes, and wrote about it.[17] Picasso had inspired them all, as well as ideas that came from their own fluent skills. The Arts Council exhibition of 1950, 'Picasso in Provence', which included his ceramics, was seminal. To give an idea of the essential qualities of throwing that made it form the core of their work and their teaching, here is Newland, writing much later, but his vision was consistent.

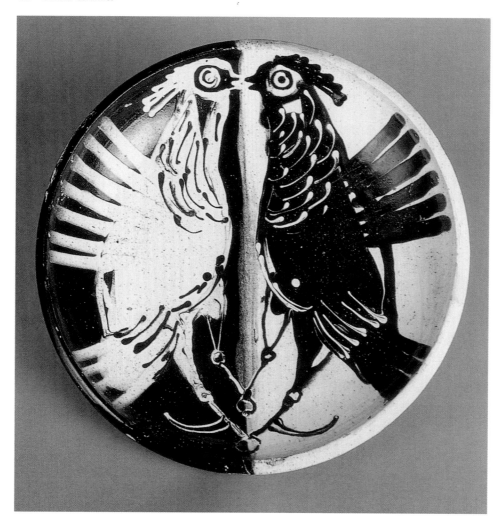

William Newland
'Confronted birds', 1948
Slip-ware dish
460 mm in diameter
Private collection

> Throwing is concerned with inner force – dynamic growth from the wheel, like a triangle on its apex or a crocus from its stem striking its way upwards... All good thrown pots must express *joie de vivre*, uplift and umph – this is the 'tom-tom' taste for form which has been given down through the ages. There are no saggy pots in the British Museum.[18]

In the post-war years there was a lot of flexibility and reciprocal access between the London art schools, and free interchange between the various fine art and design disciplines. William Johnstone encouraged fine artists to teach across the whole curriculum, and all Central students had a Basic Design element to their course. William Turnbull taught this, and Eduardo Paolozzi, who also worked in the textiles department. These classes had a profound impact on Gordon Baldwin, who was a student from 1951–54. Gordon recalls that William Johnstone took great interest in every department, and expected his staff to have frequent exhibitions. He was generally awe-inspiring but made the whole place feel important.[19] Baldwin was offered the job of technician in the pottery, a device often employed by Billington and HG to foster the promising students and keep them in a creative orbit.[20] And the creative orbit moved in an excitingly experimental direction, which began to sideline the wheel in the pursuit of more surprising forms.

> The Central represented a modern movement in ceramics. By the late fifties there was a shift to a more monumental style in undecorated stoneware. With the encouragement of Gilbert Harding Green... Dan Arbeid began to make fresh, daring, slab-built, folded and coiled stoneware. On his return from Baghdad in 1957

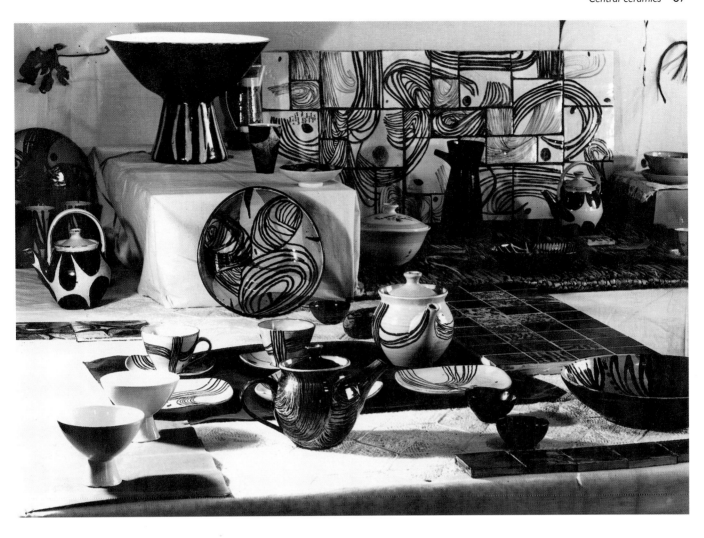

Ian Auld started making fine slab-built bottles. By the end of the fifties the Central was associated with the extraordinary sculptural work of Gordon Baldwin, Ruth Duckworth, and Gillian Lowndes.[21]

Gordon Baldwin's Central Diploma show, 1954
Photograph
Central Saint Martins Museum Collection

It is worth noting that both Arbeid and Auld were technicians first rather than students, and both had a subsequent substantial teaching role at Central.[22] Auld had first done ceramics with Newland at the Institute, and went on to lead the department at Camberwell in an ideally progressive phase. Duckworth and Lowndes were students who became part-time teachers in the department.[23] Baldwin was taken on to the teaching staff in 1956 and had a part-time job there for three decades. He taught the hand-building day, encouraging generations of first years, including me, into looking with more intelligent eyes at form and space.

Alongside the diploma students of the 1940s and 1950s were other evening and part-time students. Alan Caiger-Smith was an evening student in 1954–5 who wanted to learn to throw and paint on pots. He managed discreetly to extend his hours, and the Central experience changed the course of his life.[24] He became a leading practitioner and expert on tin glaze and lustre decoration. (In previous decades some evening students, such as Katherine Pleydell-Bouverie in the early 1920s had become very significant.)

In the early 1960s Harding Green endorsed the change of the department's name from 'Pottery' to 'Ceramics', and later the three-year full-time course was assessed and achieved the new 'Diploma in Art and Design' status, following the Coldstream report. There were no longer any evening or part-time students. HG now had a full-time post. Although in theory the Dip AD did not foster the crafts at first, well-structured courses like this one flourished. For one thing, liberal studies and the history of art had always been encouraged

by HG anyway, and were now formally on the syllabus. The monthly drawing crit is something he is remembered for by ex-students, some of whom continued the tradition when planning their own courses. Second-year students were introduced to some industrial techniques, first by a week of visiting factories in Stoke-on-Trent, followed by studio work on the lathe, and plaster model and mould making for slip casting. This was taught by Dan Arbeid, though he was a hand-builder at heart. Many more materials were in use in the department by the 1960s, a wider range of clays, pigments, and enamel colours for on-glaze decorating. Silk-screen transfer printing was set up in an extra studio.[25] In the mid-1960s the bulk of the department moved into the new building.

In 1966 the Craftsman Potters' Association was the venue for a historic evening meeting to discuss the proper training for a potter. Lines were harshly drawn between potters and educators. Harding Green and Henry Hammond, from Farnham, both represented successful broadminded Dip AD courses in ceramics, which were derided by potters such as David Leach for whom there was no truly professional path other than apprenticeship: 'the slower, radical, disciplined drill of the workshop'.[26]

This was the course I joined in 1967. One of my abiding memories is of the ceramic history slide lectures given informally in the darkened studio by John Colbeck and Bonnie van de Wetering, using their own collection of slides. They seemed to have been everywhere, to all the museums in Europe with ceramics collections, in the Landrover. It felt like education in

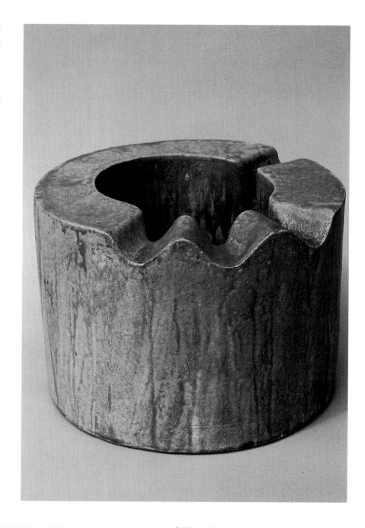

Gillian Lowndes
Stoneware drum form, 1967
180 mm high
Private collection

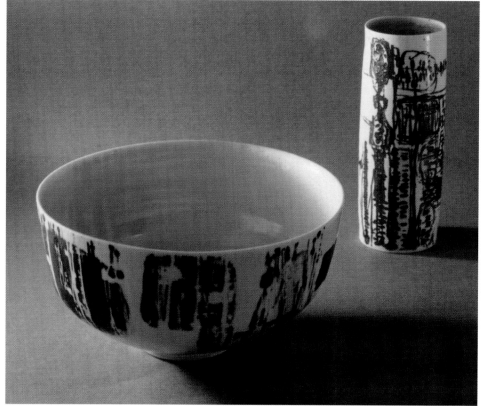

Bonnie van de Wetering
Porcelain with sgraffito decoration
with iron oxide, c. 1960
Photograph
Central Saint Martins Museum
Collection

Richard Slee
Twenty-one trays, hand-built earthen-
ware with lustre
1000 x 1000 mm, variable
Private collection

the real sense: an enlightened, connected, impassioned, unpompous, drawing out of our interest. It has underpinned my feeling for ceramics ever since.

These two were, I think, the guardians of Harding Green's liberal approach that nurtured imagination as well as skill. They had overlapped as students and Bonnie began teaching part-time in 1961, becoming Senior Lecturer in 1965. John took over William Newland's throwing day in 1962, and left to run the department in Corsham in 1970.

Richard Slee and Andrew Lord were students when I was, which suggests perhaps that the dominant tendency was towards the artier end of the spectrum. (But the walking teaset, jokey and enormously mass-produced, was also a by-product of the department in the early 1970s.) Robin Levien, who went on to join the Queensberry Hunt design partnership, and Rob Kesseler, were both enrolled in 1970. Kesseler's own work is in fine art but he teaches currently on Central Saint Martin's design-oriented ceramics course. The sculptor Edward Allington was in the last intake of ceramics students that HG interviewed.

Harding Green retired in 1971 and his leaving present from staff and students was a parrot. His retirement years were filled with the beautifying of several gardens and houses, and he died in Wiltshire in 1982. Bonnie van de Wetering left in 1972 shortly after his retirement.[27] It seemed inevitable that the course would move more towards industry with the appointment of David Reeves as head of department – he had worked at the Royal Worcester factory. Although it was the general intention of the college at this time to strengthen its industrial connections, this did not happen in ceramics until much later when the Central course was required to differentiate itself from Camberwell's, under the combined structure of the London Institute.[28]

Dora Billington would I think have approved of this continuing evidence of change and the renewed attempt to embrace both art and industry. Writing in 1956 about a new exhibition of the work of Newland, Hine and Vergette she comments:

But won't this amusing contemporary pottery very quickly date? Of course it will, just as quickly as a pastiche of seventeenth century slipware, or thirteenth century Sung wares; all aspects of twentieth century studio pottery; to be judged, a hundred, or even fifty years hence, by standards probably very different to ours. The standards of good workmanship which we recognise in all good pots of any period, and to which we cling, passionately and a little dogmatically, need to be restated and interpreted afresh by each generation; each making its own imaginative contribution. Why are we in this country so afraid of imaginative experiment? Even a little breaking of the rules would be a tonic occasionally. Every pottery studio in this country might well have inscribed on its walls, 'Craftsmanship is not enough'.[29]

1 Dora Billington, *The art of the potter*, Oxford University Press, 1937.
2 John Farleigh, *The creative craftsman*, G. Bell and Sons, 1950, Chapter 12, p. 189.
3 O. Watson, *British studio pottery: the Victoria and Albert Museum collection*, Phaidon Christie's, 1990, p. 153.
4 Ibid. p. 23.

5 Central School of Arts and Crafts *Prospectus*, 1937.

6 Tony Birks and John Colbeck, 'Obituary: H. G., the gentle autocrat', *Ceramic Review*, 1983, p. 79.

7 Dora Billington, *The technique of pottery*, Batsford, 1962.

8 It is a pity not more is known or written about Dora Billington. She has pots in the Victoria & Albert collection, a set of six tiles from 1937, and a coffee set from 1950. William Newland was talking about doing a book on her in his last years. For a comment on the papers of single women which have not been archived, see T. Harrod, *The crafts in Britain in the 20th century*, Yale, 1999, p. 118. See also J. Stair, 'Dora Billington', *Crafts Magazine*, 1998, no. 154, and C. Buckley, *Potters and paintresses: women designers in the pottery industry, 1870–1955*, The Women's Press, 1990.

9 Dora Billington, *The art of the potter*, Oxford University Press, 1937, p. 53.

10 Bernard Leach, *A potter's book*, Faber & Faber, 1940.

11 Ibid. p. 4.

12 Ibid. p. 26.

13 Interview with John Colbeck, 8 January 2000.

14 Interview with William Newland, 19 December 1997.

15 Interview with David Queensbury, 4 January 2000. He formed the Queensberry Hunt Design partnership and was Professor of Ceramics at the RCA from 1959 to 1983.

16 Interview with Kenneth Clark, 5 January, and a letter from him, 10 January 2000.

17 Dora Billington, 'The younger English potters', *The Studio*, 1953, vol 3. 'The new look in British pottery: the work of William Newland, Margaret Hine and Nicholas Vergette', *The Studio*, January 1955, vol 1. Both are anthologised in John Houston, ed., *Craft classics since the 1940s*, Crafts Council, 1988, pp. 53–9.

18 W. Newland and P. Dormer. 'The modern potter's craft: conversation with William Newland'. In *Fast forward*, exhibition catalogue, Institute of Contemporary Arts, 1985, p. 40. See also P. Dormer, *William Newland: it's all there in front of you*, retrospective catalogue, Aberystwyth Arts Centre, 1996.

19 Interview with Gordon Baldwin, 4 January 2000.

20 Robin Welch and Richard Slee are later examples.

21 T. Harrod, 'From a potter's book to the maker's eye; British Studio ceramics 1940-1982', *The Harrow Connection*, exhibition catalogue, Northern Centre for Contemporary Art, 1989, p. 20.

22 Arbeid taught from 1966 to 1983 and was a Senior Lecturer from 1972. Auld taught from 1957 to 1965.

23 Duckworth taught from 1959 to 1964 and then went to the University of Chicago and a notable career in the USA.

24 Interview with Alan Caiger-Smith, 4 January 2000.

25 Interview with John Colbeck, 8 January, and a letter from him 9 January 2000.

26 T. Harrod, *The crafts in Britain in the 20th century*, Yale, 1999, p. 240. Quotation from 'Training the potter'. In *The Craftsmen Potters Association Year Book 1966*, p. 29.

27 A. Lord, 'Obituary: Bonnie van de Wetering', *Ceramic Review*, 1994, no. 148.

28 Interview with Rob Kesseler, 15 January 2000.

29 Dora Billington, 'The new look in British pottery: the work of William Newland, Margaret Hine and Nicholas Vergette', *The Studio*, January 1955, vol 1.

Half a century of theatre design

Anna Buruma

*Anna Buruma trained as a theatre
designer at Central School of Art &
Design from 1974-77. She worked as a
costume designer in the theatre and
later for television and film. From 1993-
94 she studied the history of dress at
the Courtauld Institute and became the
archivist at Liberty's in 1995.*

Jeannetta Cochrane conducting a
'crit' with Theatre Design students in
1955
Photograph
Central Saint Martins Museum
Collection

When I was a theatre design student at the Central School of Art & Design in the mid-1970s we had to design and make a costume, which was then paraded on the stage of the Jeannetta Cochrane Theatre in front of an audience. What I did not realise at the time was that this was a tradition started by the very person after whom the theatre was named.

In 1905 Ellen Wright and May Morris began teaching a course in high-class dressmaking to work in conjunction with the embroidery class. Some design would be included. This course proved to be popular and dress design became part of the syllabus. In 1914, by which time Frederick Burridge had replaced W. R. Lethaby as principal, the classes were further refined. Design, cutting and making was to be based on the study of historical costume. This is the first year that Jeannetta Cochrane is mentioned in the prospectus as teaching dress design. She was born in Hampstead in 1882, the daughter of a doctor. While at the Polytechnic School of Art, she developed her interest in historic costume.[1] Teaching designers the importance of looking at the history of dress was to be a life-long crusade.

The Central School of Arts & Crafts encouraged their staff to continue to practice their professions. Lethaby thought that 'instruction is useless unless it is given by practising craftsmen producers who actually live by their work'.[2] Jeannetta Cochrane followed this precept

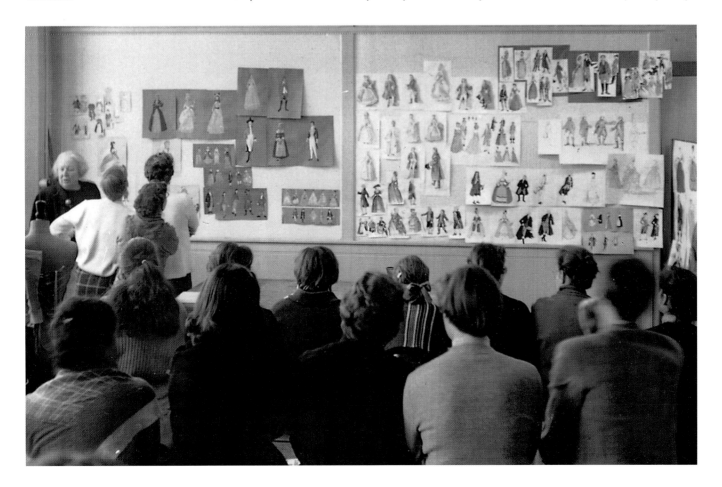

by continuing to run a costume business from Sheridan House in Bedford Square which supplied costumes to the fancy-dress balls so popular at the time. Through Sheridan House she was also involved in dressing historical pageants and several Lord Mayor's Shows. This eventually led to work in the theatre and she provided the costumes for a series of Masques in Regent's Park, and designed for productions at Covent Garden, the London Pavilion and the Abbey Theatre in Dublin.[3] Her varied career included an association with the couture house of Lachasse and the direction of the Craft Studio at Heal's.[4] Lady Prudence Maufe, the wife of the architect Sir Edward Maufe,[5] ran the Mansard Gallery and used the products of the Craft Studio for her furnishing projects. Jeannetta Cochrane also worked on church furnishings for Sir Edward Maufe. During the 1940s she was the costume designer on several productions for Sir John Gielgud, including 'Hamlet' at the Theatre Royal Haymarket (1944), 'The Relapse' (1948) and Congreve's 'Love for Love' (1943) at the Phoenix Theatre.[6]

In 1919 the Central School of Arts & Crafts was reorganised and dress design now came under a different department. A School of Textiles & Costume was set up in which historical and modern costume design, cutting and making, along with fashion illustration, were taught. The prospectus notes that the needs of the theatre would be especially dealt with. It refers to the School of Painted, Sculpted and Architectural Decoration where heraldic and theatrical design were taught, including the designing and making of theatrical properties, scenery and other stage effects.

In 1930 the School of Textiles & Costume was divided. In the School of Costume, Jeannetta Cochrane taught costume, fashion from life and theatrical design. Ruth Keating started teaching there the following year and stayed for the next thirty years. She was then designing for the Croydon Repertory Company, one of the many repertory theatres around the country which changed their productions every week or fortnight.

Jeannetta Cochrane's interest in the history of dress was part of a movement which had begun in the mid-18th century for greater historical accuracy in theatrical costume. This continued throughout the 19th century. The costume historian J. R. Planché wrote the extensively researched *Cyclopedia of costume and dictionary of dress* in 1876 and 1897. Apart from writing about costume, he also designed them for the theatre, and he wrote plays. He was an important figure in the increasing trend for setting plays in their right period and was to have a profound influence on the artists and designers that came after him.[7]

In the late 19th century productions became steadily more elaborate and rather top-heavy with historical details. In Herbert Beerbohm Tree's production of 'King John' in 1899, for example,

Jeannetta Cochrane
Costume designs for John Gielgud's production of William Congreve's 'Love for Love' at the Phoenix Theatre, 1943
Photograph by Cecil Beaton
© The Beaton Archive, Sotheby's

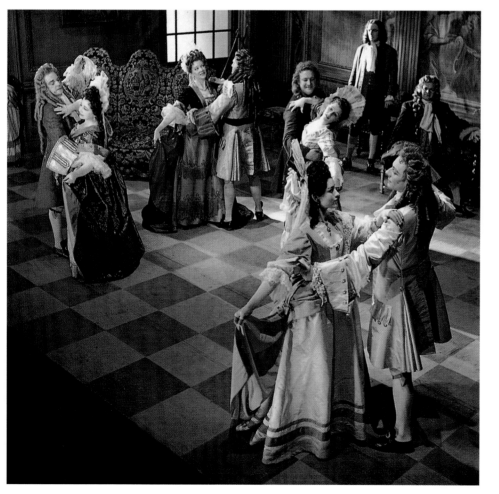

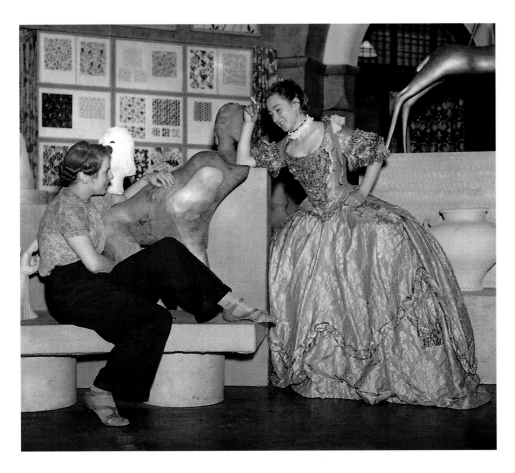

Theatre Design students taking a
break at the Central Diploma show,
1939
Photograph
Central Saint Martins Museum
Collection

one of the scenes is set in a real-
istic vaulted stateroom full of
noblemen in Plantagenet cos-
tumes. The Royal Guards march
in to a trumpet-call, followed by
the ladies of the court, each
with her own page. Finally the
king makes his entrance down
the stairs after several minutes
of this colourful pageantry.[8]
Productions like these inevitably
led to a reaction in favour of
greater simplicity in theatre
sets and costumes. Although
Jeannetta Cochrane believed in
the value of learning the history
of dress, it did not cloud her
sense of design. Her tastes for a
plainer, less ornamented silhou-
ette accorded with the ideas of
the 1920s and 1930s. She
admired especially the designs of
Charles Ricketts for their sim-
plicity, and believed that historical
accuracy could be achieved with-
out becoming over-decorative.[9]

Jeannetta Cochrane's students and colleagues remember her as a witty and remarkable
woman, who was much loved. She took a tremendous interest in her students and was
a catalyst to many a career. She had a way of letting a student find his own interests
and strengths. She felt she was there to sow the seeds; it was up to the students to foster
their growth.

Although she encouraged students to follow their own interests, she made sure they had
a thorough grounding in drawing, which was considered to be the most important skill at
Central. There were various drawing activities. Students from other courses participated in
the life drawing classes. They were held in one of the largest studios with two or three
teachers teaching at the same time, helping individual students. Tanya Moiseiwitsch desper-
ately wanted to be taught by Bernard Meninsky, but he was always on the other side of the
room, and William Roberts taught her instead. The illustrator John Farleigh gave another
drawing class, called 'draped life', which took place within the department for both dress
design and theatrical design students. Here a model was dressed either from the stock of
historical costumes made by past students or draped with fabrics.[10] This emphasis on draw-
ing skills continued throughout Jeannetta Cochrane's life, and much later (in order to help
him work on his drawing), she sent Peter Avery to the fine art department, run at the time
by Morris Kestelman; Blair Hughes-Stanton, S. R. Badmin, Keith Vaughan and Mervyn Peake
were his teachers.[11]

Although Jeannetta Cochrane's lectures on historical dress were for both theatre and
fashion students, she often spent more time with the theatrical, which was what interested
her most, and they were full of anecdotes about the celebrities she had known. Like all good
storytellers, she embellished her reminiscences. Of the many names mentioned, Alice
Comyns Carr was one. She had been Ellen Terry's costume designer. One of her anecdotes
has Jeannetta Cochrane sewing the beetlewings onto Ellen Terry's Lady Macbeth costume
designed by Alice Comyns Carr. But this is unlikely, as she would only have been seven at
the time. Sheila Jackson tells how Jeannetta Cochrane would come into the office after

telling such stories saying how well she had done, and how she had made the whole thing up.[12] However, as she really did have an extensive experience in the outside world and knew all the important people of the theatre and the decorative arts of her day, her stories must have had some truth to them.

Tanya Moiseiwitsch felt much was learnt about the nature of theatre through her lectures, but rather less about more practical things like the construction of a costume. This was taught from the mid-1930s by Norah Waugh. In the morning Jeannetta Cochrane, and later Pegaret Anthony gave lectures on dress of a given period, using any available visual aids such as brass rubbings, reproductions of paintings and drawings. These were later replaced by slides. In the afternoon Norah Waugh would show the students how to create the shape of that period on a dummy, and how to translate the results into a pattern. Examples from a growing collection of original garments were used to illustrate what the real thing looked like. For students to be able to learn about the history of dress through the shape and cut of clothes when it was still usual to look at illustrations rather than the inside of a garment, was invaluable.

Norah Waugh also shared her extensive knowledge of social history. She later wrote three important books on historic costume cutting, illustrated by Margaret Woodward,[13] which are still used by designers, cutters and historians today.[14] Many of the patterns in these books were taken from the original garments in the Central School collection. Margaret Woodward, who had been a student of Jeannetta Cochrane, came in 1946 to teach cutting with Norah Waugh, and later on her own. David Walker still remembers the exquisite way she had of handling the materials.[15] Ann Curtis recalls being impressed that a length of muslin could be coaxed to take on a sculptural shape on the dress stand, apparently without effort. Her great interest was in the medieval period. Norah Waugh had deliberately started her books in 1600, because Margaret Woodward would be writing about the earlier period. Unfortunately she died before she could do so.[16]

Once a week the students were taken to the Victoria & Albert Museum to attend lectures, work in the library or draw the exhibits. In the early 1930s the textile designer Lindsay Butterfield took these classes;[17] later it would be Pegaret Anthony or Sheila Jackson. In the late 1950s it was Geoffrey Long, who inspired students by showing them what the museum collections could teach them.[18]

Sheila Jackson had been a student in illustration with Noel Rooke at Central, but because of her great love of the theatre, she was drawn to the theatre department whenever she had a spare moment. She got on well with Miss Cochrane, and was asked to come and teach drawing in the theatre department. Sheila Jackson also took the 'presentation' class on Friday afternoons, in which students were taught how to present, draw, and mount their work. Marian Fernau, a student of Sheila Jackson's, in the early 1950s remembers the high standards she set.[19] Pegaret Anthony had started as a student of Jeannetta Cochrane in dress design, and came back to teach the history of costume and the theatre for over forty years.

The costume parade mentioned at the start of this article, was something Tanya Moiseiwitsch remembers well. In her day they were called 'The Episodes'. The student had to choose a person to dress; they were given fabric, usually a cheap cloth, and then had to design and make a costume. It was all rather haphazard. Jeannetta Cochrane would say 'let's do The Episodes'. She would help choose the models by going round the school deciding on unsuspecting students or teachers, dragging them off to be a 15th-century baron or a twenties flapper, depending on their looks. When it was discovered that Sheila Jackson could do the Charleston her costume was changed from a heavy medieval gown to a 1920s dress.[20]

The Episodes were done in one of the studios in front of an audience. The students were dressed in the costumes that had been designed and made by their colleagues. Tanya Moiseiwitsch remembers that 'we just walked on and swanked a lot – the teachers had a good giggle. The characters didn't speak. There may have been soft music being played on a

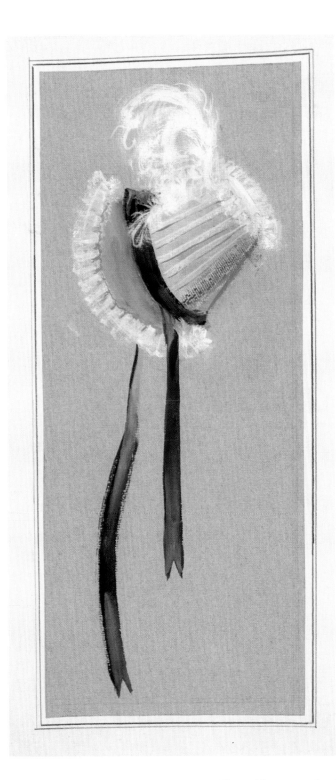

Marian Fernau
Bonnet with satin ribbons. A presentation exercise set by Sheila Jackson in the 1950s
Watercolour
410 × 170 mm
Private collection

wind-up gramophone… then we put the costumes on stands for people to walk round and look at'.[21] Sometimes The Episodes were done outside the School. During the Festival of Britain the students staged an event outside County Hall in the presence of Princess Elizabeth. Ralph Koltai remembers parading as a medieval knight at Penshurst Place. They even produced a version of The Episodes, in the early days of television, at Alexandra Palace.[22]

The 1940 prospectus mentions that there was sometimes an opportunity to do general theatrical work at London theatres. This and other practical work was already happening before this time. Sir George Clausen got the students to design and make accurate historical costumes to help him with his mural painting in the House of Lords.[23] In the early 1930s Tanya Moiseiwitsch would go out to Croydon to help Ruth Keating with her productions. When Ruth Keating designed the Tyrone Guthrie production of 'Trelawney of the Wells' at the Old Vic in the late 1930s, the students made the costumes.[24] They also made the corsets for Gielgud's production of 'Love for Love', which Jeannetta Cochrane designed.[25]

In Tanya Moiseiwitsch's time the course was firmly costume based, but she was impressed by some models exhibited by Ruth Keating, and proceeded to make one herself. When she proudly showed it to Ruth Keating it collapsed. This did not deter her and later she was encouraged by both Jeannetta Cochrane and Ruth Keating to take a two year studentship in the paint shop at the Old Vic.[26]

At this time most of the students graduating from the Central School costume course who wanted to work in the theatre went into the craft side as their skills at making costumes and props, as milliners and mask-makers, were much in demand. This work was often not credited in the programmes, even if it included designing the costumes. Alix Stone, who was a student of Jeannetta Cochrane and who taught on the theatre design course during the 1960s, had a long and varied career in theatre, film and television both as a maker of costumes and props, and as a supervisor and designer. A list of her work shows that many times she was not credited for her costume designs. Although many of the big names in theatre design in the 1930s and 1940s, such as Rex Whistler and Oliver Messel, had studied at the Slade School, there were also successful theatre designers from the Central School, such as Tanya Moiseiwitsch, Alix Stone, Morris Kestelman and Peter Williams.

Ruth Keating introduced scenic design to the course in the late 1930s. Ralph Koltai, who was a student after the War, was not interested in costume and had more or less excluded himself from the costume classes. Ruth Keating's set design classes were well established by this time. He remembers her as an excellent teacher with a good eye and sharp judgement.[27] Anthony Powell also remembers her being inspirational, opening his eyes to what lay beyond the obvious.

Jeannetta Cochrane's dream was that the students should see their work realised in a theatrical performance. She had felt for a long time that for the course to progress there

should be a theatre attached to the school with design studios, costume workrooms and a scenic workshop. She had already mentioned this wish to Peter Williams when he was her student before the Second World War.[28] After much lobbying her arguments finally persuaded the LCC education committee to build a theatre. By the mid-1950s it was agreed that a fully equipped theatre was essential to the teaching of theatre design. When Jeannetta Cochrane died suddenly in 1957, Michael Trangmar took over as head of department and continued to press forward the theatre project. It finally opened in 1964. The students designed and made the set and costumes for the opening performance of the opera 'One Man Show' by Nicholas Maw and Anthony Jacobs, commissioned by the LCC.

The theatre, which was named after Jeannetta Cochrane, was a great success. The workshops and especially the paint frame were in constant use and the stage was used for teaching as well. George Devine came in to work with the students. By getting them to walk from one given point to another on the stage he gave them a practical lesson in the dynamics of stage space.[29] It also became possible to teach students the importance of lighting design, then a relatively new discipline. When Ralph Koltai took over as head of department from Michael Trangmar he invited Ballet Rambert to make their home in the theatre. This enabled the students to experience a professional company on their doorstep, and several projects between new choreographers and the design students followed.[30] These collaborations between the theatre design course and Ballet Rambert continued in the 1970s. In 1989 the tradition of dance collaborations was revived when Pamela Howard, then directing the theatre design course, developed a new project for the third year BA Hons undergraduates. She enlisted the help of Peter Docherty, an experienced theatre and dance designer, who had trained at Central.[31] At first the project was called 'Design for Dance'

Alix Stone
'Isabella', 1962
Costume design for Judi Dench in Royal Shakespeare Company production of 'Measure for measure'
Watercolour
215 x 165 mm
Central Saint Martins Museum Collection

Theatre Design students modelling costumes they have made, mid-1950s
Photograph
Central Saint Martins Museum Collection

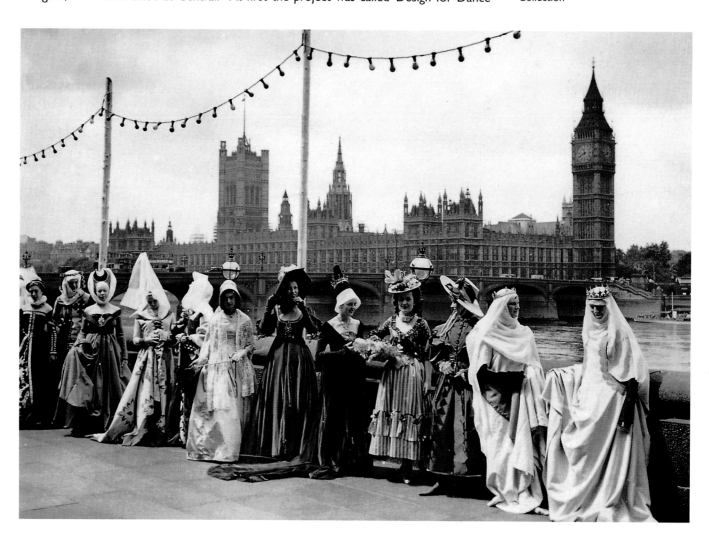

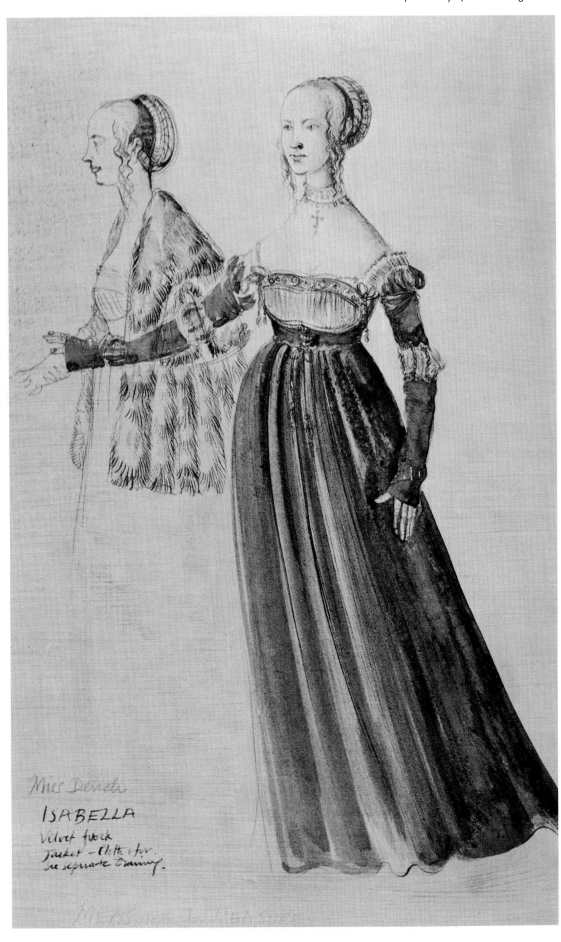

Miss Dench

ISABELLA
Velvet frock
Jacket – Cloth + fur.
See separate drawing.

but later it was renamed 'The Peter Williams Design for Dance Project' after the dance designer, writer, critic and teacher. It still continues today.

Under Michael Trangmar the course continued to be structured along the same lines as in Jeannetta Cochrane's time. During the week students had a day of history and costume cutting with Pegaret Anthony, Norah Waugh and Margaret Woodward. A day of set design was mainly spent making models with Ruth Keating and Ralph Koltai, and there were still days at the Victoria & Albert Museum for life drawing.

The philosophy of Central that teachers should continue to be practising professionals meant that the department kept a floating pool of people who could be called upon to come in and take over when one of the teaching staff got a job. Desmond Heeley was teaching prop-making and millinery. While still a student, Anthony Powell gained outside experience making props, and when Desmond Heeley was too busy with his own work to teach, Anthony Powell was asked to help out. Presentation was now taken by Geoffrey Long and Bernard Nevill. To breathe some fresh life into ideas about theatre design, Tom Fairs, a stained glass designer, was asked to come in to teach basic design. He stayed for many years, teaching drawing and later becoming third year tutor. Another influential teacher, Peter Avery, started by taking the drawing class once a week.

Michael Trangmar ran the theatre department during a time when things were rapidly changing in the theatre and elsewhere. There was a mood for innovation with the post-war generation; everything that had previously been accepted was questioned.[32] In the theatre department, costume design, always seen as a rather feminine subject, was still taught, but there was a clear shift of emphasis towards set design.

Change was in the air. In 1953 the director Joan Littlewood had taken the lease of the Theatre Royal in Stratford East. John Bury and Sean Kenny designed for the Theatre Workshop productions there. Along with Ralph Koltai they were perhaps the first in the country to move away from conventional sets with painted flats, towards new materials such as scaffolding, wood and cement. German theatre design before the the Second World War had seen a lot of experimentation and when Peter Daubney brought over the Berliner Ensemble in 1956 many of those pre-war ideas were seen in this country for the first time. Peter Daubney also started the World Theatre Season which ran from 1964 to 1973; Josef Svoboda's work was first seen in this country in the 1965 World Theatre Season. He was then commissioned by the National Theatre to design sets for the productions at the Old Vic of Ostrovsky's 'The Storm' and Chekhov's 'Three Sisters'. A whole generation of theatre designers grew up with these influential examples. American Abstract Expressionism also made an impact on theatre design.[33]

According to John Napier this change had not spread through the theatre department at Central when he came as a student in the early 1960s, and he decided to leave at the end of his first year. 'I was perplexed, coming from the discipline of sculpture which seemed to be trying to break barriers and ask fundamental philosophical questions, to be met with a form, set in aspic, which seemed to attract those more interested in decoration.'[34]

Cameron Mackintosh, the theatre producer, makes the distinction between the painter–theatre designer and the architect–theatre designer. Simply put, the one works mainly on the flat, the other in three dimensions. This was a time when great debates went on between the relative merits of the two schools. It is interesting to hear that Loudon Sainthill, a painter–theatre designer par excellence, innovative, but using traditional means, debated this issue with Ralph Koltai in front of the students, and told him he was old-fashioned and stuck in the style of continental design.[35]

When Ralph Koltai took over the department in 1966, John Napier came back to finish his studies. The theatre department changed under Koltai's regime along with the transition that was happening in the professional theatre. Koltai believes that theatre design is an art form rather than a craft.[36] This is reflected in the direction the course took at that time. Students would now concentrate more on design concepts, and perhaps less on absolute practicalities. They could spend more time experimenting with ideas, which would not

Ralph Koltai
Set design for Bernard Shaw's 'Back to Methuselah', 1969
Private collection

always be possible once they entered the real world. Set design had lost its purely decorative function and in a mainly text-based theatre, it was important to learn to find new ways of interpreting that text.

By the time I was a student in 1974 John Gunter was head of department. We were certainly given time to experiment, both in our drawn and model work and on the stage of the Jeannetta Cochrane Theatre. The craft side was not forgotten; Patrick Read taught us how to make props, Tex Greenwood showed us how to build sets, and Judy Lloyd-Rogers helped us make costumes. We still had life classes and Mrs Anthony was still teaching the history of costume with the help of Norah Waugh's wonderful dress collection, which was still there and a most valuable resource for students. Even though more time was spent working on set design than on costumes by this time, it is interesting that the latest recipient of the Oscar for best costume design is Sandy Powell, who was then a student on the theatre design course.

The department was enormously influential and innovative in both costume and set design, and as it gained in reputation people came from all over the world to study under Jeannetta Cochrane, Michael Trangmar and Ralph Koltai. Other professionals, such as dress historians Diana de Marly and Geoffrey Squires, and the directors Mike Leigh and John Copley, also trained here as theatre designers. The list of theatre, television and film designers who started at the Central School, such as Maria Bjornson, Sue Blane, David Fielding, Eileen Diss, and Bob Ringwood, is extraordinarily impressive. They in their turn have been a great influence on the following generations, thus perpetuating Jeannetta Cochrane's teaching.

1 *Jeannetta Cochrane 1882–1957, The opening of the Jeannetta Cochrane Theatre. One man show*, theatre programme, 12 November 1964.

2 Peter Docherty and Tim White, eds., *Design for performance*, Lund Humphries, 1996, p. 34.

3 *Jeannetta Cochrane 1882–1957, The opening of the Jeannetta Cochrane Theatre. One man show*, theatre programme, 12 November 1964.

4 Hilda Bird, 'Theo Moorman', *Quarterly Journal of the Guilds of Weavers, Spinners and Dyers*, Autumn 1969, no. 71.

5 Interview with Pegaret Anthony, 3 May 1999.

6 Peter Docherty and Tim White, eds, *Design for performance*, Lund Humphries, 1996, p. 37.

7 Diana de Marly, *Costume on the stage*, Batsford, 1982, p. 69.

8 Ernest Short, *Sixty years of theatre*, Eyre & Spottiswoode, 1951, p. 26.

9 Peter Docherty and Tim White, eds, *Design for performance*, Lund Humphries, 1996, p. 34.

10 Interview with Tanya Moiseiwitsch, 16 June 1999.

11 Interview with Peter Avery, 26 May 1999.

12 Interview with Sheila Jackson, 21 June 1999.

13 Interview with Patrick Read, 15 July 1999.

14 Three books by Norah Waugh: *Corsets and crinolines*, Batsford, 1954, *The cut of men's clothes*, Faber, 1964, and *The cut of women's clothes, 1600–1930*, Faber, 1968.

15 Interview with David Walker

16 *The Margaret Woodward Prize*, The Theatre Design Trust, Central School of Art and Design, n.d., p. 1.

16 Interview with Anthony Powell, 26 July 1999.

17 Interview with Tanya Moiseiwitsch, 16 June 1999.

18 Interview with Lyn Avery, 2 May 1999.

19 Interview with Marian Fernau, 19 October 1999.

20 Interview with Sheila Jackson, 21 June 1999.

21 Peter Docherty and Tim White, eds, *Design for performance*, Lund Humphries, 1996, p. 36.

22 Interview with Pegaret Anthony, 3 May 1999.

23 'The LCC Central School of Arts and Crafts', *The Arts and Crafts*, November 1927, p. 7.

24 Interview with Pegaret Anthony, 3 May 1999.

25 Interview with Tanya Moiseiwitsch, 16 June 1999.

26 Interview with Tanya Moiseiwitsch, 16 June 1999.

27 Interview with Ralph Koltai, 15 June 1999.

28 Peter Docherty and Tim White, eds, *Design for performance*, Lund Humphries, 1996, p. 39.

29 Interview with Peter Docherty, 7 July 1999.

30 Peter Docherty and Tim White, eds, *Design for performance*, Lund Humphries, 1996, p. 44.

31 Peter Docherty and Tim White, eds, *Design for performance*, Lund Humphries, 1996, p. 56.

32 Interview with Anthony Powell, 26 July 1999

33 Interview with Peter Avery, 26 May 1999

34 Sylvia Backemeyer, ed., *Ralph Koltai*, Lund Humphries, 1997, p. 12.

35 Interview with Peter Docherty, 7 July 1999.

36 Interview with Ralph Koltai, 15 June 1999.

Enid Marx at the Central School in the 1920s

Cynthia R. Weaver

Cynthia R. Weaver is a Senior Lecturer at the University of Central England where she specialises in twentieth century dress and textiles. She has undertaken extensive research on Enid Marx and is a contributor to Antique Collecting, Craft, Fiberarts, *and the* Journal of Design History.

The academic year 1921–2 at the Central School of Arts & Crafts saw Enid Marx's initiation as a student of art and design. Sandwiched between her educational experiences at Roedean School in Sussex (September 1916 to July 1921) and her progression late in 1922 (until 1925) to the Painting School at the Royal College of Art, Marx's time at Central proved to be a formative year in her career as an important multidisciplinary designer of 1930's Britain. Best known during her lifetime for her hand-block printing on paper and on fabric, mainly for a customised market, Marx went on to design many patterns for repeat production: upholstery fabrics for the Underground trains in the 1930s and 1940s (some in service into the 1960s), furniture cladding for the government's wartime Utility scheme (from 1943–8), and (in the 1950s), vignettes, book jackets and designs for the stamps issued on Queen Elizabeth II's accession. The stamps had the widest circulation of all her work and remained in use until 1967.

In the mid-1980s Marx recalled her time at Roedean and how she came to study at Central.

> In the art department at Roedean I cut some paper stencils to print a scarf… The department was excellent; it was run by a painter, Dorothy Martin, and a calligrapher, Miss Talbot. We had life classes, went out sketching, did architectural and plant drawing, leather work and carpenting [sic]. In spite of it being a good foundation course I failed at my first attempt to get into the RCA. Instead I put in a year at the Central School… doing a mixed course including pottery.[1]

Enid Marx
'Shield'
Uncut moquette upholstery for London transport, 1937
© London Transport

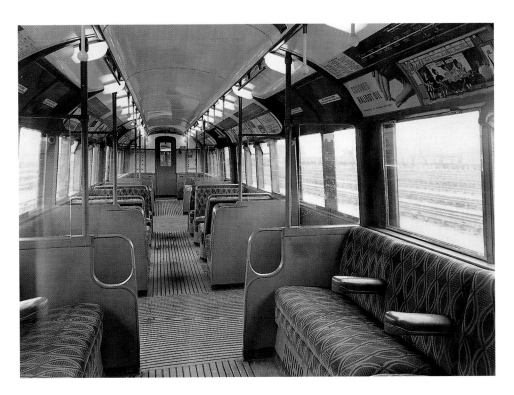

Initially Marx was disappointed at her rejection by the Royal College, but she came later to realise that the clear difference in emphasis between Central and the Royal College of Art made it helpful to have experienced both. By the early 1920s there was already a significant movement of staff and students between the two establishments. Some part-time staff are known to have worked simultaneously for both, and some of Marx's contemporaries followed a similar educational route to her own. Add to this the acknowledged lineage of tutor–student–tutor–student which also at times crossed the divide between the Royal College and the Central

School, and it becomes clear that the respective disciplines of each could be seen to be complementary.

In and around Central

At Central Marx met for the first time a range of personalities and practices which helped lay the foundations for a remarkable professional life spanning seven decades. She took full advantage of the siting of the School within an area of London ripe for exploration by the young and curious. Breaks from formal learning were often spent at the Poetry Bookshop at 35 Devonshire Street, established in 1913 and run by the poet, publisher and bookseller Harold Monro ('and his beautiful wife'). There the 19-year-old Marx listened to readings and bought broadsheets and booklets decorated by the artist–designer Claud Lovat Fraser whose work, in particular his designs for 'The Beggar's Opera' at the Lyric Theatre Hammersmith, and the pattern papers and textiles for Liberty's, she came to admire. Monro's shop, where plays were also enacted, generated a progressive and social ambience. In 1920, the year prior to Marx's introduction to the Bookshop circle, Harold Curwen's private press published a promotional leaflet *Get the spirit of joy into printed things* illustrated by Fraser. This was an early example of a successful collaboration between a private press and a contemporary independent artist, and it made a lasting impression on her. (A year earlier in 1920, designs by Fraser formed the basis of the Curwen Press series of 'pattern[ed] papers' for use as bookbindings, covers and end papers. Marx, along with others in her RCA coterie, later designed engravings for this range.

Lunchtimes at Central were sometimes spent visiting the British Museum, her favourite over many years and 'the Savage Gallery' (now the Museum of Mankind). To Marx the student, this collection had seemed more inspiring then than later. Looking back on the 1920s she described the museum as 'one long magnificent gallery with beautiful prints on bark-cloth, leather puppets from Java and inlaid wood carvings decorated with shells. All this could be seen in one long exhilarating visit'.[2] This early influence of the unsophisticated and the primitive in art, became a key to Marx's work and helped lead to her subsequent, self-appointed mission as chief promoter of our *arts populaire*. Marx illustrated and co-authored with her lifetime companion Margaret Lambert, *English popular and traditional art* (Collins, 1946), and *English popular art* (Batsford, 1951).

Enid Marx
Cover design for *The pick of Punch*, summer 1951, Chatto and Windus
275 x 200 mm
Private collection

At Central: Marx on paper and cloth

At Roedean, from the age of 13, Marx had studied in an atmosphere of 'wartime monastic austerity', alongside Bridget and Priscilla Johnston, whose father Edward Johnston later taught Marx calligraphy. Remarkably, according to Marx, Johnston forbade his offspring from taking part in drawing lessons at Roedean though Priscilla's apparent inclination toward fine art was manifested there through the reproduction of one of her 'romantic drawings' in the house magazine of Number One House, whose young art editor was Marx. Through their mutual involvement with this periodical, and the annual House productions of Gilbert and Sullivan, the three girls got to know each other well. Marx also knew these sisters' 'devoted mother' who regularly walked to Roedean across the Sussex Downs from the family home at Ditchling, bringing with her a huge black bag of welcome food.

Marx the raconteur enjoyed telling and re-telling a seemingly endless supply of stories about Johnston whom she perceived as 'tortoise-like, a perfectionist', appearing somehow to function in slow motion. Marx said, 'calligraphy under Johnston was torture', and 'where Johnston was concerned, *everything* was in slow motion'. Marx outlined this penman's ritualistic teaching practices that students witnessed. Each student was visited, a fresh quill cut and sharpened, and then 'experimental flourishes off the paper' were made, 'like a golfer tee-ing up'. In Johnston's case these practice strokes were repeated – repeatedly! – before he would even consider putting quill to ink or committing himself to paper.

A second of Marx's Johnston tales centres around her own impromptu visit to the Ditchling house after her days at Central were over. Still regarding Johnston as her master, Marx was embarrassed on arrival to find him the only family member at home that day. Politely, Edward invited her in to take tea and await the girls' return. Marx, slightly awkwardly, acquiesced. Then, to her surprise, Johnston disappeared into the garden and began, with his customary extreme slowness, to gather

Enid Marx
'Cornucopia', c. 1929
Wood engraving
223 x 140 mm
Central Saint Martins Museum
Collection

sticks with which he next lit a small fire and onto which, eventually, he sat a kettleful of water for boiling. Finally, one hour later, Johnston and Marx took tea! In the self-conscious wait which had preceded, Johnston proudly showed her a small writing desk lovingly crafted by himself. Familiar with the man and his meticulous nature she indulged in speculation as to how many of Johnston's long, slow hours such an *œuvre* had taken to complete.

Mutual acquaintances also passed on to Marx stories about Johnston, and she, in turn, delighted in spreading them further still. One favoured narrative concerned an important commission Johnston had received, well in advance of its deadline, to script an address for presentation on a specified date to His Majesty King George V. Failing to complete the task until the evening prior to the ceremony, the letterer is said to have stood at the gate of his Sussex home, flagged down the first car to come along and then, quite blatantly, requested of the stranger-occupants that they deliver his manuscript to Buckingham Palace, post-haste. To the surprise of everyone but Johnston, these obliging unknowns apparently did just that.

There were also, on occasion, compensations for Marx when visiting the Johnstons, for it was on one such venture that she first saw the St Dominic's, a hand-press set up by Eric Gill, illustrator, contemporary typographer, and an ex-student of Johnston's, in association with 'that poet, printer, and most ardent of catholics', Hilary Pepler. St Dominic's Press was Gill's attempt to perpetuate the waning tradition of English private hand-press books illustrated with wood-engravings, and there at Ditchling, each and every process was wrought by hand. Already enthralled by hand processes whilst at Central, at St Dominic's Marx eagerly met Gill, and had engravings and booklets sold to her cheaply by Pepler.

Enid Marx
Linen designed and block printed, mid-1920s
Exhibited at the Victoria and Albert Museum in 1926 and the Leipzig Arts and Crafts Exhibition in 1927
Courtesy Warner Fabrics plc

Commensurate with Central's policy of employing only skilled practitioners as educators, between 1921–2 Marx studied life-drawing under Meninsky and textile design under the aegis of both Lindsay P. Butterfield ('an uninspired teacher but an excellent textile designer') and Bernard Adeney, a member of the London group of painters and friend of the influential art critic, artist and designer, Roger Fry. Marx recollected that Adeney had designed textiles for the Omega Workshops, initiated in London by Fry. Butterfield, renowned for his floral patterned cloths (especially in collaboration with the fabric printers Turnbull and Stockdale) was described by Marx as 'one of Liberty's foremost designers'. But despite all of this, Central in Marx's day did not teach the pragmatics and techniques of transferring marks onto cloth. At the start of the 1920s 'there were no practical classes in textile design anywhere in the country' Marx later recalled. At Central, as elsewhere, 'textile design remained a paper exercise only'. At Central, Marx's works on paper were likened by Adeney to those of the artist William Blake, though until then Marx 'had never heard of him', an anecdote she later rephrased (in her 1984 letter to the Victoria & Albert Museum Print Department) as 'Adeney introduced me to the work of William Blake at the Tate Gallery'.

At Central: pots and potters

Well remembered for her work in two dimensions, when she entered Central Marx was no stranger either to the third design dimension. Roedean had fostered sensibilities and sensitivities in both two and three dimensions. Marx remained particularly grateful for the opportunity there to practice her hands-on, craft-based skills in the 'carpy's [carpenter's] shed' where she learned how to mark mortice and tenon joints and received instruction

on how to sharpen tools, the latter proving invaluable to Marx the developing engraver and block cutter.

Compared to Marx's, at times, frustrating studies in textile design, time spent in the pottery workshops at Central (headed by a former RCA student, Dora Billington), was looked on favourably as 'quite to the contrary'. Between 1912–15 Billington had worked in the Stoke-on-Trent studio of the artist–chemist Bernard Moore, where artists were employed on the decoration of earthenware and porcelain blanks. Billington would have carried with her from that time her observation of Moore's scientific approach to experimental glaze effects, but his practice of buying in pottery bodies offered his workforce little experience of ceramic manufacture. At Central therefore Billington was ably assisted by 'the Wizard Mr. Askew', a retired employee from the Potteries, experienced in pottery construction. Askew had a sense of humour and together with his technical prowess, he engaged and entertained the students. 'In a jiffy Askew would build up a fine bowl on the wheel. Then, as if by sleight of hand, he could transform it into a cauliflower before our very eyes', Marx recalled. Operating within this environment, Marx enjoyed throwing pots, or rather 'attempting to', but *decorating* pots she found to be problematic, an interesting 'problem' for a student later awarded the title of Royal Designer for Industry for Pattern Design (in 1944). When a student at Central Marx was 'dumbfounded' to sell her 'one and only' successful pot for seven shillings and sixpence ('a lot of money then') at the annual sale of students' goods.

In Billington's pottery class Marx met her 'life-long friend' 'Beano', the studio potter Katherine Pleydell-Bouverie. During the First World War Beano had driven an ambulance as a volunteer in France but had quit that service following the death of her brother (whose army belt, Marx observed, Beano always wore while a student at Central). In 1921 Beano had enrolled at Central for evening classes only but converted to full-time education two years later after the master potter Bernard Leach refused her request to join his studio, on the grounds of her inexperience. The friendship between Beano and Marx represented the beginning of a complex chain of influential encounters for the latter. After Central, Pleydell-Bouverie was finally, in 1924, allowed by Leach to study ceramics at his St Ives studio in Cornwall. There Beano later met the artist–potter Norah Braden, also a former student at Central (1919–21) who worked alongside Leach between 1925–8. By 1925 Braden was also known to Marx from the RCA Painting School where they had studied side-by-side (Braden from 1921–4). It is Braden whom Marx credits with having got her 'interested in the idea of applying my love for pattern and texture from wood engraving to cutting blocks for printing [onto] textiles'. Braden also introduced Marx to a London exhibition of hand-block printed fabrics designed and produced in the Hampstead studio–workshop of Phyllis Barron and Dorothy Larcher, a visit which resulted in these two women agreeing to Marx being apprenticed to them for one year (1925–6) to learn the practical side of printing and dyeing. Only later did Marx realise that Barron and Larcher shared a house with Bernard Adeney and his family.

In 1925 Beano left St Ives to set up an experimental pottery at the Mill Cottage on the Bouverie's Coleshill estate in Berkshire, jointly with a former Central sculpture student, Ada ('Peter') Mason. In 1928 after Mason emigrated to America, Braden took over as partner at the Mill, but by then Marx's earlier visits to Cornwall had already triggered another important alliance, that between Marx and another of Leach's co-workers (from 1923–5), the eminent ceramist, Michael Cardew. 'We all became firm friends', Marx wrote. Later on, at Cardew's first independent studio (in Winchcombe, Gloucestershire), this potter 'kindly shared with [Marx] his rural retreat' at a time when she 'most needed it'. At Winchcombe Marx also met the Japanese potter, Shoji Hamada of Kyoto (also an associate of Leach's), and his friend, Yanagi. This encounter reinforced Marx's respect for the 'Japanese colour range of indigos, blues, browns and buffs, interspersed with blacks, 'spicy colours'.[3] This palette is now familiar to us as one favoured by Marx when printing her own designs onto fabric during the 1920s and 1930s, and is another indirect legacy of her time at Central.

At the Royal College

Marx's year at Central culminated in her being accepted into the RCA Painting School. Back then 'it was simply unacceptable to be in any other'. There, despite Sir Frank Short refusing her entry to his wood-engraving class on the grounds that she drew so badly, Marx was 'brought alive for the next three years', mainly through her association with fellow scholars and Paul Nash, part-time tutor in the RCA Design School. As Marx later observed 'as all students do, we educated each other'.[4] Marx's enthusiastic period of learning at the RCA came to a bathetic end when in 1925 she failed her Final Assessment along with her student colleague, the illustrator and typographer Barnett Freedman, who, ironically, was later appointed painting instructor at the RCA. Marx forfeited her College Diploma because the subject of her painting, a fairground scene, was deemed too vulgar for the so-called 'fine arts' by one of the examiners, the artist-printer Charles Ricketts. James Holland, who studied at the RCA Painting School from 1924 and knew Marx well, later celebrated her as 'clearly one of the outstanding students of her year... a friend of Freedman and the circle which that remarkable personality attracted. These were 'The Fauves', in contrast to the traditional Italianate group; Marx was by College standards avant-garde'. In 1925 when the failed Marx left the RCA, 'Will' Rothenstein ('Rothy') was College principal. In Marx's first year at the RCA, 1922, 'Rothy' had additionally been appointed (acting) professor of the Painting School. Years later in 1986, Holland wrote to me that Rothenstein had been 'certainly aware of the more independent students of [Marx's] year'. The legendary RCA 'Class of 22' also included the artist-illustrators Edward Bawden and Eric Ravilious, and, prophetically, Rothy had pointed out at the time that it was 'always the most outstanding students who were likely to fail'.[5]

Conclusion

Twenty-five years after Marx's time at Central, in the review of education which followed the Second World War, the British system of schooling in the visual arts came under scrutiny. The resulting report stated that the RCA had, for the past 50 years, failed both in its teaching of design and the crafts and in its preparation of designers for industry, whereas Central 'under the direction of Prof. W. R. Lethaby, its first principal, aided by the brilliant staff of well-known craftsmen he gathered round him', had succeeded in establishing a sound reputation through its policy – from the outset – of only employing as teachers 'practising artists and craftsmen'. By 1946, the year in which the artist and wood-engraver Noel Rooke, an ex-student of Lethaby's at Central, retired after forty years of service, the *Enquiry* was able to assert that 'the work of the [Central] School had a considerable influence, particularly on metalwork, book-production and lettering, at home and on the Continent'. Furthermore it concluded, Central was better equipped than the RCA, and its training 'more realistic'.[6] The reference here to book-production is especially pertinent to one direction in which Marx's career was to go. The year 1946 also saw Marx's inauguration as a member of the Society of Industrial Artists & Designers.

In spite of this critical mid-1940s report, a decade later Marx still feared for the future of our British art- and design-training systems which she said were at the mercy of those who 'shunned differentness' and equated 'incompetence with experimentation'. Marx's own appreciation of the blend of painting, drawing, design and craft-based skills that she learned as a student at Central never waned. In a letter to *The Times* in 1956 signed 'Yours Neither Round Nor Square', Marx wrote:

Being one of the only two members of my year... to fail [at the RCA]... (the other is now a distinguished professor of art), I feel exceptionally well qualified to endorse... the futility of examinations in painting. But I must quarrel with the assumption that painters need no longer know anatomy and perspective... How can anyone express themselves freely if they do not know how to draw... It is on a par with wanting to write free verse, without knowing the alphabet... to drop 'fine art' from the

curriculum might well prove disastrous to the 'applied arts'… The painting and drawing from life which I learned as a student have provided an essential discipline which I return to'.[7]

In their attempt to deliver quality products at a time of shortage of materials, the British government of the early 1940s launched their 'Utility' design initiative. Robert Gooden, at the time exploring alternative materials for use in furniture construction, served alongside Marx as a member of the Design Advisory Panel. Gooden who had observed Marx through the many phases of her career noticed that what gave her the greatest satisfaction was when 'what her imagination suggested to her became a reality for hundreds of thousands of others to enjoy'.[8] Gooden was right. It is Marx's unrelenting promotion of 'art in daily use', essentially the philosophy of the Central School in her day, that renders so vital Marx's unique and enthusiastic contribution to the re-flowering of the arts in 20th-century Britain. At the end of an interview, also in 1986, Marx, by then a Fellow of the Royal Society of Arts, a Royal Designer for Industry, Fellow of the Society of Industrial Artists & Designers, member of the Society of Wood Engravers, and Hon. Fellow of the RCA, avowed: 'As a designer, above all else, I think one feels that one wants to be used'. One can picture Lethaby's approval.

Marx's hearty endeavours in pursuit of her art and her craft persisted well into the 1990s. That neither her enthusiasm, nor her down-to-earth approach dwindled is shown in the opening lines of a letter dated August 1992. At the time she was resting in Dorset from preparations for the 'Enid Marx and her Circle' exhibition, scheduled to celebrate her

Enid Marx
'Melons', 1960s
Linocut
355 x 510 mm
Private collection

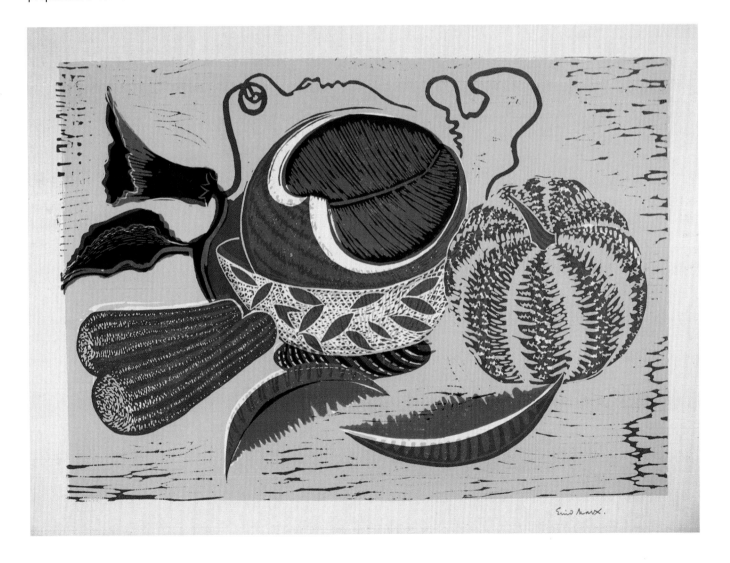

becoming a nonagenarian in October of that year. The missive begins 'My dear Cynthia… I came away just exhausted from designing a 54-inch shawl for Sally [Hunter] for the show… the designing was great fun – but I'm worried about the production'.

The teenage Marx was, at first, disappointed by her 1921 rejection at the hands of the RCA, and disillusioned by her declared 'failure' there four years later. But Marx's exclusion from the College resulted in the sound grounding she received at Central. Marx came later to realise that the difference in emphasis between the Royal College of Art and the Central School of Arts and Crafts, clearly articulated in their titles, made it very valuable for her to have experienced both.

1 Marx, manuscript letter to 'Mr Coutts, Victoria & Albert Museum Print Department', April 1984, pp. 3–4. Marx's other comments incorporated in this chapter, unless otherwise referenced, were expressed in conversations or communications to the author, mostly during the period 1984–94.
2 Marx, letter to the V & A, op. cit., p. 4.
3 Letter to V & A, p. 4.
4 Letter to V & A, p. 2.
5 James Holland, letter to the author, 30 July 1986.
6 *The Visual Arts: a report sponsored by the Dartington Hall Trustees*, published on behalf of The Arts Enquiry by Political and Economic Planning, Geoffrey Cumberledge, Oxford University Press, March 1946, pp. 85–9. Referred to within the text as 'the Enquiry'.
7 Marx, letter to *The Times*, 30 June 1956, p. 7.
8 Prof. Robert Goodden, letter to the author, 6 July 1986.

Spreading the word

Mary Schoeser

It has been said that without the Central School there would have been no Bauhaus. While the author of this statement has yet to be identified, there is little doubt, as the preceding essays have shown, that the Central was influential in fields as diverse as fine book production and theatre design; that it was founded to bring together industry, artistry and craftsmanship; and that its existence was known about in Germany.[1] Whatever the case, it seems much more certain that without Central there would have been no Crafts Centre of Great Britain, founded in 1948 and itself contributing to the creation of the present-day Crafts Council. How Central exercised such sustained influence, through substantial changes in staff and curricula between its foundation in 1896 and the introduction of the National Design Diploma (NDD) in the 1960s, is the subject of this chapter.

In 1884, when he was twenty-seven years old, Lethaby was instrumental in the creation of the Art-Workers' Guild. This gave birth to the Arts & Crafts Exhibition Society in 1888 with Lethaby a member of its first committee. It was given its name by T. J. Cobden Sanderson. The Art-Workers' Guild provided a forum for contact, communication and debate, while the Arts & Crafts Exhibition Society promoted the objects under discussion. Although, as we now know, both groups are deemed by many to have lost their influence in the years following the First World War, in both cases the desire for quality in everyday objects was undisputed, as was the recognition of the importance of both artistic sensibilities in skilled making as well as 'friendly understanding among a large body of otherwise isolated craftsmen'.[2] Perhaps more importantly, in many respects Central itself could be described as another off-shoot of the Art-Workers' Guild, being the answer to what John Dando Sedding described as essential in an address to the Guild in December 1886:

Jeannetta Cochrane
Display of fabric and embroidery designs made for Heal's craft studio, 1920s
Photograph
Central Saint Martins Museum
Collection

If we rest content with social meetings for self-improvement, we are doomed to effacement at no distant date… I foresee that unless we can establish a school for practical work of some sort, either within or beyond the lines of the Guild as now constituted, we shall not only be incapable of effective proselytism, but shall fail in any attempt at public existence and end by gradual exhaustion.[3]

Sedding's early death in 1891, aged fifty-three, denied him the chance to see such a school created. In Lethaby, Central was set on its course by someone trained in the prolific and influential office of George Edmund Street whose assistants and pupils included William Burges, Philip Webb, Richard Norman Shaw, Selwyn Image, William Morris and Sedding himself. This training exposed Lethaby to the widespread aesthetic and social impact of active idealism, as demonstrated in the numerous new religious communities and associated societies (and the buildings that housed them) that came into being in the third quarter of the 19th century.[4] For example, when he became joint principal of the Central School, Lethaby brought to it not only many members of the Art-Workers' Guild as teachers, themselves by definition inclined towards social reform through the cross-fertilisation of ideas and group effort, but the personal experience of this and other guilds, communities and societies active during the previous fifteen years. It therefore seems no coincidence that in Lethaby's lifetime, former students and staff of the Central contributed significantly to the formation and running of many of the most influential new societies that sprang up in the inter-war years to support makers and promote their work, taking up the banner first flown by the Art-Workers' Guild. Some, such as the Guild (now Guilds) of Weavers, Spinners & Dyers, still exist independently today. Others amalgamated into what ultimately became today's Crafts Council.

The commitment to the preservation of dying craft skills was allied at the Central School to the promotion of new applications of these skills in both craft and craft-based design. On the surface these might be seen as conflicting aims, but they co-existed as brothers, nurtured in the same environment and sharing the same parentage. For meanwhile, Lethaby, who was still giving occasional lectures at the Central, became 'the father figure' of the Design and Industries Association (DIA), which in 1914 brought together craftsmen, designers, educators, architects, manufacturers and – importantly – retailers. Among them was Ambrose Heal, the first treasurer and quite probably one of the retailers who sent assistants to study salesmanship at the Central (see 'Following the thread: textiles').[5] Others on the first council included James Morton, Frank Warner and Charles F. Sixsmith, all of whom had varying degrees of contact with the Central textile department. Early members included others who were advisors, governors or purchasers of designs by students and staff: Noel Carrington, Harold Curwen, William Foxton, Crofton Gane, Charles Holden, Frank Pick and the silversmith Harold Stabler (with Ernest Jackson the instigator, in 1914, of the 'committee of seven' from which grew the DIA). Central, it seems, was a place where many of the DIA members felt at home.

Evidence of the practical application of the Central spirit can be found among those who became 'shopkeepers'. For example, the china and glass importing firm Merchant Adventurers Ltd was purchased by Antoinette and Daniel Boissevain in 1924. Antoinette had not long before studied at Central as a painter and was to emerge as a lighting designer in the 1930s. Such selling outlets were important, particularly against a background of trade depressions at both the beginning and end of the 1920s.[6] The five earliest – and perhaps most lasting in their influence, each with their different points of attack – were the studio for painted decoration and embroidery at Heal's (opened in about 1915 by Jeannetta Cochrane); the annual fairs of the Red Rose Guild from 1920, discussed below; Dorothy Hutton's London shop, the Three Shields Gallery (opened in 1922); and Modern Textiles (1926–39),

Joyce Clissold
Soft card carrier bag, 1930s
Hand block printed by Footprints
300 x 300 mm
Central Saint Martins Museum
Collection

another London shop, with a textile printing workshop attached and masterminded by Elspeth Ann Little, who also trained at Central. Hutton's Three Shields Gallery gave birth to the other influential London craft shop of the 1920s, the Little Gallery, opened in 1928 by Muriel Rose, Hutton's assistant from 1922 to 1927. Modern Textiles gave life to Footprints, which gained independence when taken over in 1929 by Joyce Clissold, a mid-1920s Central student, who was to open two of her own, specialist, London shops in the 1930s. Among the Central staff and ex-students promoted by these retailers were Enid Marx, Alice Hindson, Casty Cockerell, E.F. Jackson, Noel Rooke, Vivien Gribble, Marjorie Turberville, Norah Braden and Katherine Pleydell-Bouverie, as well as many others. Smaller in scale, London studio–workshops also fed the inter-war appetite for well designed goods. At the Sign of the Falcon was H. G. Murphy's Weymouth Street studio; At the Sign of the Rainbow was Margaret Calkin James's. For much of her time as a designer, Calkin James worked from a studio in her home, as did Cockerell (daughter of Douglas Cockerell, and a jeweller and contemporary of Clissold), who also took in students. These enterprises are, to a greater or lesser degree, already documented.[7] What is perhaps less well known is the breadth of work of Hutton herself, who had begun her studentship in 1914 and maintained her gallery until 1945, when it changed hands. A highly regarded illuminator and letterer, she was also a lithographer and maker of then sought-after hand-painted Christmas cards and calendars, as well as a textile designer; her work was both hand and machine-made.[8] Also only sketchily documented is the role of Jeannetta

Margaret Calkin James
Shop sign for the Rainbow Workshop
Published in *Design for modern industry: the year book of the Design and Industries Association*, 1922
Central Saint Martins Museum Collection

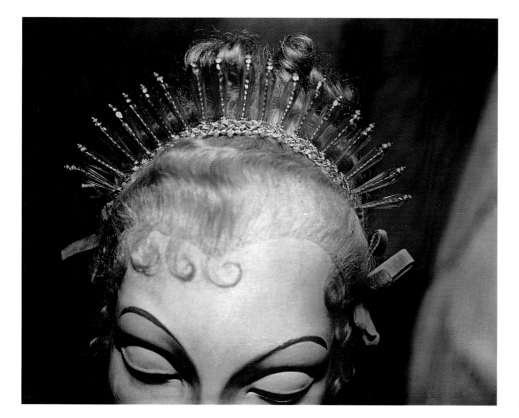

Catherine Cockerell
Tiara shown at the British Art in Industry exhibition at the Royal Academy, 1935
Courtesy the Archive of the Royal Society of Arts

Cochrane at Heal's. There Miss M. Hindshaw was responsible for the painted furniture; at Central she taught drawing and painting, specialising in china painting, from 1908 until at least 1936. Dorothy Dix was responsible for the embroidery[9] and, from 1928 to 1930, Theo Moorman wove rugs and throws there, at Cochrane's instigation. For some years afterwards both textile and furniture designs passed with regularity from Central staff and students into Heal's ranges. Merging with the entrepreneurial spirit encouraged at the School, these twin *raisons d'être* – old skills and new applications – not only gave birth to societies, but also gradually contributed to more permanent showcases: private presses, shops, galleries, and workshops. By the time Terence Conran studied textiles at Central in the late 1940s, there was no need to question the validity of retailing as a vehicle for creative expression. This philosophy also contributed to the development of craft and design courses elsewhere, to the concept of design consultancies, and ultimately influenced policy and practice in a myriad of ways.

The formation of the Craft Centre of Great Britain between 1946 and 1948 is a good example of these influences. It was initiated by a council representing five societies formed to set up a London-based centre for crafts. The five societies were the Arts & Crafts Exhibition Society, the Red Rose Guild, the Society of Scribes & Illuminators, the Senefelder Club and the Society of Wood Engravers. Of these, only the first pre-dated the foundation of the Central School, and many staff and students remained or became exhibitors. Among the eight presidents serving the Exhibition Society from 1915 to 1953, six were Central principals or staff, their terms of office covering all but seven of those thirty-nine years.[10] The other four societies, arguably, would not have existed but for the Central School.

As has already been noted, the Senefelder Club (founded 1908) and the Society of Wood Engravers (founded 1920) had a high proportion of Central staff and students among their founders, committee members and participants. For the Society of Scribes & Illuminators (founded 1921), there were similarly strong links, for 'in its beginnings the Society was largely a student body, with many of its members associated with the Central School of Arts & Crafts'.[11] The Red Rose Guild had its origins in a 1920 exhibition for Northern craftsmen living in London, held at the Houldsworth Hall in Manchester and organised by Margaret Pilkington with the assistance of Kathleen Smartt[12] and Dorothy Hutton, a friend from Pilkington's days at Central in 1914, both having been students of wood-engraving under Noel Rooke, who, with Lethaby, supported the enterprise. In 1921 the Guild was officially

Terence Conran
'Portal', 1960
Hand screenprinted wallpaper
designed for Modus
Central Saint Martins Museum
Collection

instituted and launched its annual selling exhibition, which soon, and for some 30 years (there were none from 1940 to 1946, although some small displays were organised), was regarded as the most influential national outlet for makers. Initially styled the Red Rose Guild of Art Workers, its inclusion of printmakers was defining for the crafts of this period. It aimed, too, to pair purchasers with makers, succeeding on many occasions, particularly with the Manchester Art Galleries committee. Often the final arbiter of their selection committee and a seemingly tireless organiser, Pilkington remained its driving force for much of that time.[13]

The Crafts Centre had a chequered career, attributed in part to 'an unwieldy quarrelsome council representing five interest groups' as well as to financial difficulties.[14] But although today the five founding societies might seem odd bed-fellows, they were closely linked in two ways: through the people involved, and by their shared concept of craft and of the means of supporting makers. Pilkington, for example, had served as secretary of the Society of Wood Engravers for over ten years, having also taken responsibility, with two others in 1924, for the selection and hanging of their regular exhibitions, before becoming chairman from 1952 to 1967. She

Dorothy Hutton
Hand-printed tissue designed for
W. Foxton
The Studio Yearbook, 1919
Central Saint Martins Museum
Collection

was dedicated to the society's cause and did more than anyone to spread the word out of London by promoting exhibitions in the provinces and abroad. From a wealthy Manchester family, she was quiet, unassuming, and exceptionally generous both to wood-engravers and craftsmen… helping to keep the Society of Wood Engravers afloat through financially difficult years. As a Governor from 1925 and later (1935–59) Honorary Director of the [now University of Manchester's] Whitworth Art Gallery, she was responsible for the society's liaison with the gallery where its annual exhibitions were held for some years.[15]

Farleigh, already by the 1940s a respected and influential writer and broadcaster on

design, craft, book production and illustration, had joined the Society of Wood Engravers in 1925. Further, from 1940 to 1949 he was President of the Arts & Crafts Exhibition Society and, as such, represented them on the committee formed in 1940 to devise the Exhibition of Modern British Crafts, which travelled to the United States and the Dominions from 1942 under the aegis of the British Council, with the support of the war-time creation, the Central Institute of Art and Design (CIAD). The Red Rose Guild was also involved in the selection of exhibits. Their representative was a committee member, Bernard Leach, who with Pilkington and Harry Norris (furniture maker and editor of *Crafts*, the Red Rose Guild journal, from its first edition in 1940 until 1946) also represented the Guild on a joint committee formed with the Arts & Crafts Exhibition Society in January 1943. Farleigh chaired the joint committee. He, Pilkington and Leach were also on the CIAD committee as representatives of three of the forty-odd societies it served; so too were others with Central connections, including Dora Billington and Edward Barnsley.[16]

It seemed as if the need to pool resources and ensure the survival of the crafts would lead naturally to a new body to serve all concerned. But this was not to be. As a result of the 1942 CIAD exhibition, Leach in the end was embroiled in an irreconcilable argument with Harry Norris and in mid-1943 left the Red Rose Guild committee and all the others he had served as its representative, despite Pilkington's attempts to avert the break. One can only conjecture that the potential cohesion represented by the CIAD, a voluntary organisation, was splintered, at least in part, by this rift. So when, in 1946, the five societies came together for a series of meetings at the Central School to form the Crafts Centre of Great Britain, their membership represented the long-standing strengths of Central: mark making and the championing of crafts. Farleigh was designated Chairman, a position he held until 1964. Pilkington and Norris served on the council; Dora Billington replaced Farleigh as President of the Arts & Crafts Exhibition Society. The CIAD was wound down in 1948 and was effectively replaced by the Crafts Centre.

Given their prominent role, it is worth pausing for a moment to consider the views of some of the main players. John Farleigh had urged the Arts & Crafts Exhibition Society in 1933 'towards a belief that the craftsman was destined to be the pacemaker of design in industry'.[17] Four years later he declared that 'any member who refused to design for machine production was without social conscience'.[18] Although he was later to move away from this line with regard to the activities of the Exhibition Society itself, in 1950, the year of the opening of the Crafts Centre's gallery in Hay Hill, London, he wrote:

Industry is now recognising the need for designers; and who better than the craftsman can tell the qualities inherent in good design, for he uses the actual materials and follows the process of the design from the first rough sketch on paper to the last touch of the tool? Design is the evolution of the shape in the right material for a given purpose plus the personality of the craftsman and in some cases the client.

The Duke of Edinburgh looking at a display of work by **William Newland** at Hay Hill Crafts Centre, 1955. Newland taught at the Central from 1949 to 1960
Photograph
Private collection

At the Centre… the practical and experimental will be combined.[19]

In the previous year Farleigh had expanded on this topic in a radio broadcast to promote the Crafts Centre, emphasising the need to find and encourage buyers of craft, including industrialists 'in search of a good designer', in order to sustain the existing practitioners, who in turn would train apprentices: 'the setting up of the younger generation of craftsmen is as important to the Crafts Centre as it is to the present generation'.[20]

The Red Rose Guild, on the other hand, has been described as one of the extreme supporters of the arts and crafts… Beleaguered in the industrial heartland north of the Trent [the Guild] hated industry's guts, and its Secretary, Harry Norris, never missed a chance to say so.[21]

But this seems unlikely to have been Pilkington's view, for two reasons. The first is that she was a working board-member in her family's firm, Pilkington Tiles (where she herself learned to throw a pot) and numbered among her close contacts Sir Thomas Barlow (the other significant patron of the Whitworth Gallery in this period) whose massive firm (Barlow & Jones) in Bolton specialised in fine cotton yarns and woven cloths, towels and blankets, and was parent company to Helios, an avant-garde firm supplying sensibly-priced well-designed fabrics directly to retailers. At Helios, Marianne Straub hand-wove samples as prototypes for machine production; at the weekends she resided with the Pilkingtons. The second reason is Pilkington's view, expressed directly and indirectly, that art, craft and industry *could* come together successfully. In this she had been inspired by Lethaby, whom she knew through her committee work. She persuaded him to write an introduction to the first Red Rose Guild exhibition catalogue, in which he equates the products of skilled craftsmanship with 'a way of looking at things and… an ideal of labour'. Much later, she herself said:

> A very fine and inspiring person, Professor Lethaby, an architect, teacher and writer, used to say that a work of art is first of all a well made thing. That every work of art shows that it was made by a human being for a human being, and that Art is cleanliness, tidiness, order, gaiety and serenity; that the civic (or domestic) arts are the arts of civilisation, and that the arts of civilisation are civilisation itself.[22]

This holistic view was widespread, alive and well among a generation still active and influential in the 1950s. But the impression that 'rarefied' craftwork was the real interest of the Craft Centre seemed to gain ground nevertheless. Norris, perhaps, could be seen as the

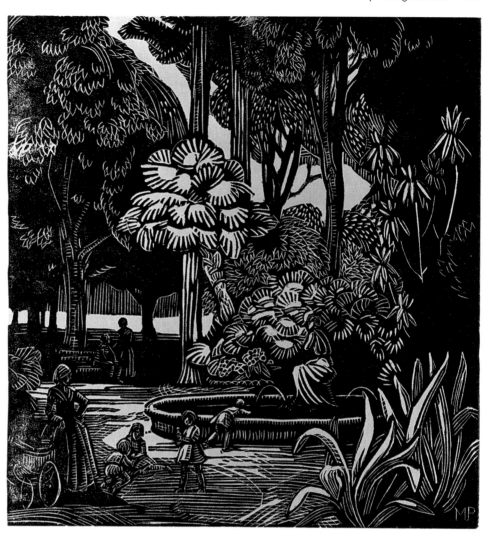

Margaret Pilkington
'The fountain, Borghese gardens', 1931
Wood engraving
126 x 120 mm
© The Whitworth Art Gallery, the University of Manchester

John Farleigh
Illustration for D.H. Lawrence, *The man who died*, Heinemann, 1935
Wood engraving in red and black
280 x 200 mm
Central Saint Martins Museum Collection

main force behind this. Leach called him a 'dictator', and although Norris was, with others on the Red Rose Guild committee, instrumental in turning attention to the future of small workshops, both under war conditions and afterward, he attacked Pilkington for 'her grand friends whose wealth was rooted in industry' and Farleigh for his vision of craft as a basis for industrial design, and his methods of pursuing publicity for the Crafts Centre.[23] This was not the gentle debate of the sort cherished by the Art Workers' Guild or Central, nor the sort that respected differing opinions. Norris had little time for what Farleigh and Pilkington in their different ways understood: that craft training was enriching in the broadest cultural and educational terms. Norris saw it as an apprenticeship leading to work, and work which had for his lifetime been threatened by industry. Meanwhile Central was at the same time caught up in the post-war scrutiny of education. Instrumental though it had been through the societies its students and staff had set up and sustained, as well as its success in suiting students to employment (127 of the 130 departing students in 1954 were 'placed in their crafts . . . so eager is industry to absorb them')[24], the Central Diploma was to disappear in the national reforms aimed at making art college courses more relevant to industrial conditions of the 1960s. And then, in 1964, came the formation of the Crafts Council of Great Britain. Its prime mover was Cyril Wood, formerly of the Arts Council and founder of the South West Arts Association, who had been introduced to the Crafts Centre council by Gordon Russell, Chairman of the Utility Furniture Design Advisory Panel from 1942 to 1946, director of the Council of Industrial Design from 1947 to 1959, and first Chairman of the Crafts Council of Great Britain.

Although Russell's views coincided very happily with Farleigh's, the Board of Trade backing for the Centre was withdrawn on the grounds that the Crafts Centre had not succeeded in bringing together industrialists and makers (although funding continued for several years afterwards despite this).[25] Massive structural changes resulted. Out of a series of twists and turns, including the formation of the Crafts Advisory Council in 1971 (administering funds to England and Wales) and a switch in government departments as the source of funding in 1972, the present day Crafts Council emerged. But perhaps of equal importance, Farleigh mistrusted Cyril Wood and in mid-1964 resigned, ending twenty-four years as the most vocal champion of interdisciplinary craftsmanship and the uniting of disparate craft societies.

The departure of Farleigh effectively removed the remaining voice of wood-engravers, many of whom had already objected, with the opening of the Crafts Centre, that they wished not to be associated with craft. The Arts Council was by then in existence and the schism between the prestigious and the practical was ever widening. The separation of printmaking from other crafts in many ways marked the end of an era; it eroded the concept of idealism, interdisciplinarity and mark making as the fundamental bases for developing creative thought and skills, within public agencies, at least. As a result, it is hardly surprising that the most recent historical overview has summarised 20th-century craftsmen and women as 'more concerned with artistic fulfilment than with social issues', adding that

in contrast with the 19th-century leaders of the Arts and Crafts Movement, the

principal craftsmen and women of the [20th] century were not versatile designers. With the exception of Eric Gill, they worked obsessively in one medium, trying to discover its essence, often deliberately ignoring hundreds of years of hard-won technological expertise.[26]

That Gill was cited as the exception is a telling indication of the difference between crafts as defined by the Central School and craft as defined elsewhere, especially after about 1960. For nothing could be further from the truth. Until the 1960s the majority of the most able practitioners (and, in principle, all who trained at Central) were interdisciplinarians. Their background generally encompassed both art and craft training. Not only did they work in more than one medium, but their products were both hand and machine made (and sometimes a combination of both) and they exercised their skills in various ways, often simultaneously creating by hand in their own studios, teaching, writing, designing for industry, or setting up retail outlets. Just one example of such craftspeople is Enid Marx. While many others are now largely forgotten, she is recognised today as a *designer* but, even there, 'her lack of specialisation and of artistic snobbery mean her name is not as well-known as it might be'.[27]

The desire to define craft as something discrete in order to fund its survival was an expediency with far-ranging repercussions. The celebration of individuality and vigorous debate by the Art Workers' Guild and succeeding similar bodies also proved unsuitable in these circumstances. In an ironic inversion of the original intentions of the main campaigners for government support, craftspeople became defined as those who specialised in one medium.

The departure of Farleigh did not, however, end the connection between the Central and the government-funded craft-supporting bodies. Peter Collingwood, Sydney Cockerell and Edward Barnsley served on the Crafts Council under Wood, who continued to reinforce the links between craft and industry. Collingwood was also represented in the similarly themed Council of Industrial Design's 1965 exhibition, *Hand and Machine*, as were Robert Welch and Ruth Duckworth, the latter two also having recently taught at Central, Welch from 1957 to 1960 and Duckworth from 1959 to 1964. Then, and for another five years, it remained unclear as to whether the Crafts Council of Great Britain or the CoID was the more effective supporter of craftsmanship and makers. At Central itself, the link between mark making and craft remained. Sustaining the interplay of art and craft as it evolved with the times, the school was widely acknowledged for the results this partnership achieved. In the vacuum left by the uncertainties surrounding the future of the Crafts Centre throughout the 1950s, the Central came to represent a way forward. It seems no coincidence that the Department of Education was eventually identified as the appropriate source of government funding for the crafts.

When in 1966 the name changed to the Central School of Art & Design, it was far less a change in tack (although courses and studio spaces *were* rearranged) and more a recognition that by then, to the world at large, the interdisciplinary studio-based training nurtured since the foundation of the School produced what had now become known as designers rather than craftspeople. Central was not alone in recognising this: the Art-Workers' Guild became the Society of Designer Craftsmen in 1960. As an educational institution, Central had

Robert Welch
Candlesticks, 1963
Cast iron
152 mm high
against a background of
'Aries', 1966
Designed by **Marianne Straub** at
Warner and Sons Ltd for Tamesa
Fabrics
Private collection

been, and remained, about *doing* and the value of group interaction, combined with an understanding of both consumers and manufacturers. This attitude has equally supported former students in the creation of independent craft workshops, retail outlets and design groups, as well as continuing to defy the increasingly entrenched division between categories of practice. These have been described as:

– the Arts and Crafts tradition (Cotswold version);
– the Council of Industrial Design tradition (Haymarket version);
– the tradition of the Oriental Mystic (Cornish version); and
– the Craftsman's Art tradition (South Kensington version) which rejects and sometimes makes fun of both the social philosophy of a Morris and the mysticism of a Leach.[28]

Katherine Pleydell-Bouverie
Vase, 1950s
Incised with celadon glaze
170 x 150 mm
Central Saint Martins Museum
Collection

The missing item from this list is the Mark Making tradition (Central version). Knowledge of one's tools as the bridge between art and commerce, hand-making and industry, was at the core of Central philosophy, a feature that allowed it to change with the times. Although 'Bauhaus' became the accepted post-war term for much of it, at Central such thinking had a far more sustained stage on which to play and, like theatres themselves, proved itself an arena in which ideas could be expressed, exchanged and given form. This life-force was summed up by Farleigh, who at the same time demonstrated the humanistic thrust of the School's sustained integration of art, craft and industry, when speaking of great artists in 1948:

They are generous, simple and wish to please their public; and they are often conceited and proud. Let us be all of these things, for a man without a proper conceit is a man who has no achievement of which he can be proud. To be adequate is to achieve little. To go on and find beauty and have dreams and to put your dreams into your work is to know and create. In other words, to design.[29]

1 Muthesius and Gropius both recommended German students to study at the Central School, and the Deutsche Werkbund founded in 1907 had many of the same aims as Lethaby and the early Central School.' See Sylvia Backemeyer, 'The School of Book Production', in Sylvia Backemeyer, ed., *Object lessons*, Lund Humphries, 1996, p. 41. The phrase itself appears to pre-date William Johnstone's reference to the Central as parent to the Bauhaus, see *Points in Time*, Barrie & Jenkins, 1980, p. 211.
2 H. J. L. J. Massé, *The Art Workers' Guild 1884–1934*, Oxford: Shakespeare's Head Press, 1935, p. 2.
3 Ibid. Sedding was in his second year of office at the time. See also p. 19.
4 For the impact of 19th-century religious reforms see Mary Schoeser, *The Watts book of embroidery: English church embroidery 1833–1953*, Watts & Co. Ltd., 1998, pp. 7–22.
5 See Susanna Goodden, *At the sign of the fourposter: a history of Heal's*, Lund Humphries, p. 44.
6 There were other implications to take into account. In 1921 the industrial depression coincided with the decision to raise fees; those for out-county students became double those charged to all students at the RCA and the Slade.
7 See Hazel Clark, 'Selling design and craft', and 'Joyce Clissold and the "Footprints" textile printing workshop', in Jill Seddon and Suzette Worden, eds., *Women designing: redefining design in Britain between the wars*, Brighton, University of Brighton, 1994, pp. 58–63 and 82–88 respectively. Hazel Clark, 'Modern textiles 1926–39', *Journal of the Decorative Arts Society*, 1988, pp. 47–54. Susanna Goodden, *At the sign of the fourposter: a history of Heal's*, Heal & Sons Ltd., 1984.

Mary Schoeser, *Bold impressions: block printing 1910–1950*, Central Saint Martins College of Art & Design, 1995. Mary Schoeser, 'All the fun of the fair', *Crafts*, September/October 1998, 154, pp. 38-43, and Betty Miles, *At the sign of the rainbow: Margaret Calkin James 1895–1985*, Alcester, Felix Scribo, 1996.

8 See, for example, *Studio Yearbook*, 1919, p. 136, for an example of a Hutton design hand-printed by William Foxton.

9 It is not yet known where she trained. She was the wife of George Dix, taught art and exhibited at the Royal Academy in 1931 and 1947.

10 Henry Wilson (1915–22), W. R. Lethaby (1923–7), Emery Walker (1927–9), C. H. St John Hornby (1929–32), Edward Johnston (1932–6), Henry George Murphy (1936–9), John Farleigh (1940–9, as Acting President in place of Reco Capey from 1940–2), and Dora Billington (1949–53).

11 *The Society of Scribes & Illuminators: an exhibition of calligraphy, lettering and illuminating at The Crafts Centre*, 1961, p. 3.

12 It is not known whether she was a Central student. Smartt was a jeweller, by about 1930 based in Woking.

13 See Mary Schoeser, 'All the fun of the fair', *Crafts*, September/October 1998, 154, pp. 38–43.

14 Tanya Harrod, *History of the Crafts Council factfile*, Crafts Council, 1994, p. 2.

15 Joanna Selborne, *British wood-engraved book illustration 1904–1940: a break with tradition*, Oxford, Clarendon Press, 1998, p. 121.

16 Reports of the number of societies involved range from 27 to 47, although they are most often in the mid-forties. The figure of 47 is given in *Report on nine years' work of the Central Institute of Art and Design*, September 1948.

17 James Noel White, 'The unexpected phoenix I: the Sutherland tea set', in *Craft history* (Combined Arts, Bath), 1988, vol. 1, p. 56.

18 Meg Sweet, 'From Combined Arts to Designer Craftsmen: the archives of the Arts and Crafts Exhibition Society', in *Combined Arts*, op. cit., pp. 15–16, referencing AAD 1/62–1980, General Committee minutes 1929–38, Annual General Meeting, 30 June 1937.

19 John Farleigh, 'The Crafts Centre of Great Britain: a brief illustrated note in *The Studio*', reproduced in John Houston ed., *Craft classics since the 1940s*, Crafts Council, 1988, p.40.

20 *The Crafts Centre* (typescript of BBC radio transmission, 11 February 1949), John Farleigh Archive 62/iii, Manchester Metropolitan University Library.

21 James Noel White, 'The unexpected phoenix', op. cit., p. 57.

22 David Blamires, 'A biographical essay', *Margaret Pilkington: 1891–1974*, Buxton, The Hermit Press, 1995, p. 69, citing an address made at the 1952 Founders' Day of Manchester High School for Girls.

23 See James Noel White, op. cit., p. 59; and Tanya Harrod, *The crafts in Britain in the twentieth century*, Yale University Press, 1999, pp. 206 and 213.

24 Neville Wallis, 'Life to-day in the London art schools', *The Sphere*, 13 November 1954, p. 284.

25 In 1965 the Crafts Centre was taken over by a new chairman, Graham Hughs, who moved it in the following year to Covent Garden, where since 1987 it has been known as Contemporary Applied Arts. In 1971 the Crafts Centre merged with the Crafts Council of Great Britain to become the British Crafts Centre.

26 Tanya Harrod, *The crafts in Britain*, op. cit., p. 28.

27 Ann Bar, 'Top Marx', in *Space*, 27 February 1998, vol. 10, p. 13.

28 Christopher Frayling and Helen Snowdon, 'Crafts: with or without arts', in *Craft classics since the 1940s*, op. cit., p. 113.

29 John Farleigh, 'To see and to design: the fundamentals of design', lecture to Shoreditch College foundation students Sept 1948, p. 12, John Farleigh Archive 62cii, Manchester Metropolitan University Library.

Insights from the inside

A student at the Central School of Arts and Crafts, 1936–1940

Margaret Till[1]

It was rather daunting at first, this big building on the corner of Southampton Row and Parton Street. You went up the steps, through the big glass-panelled door, past the porter's little office on the left, and into the hall with that funny squat pillar in the middle. Then down into the basement to the women's cloak-room presided over by Mrs Simmonds and Mrs Boultwood. They were friendly and comforting and had a tray of chocolate bars for sale, tuppence for a two-ounce bar. It was safe to leave your coat there and your baggage as well. Mrs Simmonds and Mrs Boultwood knew everybody and looked after everything. Upstairs into the hall again, to buy a sheet of cartridge paper, imperial size (22 by 30 inches) for a penny; then up the big main curving staircase to the third floor to do general drawing.

My student's card, which was also my timetable, had been made out by Mr Rooke, who was head of the Book Production department. It said I was to do general drawing on Mondays, lettering on Wednesdays, and book illustration on Fridays. On Tuesday and Thursdays he advised me to visit museums and art exhibitions, and continue as much as possible with my general education.

I certainly did the round of art galleries. My diaries provide a pretty comprehensive list of what was shown in London during this period. One of the high spots was an exhibition of watercolour drawings by Douglas Percy Bliss called 'Masterpieces in the Making' which I saw in Bond Street in January 1937. I particularly enjoyed the picture of Millais painting Lizzie Siddal posing as Ophelia in a bath, with candles underneath to keep the water warm.

Anyway, this was Monday 28 September 1936, the first day of term. I was 17 years old and had left school in July. The room marked 'General Drawing' was full of plaster casts. Some were old friends, like Michael Angelo's lovely Madonna and child that I had seen the year before in Bruges. Others were less familiar and rather terrifying, like the huge grimy reclining figure with no hands or feet that I later discovered to be Theseus from the Parthenon.

I wrote in my diary 'we just had to sit down and draw anything we liked'. I decided to choose something simple to begin with, a plaster cast of two hands clasping each other. 'The drawing master is Mr Clarke Hutton. He is quite young, and has longish darkish sleek hair, a small pointed beard and a little moustache. He just looks in occasionally, and comes round to see how everyone is getting on'. At four o'clock I put my drawing board and paper in my locker (number 312, on the third floor) having paid a shilling deposit for the key. As it was my first day, my father met me on his way from his office in Bishopsgate, and we travelled home together by tube.

On Wednesday 30 September, I went to the Lettering Room on the second floor. My diary records 'in the morning we discussed the lettering on the new stamps'. The letters had

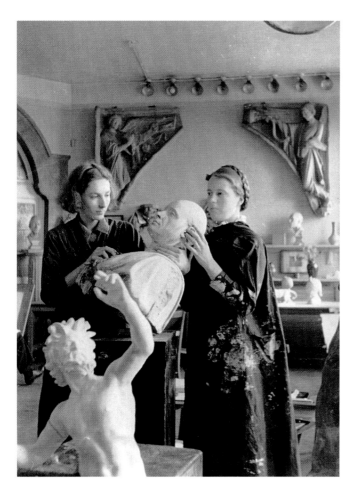

rather rounded ends, and I thought it looked as though they had been squeezed out of a tube, like toothpaste. I suppose the style suited the blunted, smooth features of King Edward VIII, but I should have preferred something more clear-cut. However, it didn't matter much since the stamps soon had to be changed. On a foggy evening ten weeks later, I came out of the Central School to the sound of a barrel organ and the whine and rattle of trams going into the tunnel to Kingsway, and read an *Evening News* placard: 'KING ABDICATES – OFFICIAL'.

After a chat about the stamps, we had to copy 'plain block letters from a sheet of paper pinned up on the board'. This might have been Eric Gill's sans serif alphabet, or perhaps the alphabet designed by Edward Johnston, who had taught our lettering teacher Mr H. L. Christie. In the afternoon Mr Christie showed us how to cut a quill pen, and how to use it (with a block of Chinese ink rubbed down with distilled water) to write out a suitable text, such as the Lord's Prayer in Latin.

On Friday 2 October I went to my first Book Illustration class. The room was on the fourth floor, and contained, besides the sink and the big hand-press for wood-engravings, about half a dozen wooden tables – they appeared to be old kitchen tables – on which students placed sloping wooden stands to support their drawing boards. A number of milk bottles served for water jars. There was constant quiet bustle and movement. Mr Rooke was there, in his grey suit, with his short grey beard, neat, brisk and business-like, but never submitting to LCC bureaucracy. I noticed on the register that we all had to sign each day, the teacher in charge had to state whether the instruction was 'collective' or 'individual'. Rooke had written boldly 'Collective *and* individual', which indeed it was. There would be a huddle of students at one end of the room, usually near the sink, being given details of the next piece of work to be done, while others would be visited, one at a time, and helped with individual problems.

Staff and students in the 'General drawing room', 1937
Left to right: **Margaret Levetus, John Farleigh, Eve Sheldon Williams, Morris Kestelman, Anthony Froshaug**
Photograph
Central Saint Martins Museum Collection

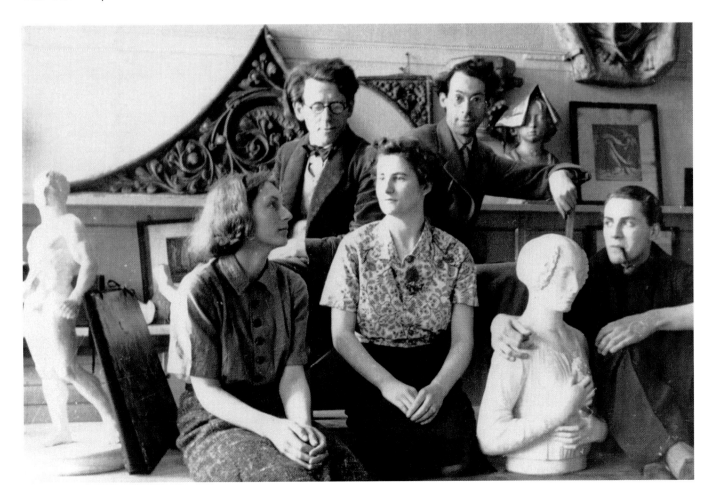

Besides Mr Rooke, who would come busily into the room and then dart away on some other errand, there were usually two other teachers: John Farleigh, in his corduroy jacket, who taught illustration and wood-engraving, (and who I soon realised, had engraved the illustrations for Bernard Shaw's *Adventures of the Black Girl in her Search for God*); and Hal Missingham, dark-bearded, in a dark green suit, teaching commercial art with an Australian accent.

Whether you were doing illustrations, book jackets, wood-engravings or press advertisements, you heard information and opinions about other aspects of graphic art going on all round you: Rooke expounding, Missingham expostulating, Farleigh explaining 'and if you've heard me say all this before, you should regard it like a Beethoven symphony – worth listening to again and again'. Mingled with the sounds – the voices, the tap running in the sink, the creak of the press, the hiss of the airbrush – were the smells: printing ink, benzole, oil stones, rubber solution.

A few years later there was another voice in that room, the gentle tones of Jesse Collins, extolling the importance of design and 'orrrganisation'. Here I must correct a detail in William Johnstone's interesting and entertaining autobiography *Points in time* (Johnstone was principal of Central from 1947 to 1960). He refers to Jesse Collins' Irish temper, but Collins himself said there was 'no Irish in him at all' and that it should be 'English temper'. Relations between Jesse Collins and John Farleigh were cordial, but, sadly, those between Farleigh and Johnstone were not.

I can't remember what I did on my first day in the illustration class, but I recorded in my diary that Mr Rooke added 'draped life on Thursdays' to my timetable. A fortnight later he made another change: I was to continue with lettering on Wednesday mornings, but do anatomy on Wednesday afternoons.

Draped life took place in the Women's Life Room, just across the passage from the Illustration Room. In those days the sexes were segregated for Life (which meant the model was nude) but not for Draped Life (which meant that the model wore clothes). Sometimes these were just ordinary clothes; sometimes they were marvellous historical or theatrical creations from the costume department. This was run by Miss Cochrane who was large and cheerful and swept into the room like a ship in full sail, sometimes accompanied by her colleague Miss Keating, small and neat with dark shining hair like a ballerina.

Mr Kestelman taught draped life, and after a while he taught general drawing as well when Mr Clarke Hutton retreated to the second floor to teach lithography. Morris Kestelman, who had dark curly hair and an encouraging smile, was a very skilful draughtsman and an exceptionally good teacher. General drawing became full of interesting challenges. 'Try doing this one in pen and wash', he'd say, indicating the Discobolus, or, 'have a go at a scene through the window'. On one memorable occasion he suggested, indicating the *Boy with a Goose*, 'now, try to draw this as though you were looking at it from the back'. At last I was helped to understand that drawing wasn't just copying the forms in front of you, but absorbing them into your brain and then re-creating them on paper.

Anatomy, taken by Mr Rooke, proved to be quite hard work. After some preliminary instruction and exercises he wanted us to produce a series of drawings in layers on tracing paper, showing first a full-length skeleton, then the same covered in muscles, then with the skin on, and, finally, clothed. He wanted the arm to be raised and suggested that a figure holding a pitcher on its head would be a good pose. One of the students, a beautiful Indian girl, agreed to pose for us wearing her sari. Another student, a young man from Canada, took a photograph of her holding a jug on her head, and we each bought a print from him to help us with the exercise. I think that is what made him start taking the series of photographs of students and members of Central School staff that is such a vivid record of the period. He didn't use a flash; they were all time exposures.

On Tuesday 5 January John Farleigh started me on wood-engraving. I wrote in my diary 'difficult to hold tools properly, but I think I can do it now'. I found it difficult to grip the wooden handle with my little finger. It reminded me of the difficulty I had a few years

earlier during a holiday on a farm when I had learned to milk a cow, by hand of course, and I seemed to need extra strength in the little finger to give the final squeeze. My first engraving was a sampler of tones and textures. John Farleigh first blackened the surface of my beautiful new block with a thin layer of ink, then engraved four lines and so divided the block into six equal squares. In one of them he engraved smooth, straight parallel lines, close together, to make what he called a 'tint'; I had to carry on from where he left off. It is easy to see where he left off and my wavering lines began. I filled the squares with tints of differing tones, taking prints as each square was completed.

I also started going to life classes in January 1937. Here we were taught at various times by Mr Porter, Mr Grant, Mr Greenwood, Mr Roberts and Mr Meninsky. All did their best to help us in confusingly different ways, and all had their endearing idiosyncrasies. You would feel a tap on your shoulder and one of them would take your place on the donkey (a short bench with a support at the front for your drawing board) and do a demonstration drawing beside yours. Some of them talked and explained, others just drew.

On 2 June 1937 I wrote in my diary 'Porter... showed me how to draw the man's hand, carefully planning it all out and giving it five fingers instead of four. When I gently pointed this out to him he counted the fingers, saw that I was right, burst out laughing and said "Bother, it's put all my calculations wrong" '.

My chief memory of 'Jimmy' Grant in the Life Room is the time when a little mouse appeared. The model, feeling too vulnerable to maintain her pose, stood helplessly, first on one foot and then on the other, while Mr Grant, crouching, half crept and half ran to the rescue, peering after his prey which quickly disappeared. Mr Grant straightened up, the model calmed down, and we resumed our drawing.

Mr Greenwood was usually rather silent. He used a tiny black pencil and pressed hard so that his drawing was very dark and heavily modelled.

William Roberts didn't say very much either. He had a round, pink face and used

Clarke Hutton
Cover for Noel Carrington and Clarke Hutton, *Popular English art*, King Penguin, 1945
185 × 123 mm
Private collection

sweet-smelling hair oil. He drew slowly but unhesitatingly. His beautifully controlled contours and carefully graded tones were miraculous to watch. Usually he would draw just part of the model (a shoulder, or a knee) but once he did a complete drawing for me of a model seated on the floor, leaning back on her supporting arms, with one leg stretched out in front of her. It's a lovely drawing which I still treasure, but at the time it worried me because I didn't think it was like the model.

Bernard Meninsky always had something interesting to say and was always encouraging, leaving you with something definite to aim for and the conviction that you would eventually achieve it. Tragically, despite his gift for encouraging others, he could not fight off his own depression and took his life in 1950.

Models at that time were paid half a crown an hour. The day would start with a long pose from 10 a.m. until 3 p.m., with three 15-minute breaks and an hour for lunch. Then, after another 15 minute break, there would be three short poses of 15 minutes each, and the class would end at 4 o'clock. Occasionally if a model didn't turn up or was late, we would take it in turn to pose (clothed) for 10 or 15 minutes. This experience showed me that posing is no easy task.

In the Illustration Department and probably in all the departments at Central drawing and design were all-important and interdependent. The ability to draw enabled you to design, and an ability to design should enable you to tackle *any* design problem, i.e. produce shapes that please the eye while fulfilling the purpose of the design.

An important aspect of book production, much emphasised in our training, was co-operation. Ideally a book should be the result of harmonious co-operation between author, artist, printer, binder and publisher, though this seldom happened in real life. But at least we had co-operation from the printing department. When we had decided on a book to illustrate as an exercise, they would set up specimen pages so that we could design our illustrations to harmonise with the type.

We were told how to decide on the distribution of illustrations through the text, and which incidents to illustrate. This included making a chart of characters and their actions, and paying particular attention to detail, so that they would be accurately portrayed. We were told how to approach publishers, how to present our work, and the importance of delivering it on time. Every exercise in the class was treated like a 'real job', with a deadline, when the work had to be handed in, or rather, pinned up on a board, for discussion and criticism. Book jacket criticisms were a regular occurrence. Our work would be pinned up and John Farleigh would very thoroughly point out its strengths and weaknesses. The system had the added advantage of showing us our work in competition with others', just as in real life book jackets compete with each other in a shop window. Sometimes we had outside speakers. In June 1938 Ian Parsons of Chatto & Windus came to criticise our book jackets. He told us that a good book jacket should have three qualities: it should attract attention; give an idea of the book's contents, and be visually pleasing.

We were fortunate in having many visiting speakers at Central. These included John Betjeman,

William Roberts
Pencil drawing done for Margaret Levetus, 1937
280 x 380 mm
Central Saint Martins Museum Collection

Sir Muirhead Bone, Robert Gibbings, Kenneth Clark, and E. McKnight Kauffer, whose poster designs were an inspiration to students of commercial art. For us illustrators the most exciting visitors we had were Leonard and Virginia Woolf. As an exercise we had all done illustrations and book jackets for Virginia's *Orlando*. As the Woolfs were living just round the corner in one of the Bloomsbury Squares, John Farleigh invited them to come and see our work. On Thursday 2 March 1939 I wrote in my diary 'At 3 o'clock we went into the Men's Life Room where our work was pinned up, and Leonard and Virginia Woolf were there. VW is tall and slim, aged about fifty I suppose. She smokes a cigarette in a long delicate holder. She's rather beautiful. She told us how she came to write *Orlando*… She liked our more abstract and symbolic illustrations. Leonard Woolf criticised the book jackets. He liked mine all right, except the author's name did not show up enough'. On the evening of the Woolfs' visit to the School a group of us went to the ballet at Sadler's Wells and saw 'Harlequin in the Street', 'Checkmate', 'Judgement of Paris' and 'Façade'. Looking in Virginia Woolf's diary for 1939 I see that she refers to the visit to 'the Polytechnic' as 'rather cheerful and free and easy', comparing it favourably with Oxford and Cambridge. Later (while we were at the ballet) she had a 'long, but on the whole admirable and agreeable, Thursday evening' dining at Vanessa's studio with friends.

Sometime in 1938 my timetable was increased to include lithography which was taught by Clarke Hutton in a room on the second floor. Ernest Devenish was the technician on whom we all depended for the complicated business of fixing, etching, proving and printing our work. Unceasingly he stood at the big press, rubbing a stone with gum or sponging it with nitric acid, or washing it, or drying it with a home-made fan like a cardboard flag, which he swung round and round over the stone. While we waited for our prints he entertained us with amusing anecdotes. One that I recorded in April 1939 was that 'Missingham once went out for a whole day as a pavement artist and collected tuppence, and on another occasion he went round with an organ and got fourpence'.

On 11 January 1939 I wrote 'Ernest was suffering from a broken rib and wasn't supposed to do any printing. He was able however to teach me to take proofs at the small press by the window. Farleigh worked at his flowers' (illustrations for *Old-fashioned flowers* by Sacheverell Sitwell). 'Kestelman came and took proofs of one of his four-colour lithos of clowns and acrobats… He wore a weird old smock which Ernest dug out for him and looked very funny. Some LCC Board of Education people came… Clarke Hutton showed them round in his best Cook's tour style. They surrounded Kestelman and his press… When they had all cleared out K triumphantly announced they had tipped him a shilling… After 4 o'clock I caught a brief glimpse of old Mr Hartrick who used to teach lithography here. I am told he knew Van Gogh, Manet, Monet, and all the rest'. I was always interested in these links with the past, and enjoyed hearing the printer J. H. Mason, by this time an elderly man wearing an eye-shade, talk to us about working with William Morris on the Kelmscott *Chaucer*. He believed that every student should learn lettering and that it was of more importance than life drawing.

At the end of the summer term in 1939 I had won a Queen's Scholarship to stay at Central for another year. However when October came, the War had begun and the School did not re-open. So, through a combination of circumstances which included my being able to live in my grand-parents' house in Reading, I spent the Christmas term as a student in the fine art department of Reading University.

Here wood-engraving was taught by Robert Gibbings. Large, bearded and genial, he was infinitely kind and helpful. He and Farleigh had both been taught by Noel Rooke, but now their approaches were different. As a 20-year-old student I found this a problem. I wrote in my diary for 17 October 'Gibbings and I had a slight controversy on the way to prepare a drawing for engraving. His method was to make the drawing look as much like the finished engraving as possible'. In his speech at the Arts and Crafts Society meeting held at Central about two years previously he described himself as 'Quads: author, artist, printer and pub-lisher', so I told him it was his 'passion for being more than one person' that led him to

become first a designer and then an engraver, instead of merging the two arts into one, as Farleigh had done for instance. 'I agree that precision is necessary and vagueness to be avoided in wood engraving, but I do like to let the graver find its own way a bit, otherwise the thing is liable to look stiff… and… dry. I must steer a middle course somehow.'

Nevertheless Gibbings' class brought me valuable new experiences. Not only did we have a press and all facilities for printing wood-engravings, but we were also allowed to set up type, an activity at that time forbidden at Central to all except male printing apprentices. I learned an important lesson about typesetting. Having composed and printed some type to go with a Christmas card, my astonished gaze met the word 'SGNITEERG'.

In January 1940 the Central School had re-opened and I was back after my term at Reading. An enterprising pair of students started producing on a private press in Essex a series of illustrated *Linden Broadsheets*. Shelley Fausset was a typographer and Honor Frost was a student in the illustration class. (She later became a well-known marine archaeologist.) I don't know how many *Linden Broadsheets* were eventually published, but I illustrated the poem 'Fear is fast' by Marjory Rolfe in number six, with a wood-engraving in black on a linocut in yellow.

In December 1940 the Central School was evacuated to Northampton and those who could not go with it had to seek other employment until the War was over and the School returned to London. During the war we tried to combine illustrating with Civil Defence, or whatever activity was absorbing most of our time, and helped each other with advice, such as 'Go and see Noel Carrington. He'll give you a Bantam book to do.' (These were very small paperbacks, with lithographic illustrations drawn by the artist on zinc plates, which sold for 4d). It was not a good time for budding illustrators. Paper shortage cut down the use of illustrations. Even John Farleigh was reduced to doing textbook illustrations at five shillings a drawing.

The War dispersed us to factory or hospital, the land, the Services, or Civil Defence, but we eventually followed careers in the visual arts. To mention just a few of those who started by learning wood-engraving: Hilary Stebbing wrote and illustrated her own books with lithographs; Monica Walker produced illustrations for books and the *Radio Times*; George Downs made theatrical masks and costumes; John Parsons became art editor of *Vogue*; and Roderic Barrett produced dark, mysterious wood-engravings and paintings of a haunting, timeless quality. Later he returned to teach book illustration at the Central.

I did illustrations for books and periodicals, including *Radio Times*, and also book jackets. I exhibited and occasionally sold

Robert Gibbings
From *Sweet Cork of thee*, J.M. Dent, 1951, written and illustrated with wood engravings by Robert Gibbings
Wood engraving
140 x 130 mm
Central Saint Martins Museum Collection

JOHN PARSONS, M.S.I.A.
for the Council of Industrial Design, 1945.

John Parsons
Symbol for the Council of Industrial
Design, 1945
Drawing for *Vogue*
Published in *Designers in Britain*, vol. 1,
SIAD, 1947

Hilary Stebbing
From 'Maggie the streamlined taxi'
Transatlantic Arts, 1943, written and
illustrated by Hilary Stebbing
125 x 180 mm
Central Saint Martins Museum
Collection

Margaret Levetus
Wood engraving for Marjorie Rolfe,
'Fear is fast', *Linden Broadsheet* no. 6,
printed by Shelley Fausset, 1940
300 × 220 mm
Central Saint Martins Museum
Collection

wood-engravings, linocuts, and vinyl-engravings. After the war I taught drawing and wood-engraving at Sir John Cass College in the City of London.

I am told that the post-war illustration class at Central became very large. I don't know if individual tuition such as we enjoyed was still possible.

Noel Rooke once told me 'there's no security; you just have to swim'. Thanks to the care and expert teaching we received, and despite the war and the paper shortage, we were lucky and managed to keep afloat.

1 Margaret Till was formerly Miss Margaret Levetus.

Edward Wright[1]:
Teaching and experiment

Ken Garland

Ken Garland
Design made in Edward Wright's
evening class, c. 1952
230 × 380 mm
Private collection

Yes, well I suppose I know quite a lot more about Futurism, and Dada, and Constructivism, and all that, than I did when I was frolicking with large hunks of type matter on the hand press in Edward Wright's evening class at the Central School of Arts & Crafts in 1952–3. Now I can tell you the date of Marinetti's *Zang tumb tuum* and the date of the first issue of *Lacerba* and Hugo Ball's sound poem *Karawane* and Picabia's cover for *Le coeur à barbe* and Lissitsky's *Tale of two squares* – go on, ask me. Goddamit, though, even the students of my ex-students know all that stuff nowadays, don't they?

But I'd swap all these historicisms for another good bash at the old platen right now, with a merciful mind blank about what those geezers did before we got onto the scene. See, Edward didn't go on about them at all, though he knew all about them, of course. No, he just set up the conditions for us to have fun, and feelings, and excitement, and the belief that we were inventing all the time. No, that wasn't a confidence trick – it was a fruitful and considerate teaching method, and speaking for myself, it has supplied me with a head of steam that's kept me going for thirty years. There are some things I started on then that I'm waiting to develop tomorrow, or maybe the day after, and the hell with nostalgia.

1 From Ken Garland, *Edward Wright: graphic work and painting*, Arts Council, 1985.

Ken Garland
Design made in Edward Wright's
evening class, c. 1952
230 x 380 mm
Private collection

From the first number of
Central Papers, 1930

Edited by Lynton Lamb
and produced by Central School Students

An appreciation of Mr Burridge

When one sees an appreciation of a person in a journal or magazine it is often approached with some feelings of doubt as to its sincerity. Here, you think, is a man writing an appreciation and so, having headed his page 'appreciation of' he cannot very well do anything but write appreciatively. He has consented, either for financial remuneration or because he was not strong-minded enough to refuse, to write nice things about someone and conveniently slur over or omit all else that does not fit in with an epitaphic scheme of graces.

Let me then clear myself of these two charges. First, as you may surely guess, I am not getting any payment for this effort, and secondly, though I cannot claim excessive strong-mindedness, I will not at least start by writing nice things, but state honestly that when I, as a new and very green student, met Mr. Burridge over ten years ago, I did not appreciate him at all, and also I thought him most unduly unappreciative of me. Here was I, straight from a secondary school, surely one of the brightest boys as far as Art was concerned, who had ever been educated there: had I not painted two decorations on the walls before I left so that future students could see what a genius the school had at one time harboured? And then to have my drawings, no more than that, my life's work, gruffly glared at by Mr Burridge and be told that of course I could not draw and to have 'General' written down on my card for four out of five days of the week. Yes, I can safely say that at that time I did not appreciate him at all, in fact my thoughts were far from complimentary. Then, after six months 'hard labour' in general, I again ventured to present myself to him. I sat on the seat outside his door, where the women students eat buns at lunch time, and waited with two or three others, all with rolls of antiques under our arms and feeling that perhaps it would have been better if we had not troubled to come, our drawings being so bad that a visit like this could do us no good. At last we were ushered in. I spread out my drawings and murmured something about a day's 'life'.

I left his room feeling that perhaps after all he was human. At the beginning of my next year my programme contained two days 'life' and this second day granted without any asking on my part. I was sure now that he really was human and more than that I was soon to learn that here was someone who watched your progress, and distant and remote as he might seem, was doing a difficult job tactfully and well, few of us have ever realised, for it is no fun maintaining that compromise between art and The Institute which a school like Central must be if it is to be a success, and there is no doubt that Mr Burridge has preserved that subtle compromise with success, steering the school like a ship amongst difficult winds and currents and of the intricacy of those engines, the more we praise and thank Mr Burridge for his wise command.

Each of us have only met him in connection with our own line. As students, especially in our first years, we did not see him without we wanted to change our programmes or when we got into some scrape and it was necessary for special wrath to descend on us. Yet here has been Mr Burridge settling continually a hundred and one difficulties, dealing in a few hours with questions connected with furniture or life drawing, lithography or bronze casting, book production or modelling, and sitting on numerous committees we know nothing about; those collections of serious gentlemen who gather in the Library settling all those problems of a Technical School and the connection of the School and the Trades.

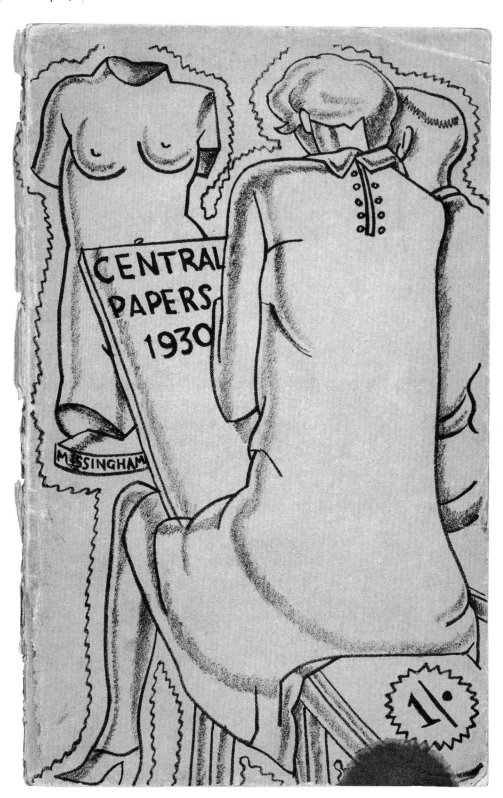

Cover for *Central Papers*, 1930
225 x 140 mm
Central Saint Martins Museum
Collection

And amongst all these occupations Mr. Burridge has been carrying on whenever he could find time with his real work, that is whenever possible returning to his etching, though he has not often managed to get more than one plate finished a year. If it is so that he can get back to this work that he is resigning now, instead of in five years' time, and though I know he is sorry to leave the School and give up being the 'Old Man', I am sure he is leaving to start a life of real enjoyment, having reached that time which we all look forward to, when he can do just that work which pleases him and no other.

Mr A. S. Hartrick

Mr Hartrick is leaving us. Many of us who have been fortunate to know him will regret it.

He is a fine teacher for he teaches as one whose pleasure it is. His witty recollections are packed full of wise things about painting and in these very human talks he has made many of us see and understand things. His most drastic criticisms are always given with such a kindly humour and his sympathies with all phases of art, old and new, have attracted large numbers of students to him during the time he has been teaching in this school.

Though we must now reluctantly lose him we hope he will have the leisure to put on to canvas and lithographic stone the things he has so long been giving to us. This note is but a lame expression of his many friends who wish him happiness.

Mr Graily Hewitt

The Central School will incur a great loss when Mr Graily Hewitt retires from it in June, after having taught there for twenty-seven years. At the outset his career was legal and lit-erary; he was called to the Bar and there are several poems and novels written by him. He is very musical and makes a hobby of singing. In 1900 he came under the influence of Edward Johnston who had started the revival of Illuminating. He studied in his class at the Central School and in 1903 commenced to teach there himself. This is the first Scriptorium in England since the Middle Ages; in the quiet country he and his assistants have developed the Treyford Pattern and their garden is their Herbal. From there came the Great War Royal Army Medical Corps War Memorial, the Memorial for all combatants in the South African War, The National War Memorial for Wales, the Eton, Harrow, Winchester and Haileybury War Memorials, the Royal Army Medical Corps South African War Memorial, the Regimental Memorial Rolls for Hampshire and Suffolk, and the War Memorial for the House of Lords. The first named, called the Golden Book, is probably the best known and is in the Chapterhouse of Westminster Abbey. He also writes the Letters Patent under the Great Seal for each new Peer. He is undoubtedly the finest gilder since the fifteenth century and all the students who have passed through his hands will remember with gratitude his patience and helpfulness with this difficult craft.

Roy Coulthurst: Industrial designer

Based on an interview at his home in Cuffley
with Bridget Wilkins, 8 November 1999

Roy Coulthurst
'Standing figure in copper tubing', an
outcome of the 'exchange class' pro-
gramme. The sculpture was entered
for the Young Contemporaries
Exhibition, 1950
Private collection

BW You were a student and then a Visiting Lecturer at Central. What were your first experiences as a student?

RC I started in 1949. I was a term late starting the course because I was late in deciding to do it. I had already done four years at Blackburn Art School, getting my NDD in Interior Design, and then for some reason I began to fall out with Interior Design… At some point I must have heard about Industrial Design, designing all kinds of products. I thought, that's what I want, to be involved in products where the aesthetics were part of the function and not just a dressing up of the product. Someone said 'you want to go to the Central School in London, that's got the most marvellous Industrial Design course. It's the only one at the moment, the Royal College don't do Industrial Design'. I had wondered if I could get into the Royal College because I had done four years already. I decided to go and look at Central, so I went in the autumn of 1948 and had a look round this wonderful college. I was impressed with the college and the building.

BW What was 'wonderful' about it?

RC The atmosphere. At that time it seemed to be partly in the building. I visited it with my father, he chaperoned me. I was only twenty. We went and saw Mr Halliwell, and the Industrial Design department, and there was a sense of energy and activity. I saw some of the students doing presentation drawings. It was a very impressive building, pretty old, and when you analysed it, a fairly muddled one inside. There's a certain quality about the recep-tion area; it also has a nice acoustic. If you stand at a particular point, you can say something quietly and it bounces into your ear as a terrific noise! It only happens at one spot, just after you have gone through the double doors.

BW You arrived a term late?

RC For some reason I had not got moving. I was waiting for the NDD results, which I passed. I don't know why I decided to do another three years – seven years altogether; that's a long time.

BW What were your memories of your first term?

RC The thing I remember about the first day was going out with the rest of the class. At first there were only five students; eventually there were six. We went to a greasy spoon across the road to have a bite to eat. I thought the way they were talking was marvellous. They were all much more adult than me; I was the baby, they had been in the forces, and had much more experience of life. They were talking about what they were doing, what they were designing. There was a sort of enthusiasm – that attracted me.

BW I noticed in the prospectus that one of the subjects in the Industrial Design course was 'creative photography'. What was that?

RC We had one day that was called 'exchange class', and this is where we chose to do either sculpture or painting. They had Victor Pasmore doing the painting, Adams did the sculpture. I did a wire figure [*in the corner of the room*] that went in the Young Contemporaries Exhibition, and was featured in the *Illustrated London News*. It was

marvellous doing these different things. This creative photography involved making patterns by laying things like mottled glass on top of sensitive paper, exposing it for a little while, and seeing what we got.

BW How did that help you as an industrial designer?

RC By giving you ideas for textures or a pattern that you might use on some product. Another thing that was useful was typography and graphics. We did it with a gentleman called George Collet. He was a marvellous chap. He was so gentle in persuading you that one thing was better than another. He made us do things like packaging, and displays for a particular company at an exhibition, like Ekco.

BW How long were you at Central?

RC Just under three years. I finished with a nice little peak in 1951 – Festival time! We went there with Misha Black. I can't remember if it was organised by the SIA or by Central. I think I was a student member of the SIA by then: it sounded a good organisation to be in. An interesting detail was that I went to the Festival on a workman's pass, which was Paolozzi's. How I was able to borrow it I don't know. He was at Central at that time. The thing that impressed me about Central was that the part-time teachers were also working professionally. You could believe what they said, because they were still doing it!

BW The professionals you've mentioned so far were more in the Fine Art area. Were there any from the Industrial Design area?

Douglas Scott teaching industrial design students, 1955
Photograph
Central Saint Martins Museum
Collection

RC There was Douglas Scott: I think he took silversmithing at Central and he was already a well known practising industrial designer. Alan Patchett was a professional product illustrator, a presentation person, Nigel Walters with his furniture, and Naum Slutzky the ex-Bauhaus designer.

BW Wasn't this the start of the new profession of Industrial Design?
RC Yes but the Americans were well ahead of us…. My father owned a cinema so I was able to watch films free. I became a real glutton for films… In *North by North West* Cary Grant meets a woman on a train and he says 'what do you do?' and she says 'I'm an industrial designer'.

BW Why do you think industrial design is more appropriate than product design?
RC It's something I have grown up with. Product design hasn't got the same functional aesthetic background. You might say that industrial design does not suggest a functional aesthetic background either, but it was already established a long time ago, particularly with the Americans, dealing with the function *and* the aesthetics of the product and making sure the two worked together.

BW Is there a particular piece of work you remember doing as a student?
RC I did a sewing machine in the final year, and a space heater, and the interior of a railway carriage, with space for a bar and a buffet. Of course we made models of most of them.

BW That's a lot. The weekly timetable in the prospectus seems very full, including evening classes.
RC Yes, we had night school – some students only came then. We took engineering drawing during the evening. If there was any weakness in the course it was that we were not given enough on business methods.

BW Did you manage to pick that up when you left Central?
RC No, not really.

BW Was there any difficulty getting employment when you left Central, or was it so famous that there wasn't a problem?
RC I don't think it was that famous in the industrial area. I think I wrote about 14 letters: that's not a lot is it? Out of that I got one interview, but I got the job, Ferguson radio and television. The first design that was accepted by Ferguson's was the best one from the point of view of the money it earned: the '991' television. It had some interesting features. One was what they called a proscenium front, which is almost like a picture frame. The shape of that moulding had an interesting effect on the body of the cabinet. There were no right angles on the joints on the body. The back of the moulding slopes in and when you take a sloping cut (because I wanted to slightly tilt the screen), the body had to go out. There was also a slope on the back. It gave it a lot of visual stability at the base…

BW Was there anything in your training and education at Central that enabled you to think in that sort of way?
RC I just think it was the general feeling that industrial design wasn't the business of just putting a pretty surface on the external design. There had to be more to it than that. There was a lot of bad design about where nobody had really thought how that design related to the human being, or how the human being was going to know what was required, whether a knob was going to be turned or pulled or pushed: this could be shown by the knob itself… In this Futura radio, designed in 1958 [*points to the radio nearby*], because this is a large disc it signifies and enables you to do fine tuning whereas if you want to zip across you just use the smaller inside one …

BW Can we move on to you as a teacher at Central?

RC When I got the job with Ferguson, I was their first ever staff industrial designer, although they had employed freelance designers before. It was a bit of an experiment. That TV carried on for four years although they usually changed models every year. But I moved back up north, as I wanted to get married and my father tempted me into his business – in the financial area, nothing to do with design. But they kept in contact with me and asked me to suggest some designs. I was thinking I could do a bit of freelance design on the side, but it didn't work. I got so frustrated adding up columns of figures, I had to leave. I tried to get a design job with Granada television, but trying to switch to graphics was hopeless. I wrote to Ferguson to ask if they could supply me with a reference, and they said why don't you come and see us. I went to see them and they said 'we would like to have you back'. By that time they had at least four other industrial designers. I joined them and was given radios to do. That was how I started a ten-year stint with them. At the end of ten years I was beginning to find the repetition a bit wearing and a lot of my designs weren't acceptable to the sales people. About 1967 I was getting a bit frustrated. In a peculiar way it was too easy to design a television. It was almost like juggling the cards to get a different hand. You knew what the restrictions were, you knew what you were allowed to do. There was too much emphasis on the aesthetics purely as a visual gimmick. If you argued that this should not be done because it altered the hierarchy of the controls; the salesmen just didn't want to know. When we finished at Central, Wells Coates had been our External Assessor. He offered me a job, but I didn't take it because I had a peculiar feeling that somehow I was still not adult enough to go into the business world. Halliwell offered me a teaching post, in the area of creative photography. I said 'I don't think I can teach, the present students are only a year behind me'. I turned it down.

BW But you went back in the end.

RC Yes. When I was getting to the point of wanting to move on, one of the Ferguson directors said to me, 'Roy, do you think you might be interested in management?' I'm afraid I said 'no, I want to design, I want to be on the drawing board'. I have that urge to be solving visual problems. Halliwell wrote to me because I'd kept in touch and occasionally popped into Central. His letter said he had been given permission to start an MA course, and he was going to have openings for lecturers: 'would you be interested in doing some part-time lecturing?' I said 'yes'. I thought this was an opportunity. I could do two or three days teaching a week and the rest freelance. That's what I did, but it was a disaster because

Roy Coulthurst
Ferguson 'Futura' 3166 AM/FM table radio in rosewood veneer and brushed aluminium. Designed and produced in 1967
Private collection

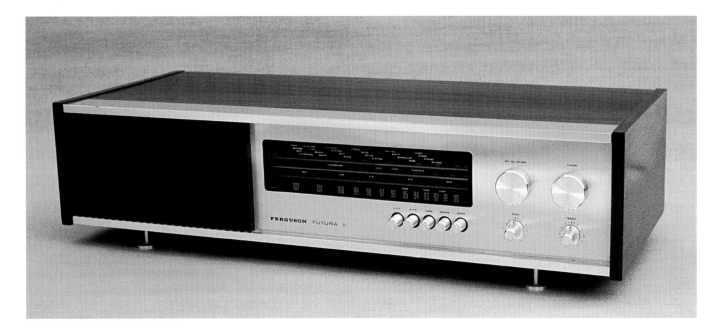

I didn't have the business sense to really get things going. There was only one design that I produced, and that was an industrial spray gun.

BW Doesn't industrial design today involve very different criteria?
RC In some ways it is a bit of a comfort that my time has gone. When I go back to Central, it's not what it was. So many of the staff have changed. This is probably a little bit of sour grapes. On the other hand there was something special about Central when it was really booming and getting the students' models featured in *Domus*, having the American *Industrial Design* magazine ask 'how do you get your students to produce such excellent work?' We replied that a lot of aesthetic problems are solved by making 3D models which were necessary to evaluate the design. There was a standard of excellence which depended on the method of having crits and deadlines that made the place alive.

Ann Hechle: Calligrapher

Based on an interview at her home in Somerset
with Bridget Wilkins, 15 November 1999

BW You studied calligraphy at Central when Irene Wellington was teaching. Tell me your first impressions.

AH The first thing is that I was incredibly young and green. I can't tell you how naive I was. I had just left school and gone straight into the local Art School at Reigate. It was the first time I had ever met 'arty' people. I had never come across them or people who thought about things so seriously. It was the most amazing new world; I was terrified. I was very open and wanting to learn, because it was so exciting, but part of me was terrified. I came to the Central School knowing I wanted to do calligraphy. That made a huge differ-ence because I was very focused and I happened to get Irene who was perfect for me.

BW Did you know Irene before you went to Central?

AH No. I had never met her before, but I had gone to Heather Child. My father had writ-ten to ask her if there were any openings in calligraphy and she had been very cautious and said that calligraphy didn't pay very well. My parents were terribly keen that I should do graphic design, but my heart was set on calligraphy. I had done some calligraphy and letter-ing at Reigate School of Art because the head was very enthusiastic. I had had William Bishop, quite a well known calligrapher. Having done calligraphy at school I automatically went to the local Art School and did a general course, and a bit of lettering. In those days, people said 'what would you like to do?' and you said 'ah, I think I'd like to do this' and you strolled in. I had an interview, but they took anyone really. I had life drawing with William Roberts and Morris Kestelman, but I didn't see much of them. Central had all these very big names. We had Gertrude Hermes for sketching. She was such a character, but she gave us very little direction. For a very green 17-year-old there wasn't enough direction; I sort of floated around. I did bookbinding with Frewin and Mathews. What anchored me was Irene. She was absolutely terrific because she was such a sensitive person and realised I was floundering. One of the things I remember about Central was that the departments were incredibly disassociated. But that might just be my perspective. I didn't try and go out of my department and explore because I was too young and terrified. It was very enclosed, and what I think was difficult (in 1958) was that the calligraphy group was tiny. There were five of us who were doing it full time. You were allowed to do a specialist subject in those days, and there were a few from graphics. In the same room there was this little calligraphy group and the graphic designers. Irene and I found it very difficult. Graphic design is much punchier and easier to get something together. With calligraphy it takes you two years to even build up and articulate a hand and get anything done at all. It's a very slow thing to learn, so it was rather dispiriting to have this rather slick thing going on in the other side of the room. Bang, bang, bang: 'bit of red there!'. Calligraphy was much slower, more thought-provoking, and manual. I think Irene found that difficult too.

BW You must have been one of her last students at Central.

AH Yes. She left in 1959. I had two years of her, 1958 and 1959. Dorothy Mahoney came in 1960. But Irene was extraordinarily wonderful for me, because there were so few of us, she really did things in depth with you.

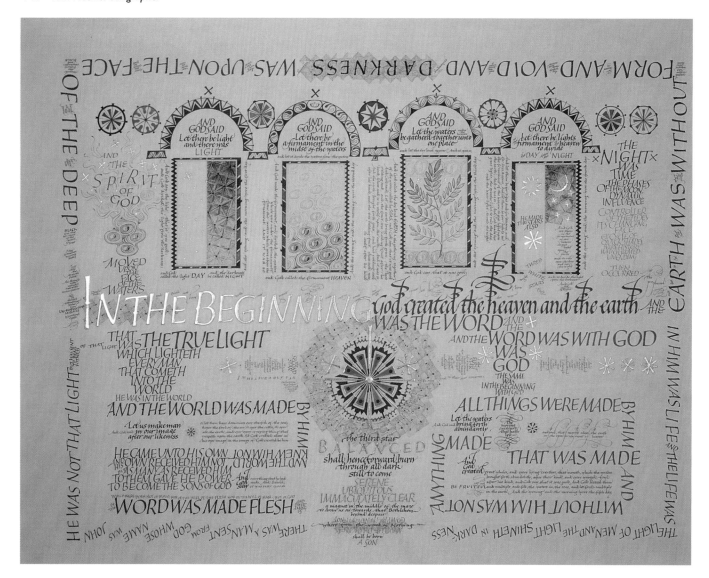

Ann Hechle
'In the beginning', 1984
The opening verses of Genesis and St John's Gospel woven together
Raised and burnished gold and powdered gold and watercolour on vellum
71 x 89 mm
© Ann Hechle

BW I noticed in the book on Irene that you contributed to with Heather Child, Heather Collins and Donald Jackson, that you mentioned Irene thought of special projects for each student.

AH That's right.

BW What were yours?

AH What she did was incredibly inspired and brave. It's easy for a teacher to give exciting projects that the teacher can do, but it's terribly difficult to field what comes back from somebody who is not very experienced, because it doesn't come together at all. What she did was throw you in the deep end, so that you really struggled and got a sense of how fantastically complex and exciting it was and how huge the horizons were. So even if you couldn't do it, it widened your horizons, if you had the imagination. On the second day however (I had calligraphy for two days) I had M. C. Oliver, and he was much more traditional. He taught you to choose this size nib and that size, and how to use them together. It worked, but it was the safe option. Things change, and his approach gives you no foundation, as fashion changes, or you grow, or the whole art movement develops; it gives you no inner sense of how these things work. What Irene was trying to do was get it to work in you and for you, to understand how these things came together... Irene was trying to get you to seek your roots much more deeply, so that even if you could not do it in the three years you were there, you would have a foundation for life. She got into terrible trouble in

the department, because they said this was too slow, irrelevant, not viable, and I think she had a struggle keeping calligraphy going.

BW In the prospectuses the name was changed in 1963 to 'letter design and calligraphy'. In 1964 there was no calligraphy.

AH Yes. They thought it was too slow and irrelevant, but what they did not see was that the foundation for all sensitive letter forms comes out of the hand. It's the physical movement and co-ordination of hand and eye, that gives letters their warmth. It comes out of what the pen has done and what tradition has built up over hundreds of years. As soon as you lose that and start drawing lines by machine, the letters become terribly dead and difficult to read. That's why David Kindersley was such a good computer programmer; he understood all the little subtleties that made things work that fell out of your hand. Unless you have that underlying sense of how letters came to be as they are, letter design is sterile. Irene was incredibly ungraphically oriented herself, but she thoroughly understood the power of letter forms. She was terribly keen on the structure of writing, and the sensitivity of touch that it required. She wasn't interested in 'this will make good type'. She was very much in the tradition of Johnston, and I think when she left, other people who had not had Johnston, did not quite understand the power of Johnston's thought that would carry through to type.

BW In the book¹ Irene is quoted as having said that in her latter days at Central she started a class by talking about Edward Johnston and suddenly realised no-one knew who she was talking about. How conscious were you of being within the Johnston tradition?

AH Her teaching was rooted in Johnston, but she had also moved on from him. What grabbed me much more was the poetry side and other possibilities and I took off on that. So the fact that in the last two years she was talking about Johnston, those are the things I personally did not pick up on.

You had to choose your own poet, and poetry, what you thought of it, what it went with and why you were doing it – all those things that I found so incredibly rich. She brought in paintings to show you, Persian manuscripts and other things; she was very eclectic. Terribly stimulating, at least I found her so. Some people just could not understand what she was talking about. For me she was just wonderful.

BW Quite a lot of Irene's work has some meticulous and well observed drawings of nature, including plants that you can easily recognise. Was this love of nature something she communicated to you as a student?

AH Yes I think so, but it went along with her sensitivity of observation and the poetry of nature. She introduced me to a lot of nature poetry. It was all part of observing the natural world.

BW I heard you were called 'scribes' then.

AH Yes. Irene used to sign herself 'scribe and illuminator'. It seems very old fashioned now.

BW You also said in the book that much of Irene's teaching was lost on you.

AH Irene never talked down to you. She had absolute standards, and although she was very compassionate, she would not lower them. She would always try and raise you to her level. Some of her comments I have only understood in the last ten years. She was right ahead of you. She would say 'It didn't quite go', and you didn't understand what this meant. I didn't understand, because I didn't have the eye or the vocabulary.

BW I am surprised there were so few students. Was calligraphy unpopular?

AH You are always hearing tales of Johnston sitting in classes along with hundreds of

students, because he was such a dynamic and charismatic person. That was at the beginning of the movement. But how many of Johnston's students do you hear of now? There is a terrific grass roots calligraphic world, but terribly few who are doing it as a life.

BW You are one of the few.

AH No, there are quite a lot, but relatively few who put their heart and soul in it and are using it as a vehicle of discovery. Maybe that has always been true. But we did have the privilege of having calligraphy at the Central School as a specialist subject. In 1964 it was one of the subjects that came under the umbrella of Dip AD.

BW What was the gender balance? Were there mostly women doing calligraphy?

AH Yes I think so. Donald Jackson was two years ahead of me and we overlapped for a year. He was incredibly professional and brilliant. I was terrified of him, and he has gone on to do it professionally, but I think the balance was more women than men. Maybe Irene's way of teaching was very feminine. I think there were more men in M. C. Oliver's class. Later, William Gardener took over his class, doing much more heraldic design and formal work, and I think there were more men. So maybe that had an influence.

BW After three years at Central, what did you do when you left?

AH I taught calligraphy, first at Epsom School of Art for a year and then at Sutton School of Art. The head of the Art School was interested in calligraphy which was why they had a calligraphy and lettering day there, otherwise I would not have got a post in the climate of the early 1960s. It was very much 'I'm a painter, what is this awfully boring stuff we have got to do?' It was difficult to make it relevant to them. They didn't want to do Roman lettering and I had to devise ways of making it interesting.

BW How did you do that?

AH In two ways really. One was the calligraphic side: make it much more to do with drawing, the liquid movement of the pen, which is really drawing. And then taking it more towards graphics, getting them to see letters in terms of shape, doing progressions and making them more abstract and 3D. I found that quite difficult. Then by 1965–6 I think the Art School was taken over and I was getting a bit desperate because I did not want to do this. I wanted to go back to calligraphy. That's when I did my archaeology, and stopped teaching.

BW Since then you have been a very successful professional calligrapher.

AH I've earned my keep, and managed to balance the things I want to do by subsidising those things that might take a year to research. I make posters of them and sell the posters to subsidise 'the thing'; I never try to make the money on the things that I'm passionately interested in… Looking back, I have been very lucky. The easy thing is to be a pioneer, all you have to do is open the gate and discover, and it's fantastic because everything is new. The next person who comes along, say Irene, refines it a bit, clarifies it a bit, explores it a bit more, takes it into their personality, and from that produces something that takes it further. The next person comes along, say my generation, does that a little bit more, but after a bit, there is less to discover… So it's difficult to be innovative without going over the top… Irene saw how you could use calligraphy as a vehicle for personal expression. What you say and how you say it is bound into one, by personal experience. I was still very much in the structure. My things are very classical really. Partly because it's a temperamental thing, I have not gone down the painterly road at all, whereas a lot of people have. I have stuck very much with calligraphy as the recording and imparting of information. I want to read it. It can be decorative and informative, but it is very much to do with reading. As soon as you get the painterly side, you lose that tension of being able to read it. It's much more mark making, which is a whole thing in its own right. Quite valid for some people, but it loses this tension.

BW That is interesting because is not Donald Jackson, who was also taught by Irene, a more painterly calligrapher?

AH Yes, but Donald's work is slightly different and grounded in the medieval. His work in some ways is very classical.

BW What has Irene contributed to your own life and work?

AH The breadth of her thinking, her imaginative capacity. Her landscape was huge. Everything that that landscape touched had to be grounded in you. That's how it all came together, because you understood the relationship between your love of poetry and your love of calligraphy and nature, and that world was based in the thread that joined them. That's why it had authenticity. That's what I think she had, which I think she picked up from Johnston, authenticity. That's why she probed at you all the time. She could tell if you were just showing off, doing a flourish just because you could do them and they looked nice. She wasn't a killjoy. If you felt exuberant, and wanted to put a flourish there, that was all right, but not just to display your technique. You can tell if it's just display of technique, and you can see it in people's work, but, the intention, and the integrity and the passion for the subject, should dictate the form so that the whole thing was integrated and part of you. Then everything that you put down came from and was coloured by you and your sensitivity and work. She had enormous integrity, without being prissy. She was a very warm person, but she could be very penetratingly perceptive.

Irene Wellington
Alphabetical fragments, 1957
A collage of extracts from other calligraphic pieces compiled 'for fun' on a background of S.M. Cockerell combed paper
455 x 610 mm
Courtesy of the Irene Wellington Educational Trust and Crafts Study Centre

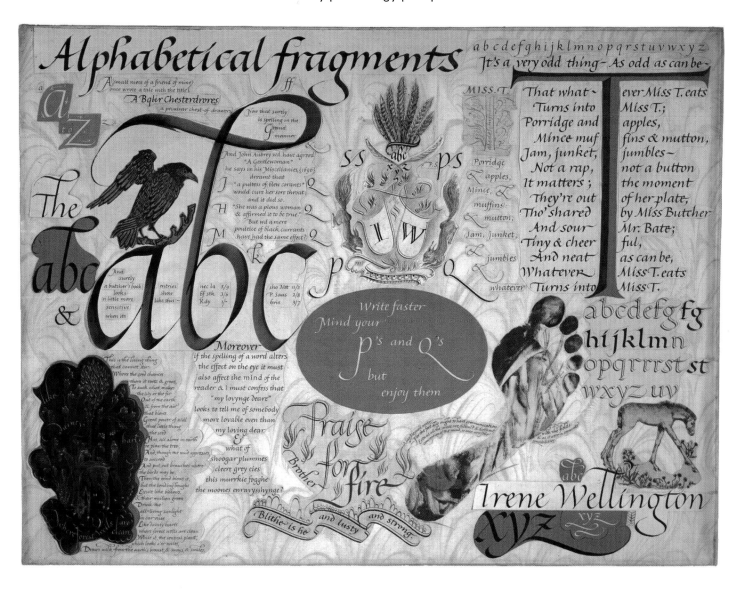

BW Do you have contact with any of the other students at Central?

AH Donald and I were the only products of those years. I have no contact with the other students. After calligraphy stopped at Central and there were no more specialist courses in England, Ann Camp started the course at Roehampton.

BW So the continuation of the teaching of calligraphy does have a connection with Central?

AH Yes. Ann Camp used to teach the evening classes at Central. The people who came to the evening classes were those who did it for pleasure. Irene found it difficult to teach calligraphy at Central because there was a movement towards graphic design.... Graphics was the big push at that time, and calligraphy was too slow. They were saying 'what do we use it for?' without having the sense to realise that everything stems from this human touch. Maybe it should have been taught differently. Nicolette Gray came fairly soon after I left and brought another way of teaching it, not the Johnston tradition, but 'look at everything, all these different kinds of lettering and take what you want out of it'.

1 *More than fine writing; Irene Wellington, calligrapher (1909-84)*, Pelham Books, 1986.

Biographies of some of the Central School staff and students mentioned in this book

Bernard Adeney 1878–1966

He studied at the RCA, the Slade and the Académie Julienne in Paris and became well known as a painter. He was closely involved in the founding of a number of societies for the arts, including the London Group in 1913, the National Society of Painters and the London Artists' Association. Except during the First World War, he taught at the Central School from 1904 to 1947 and ran the School of Drawing and Design from 1908 to 1930, during which time one of his students was Enid Marx. He was then head of the School of Textiles from 1930 to 1947. Although few of his own textiles have been traced, he is known to have designed for Donald Brothers.

Dora Batty 1900–1966

An artist and designer who worked in several media, little is known about her early life and education. She is well known for her London Underground posters – she produced over fifty – and for her advertising work for MacFisheries. As a textile designer she worked for Barlow & Jones and Helios, and as a ceramic designer for Poole Pottery. She was also an illustrator: her work was included in the 'Britain can make it' exhibition in 1946. From 1932 she taught textile design at the Central School and was head of Textiles from 1950–58. Her innovative teaching attracted a number of well-known designers to the staff.

Dora Billington 1890–1968

Born into a family of potters in Staffordshire, she attended the Hanley School of Art and worked as a decorator for Bernard Moore from 1912 to 1915. She studied and subsequently taught pottery at the RCA from 1916 to 1925. She taught at the Central School from 1924 to 1955 and became head of department, which she transformed with her own technical experience and open-minded attitudes. Among her students were Alan Caiger-Smith and Katherine Pleydell-Bouverie. Her own work consisted of studio stoneware typical of the period, and designs for industry, notably J. & G. Meakin. She also wrote on pottery, her book *The art of the potter*, Oxford University Press, 1937, being the first to feature contemporary studio pottery.

Pearl Binder 1904–1990

Born in Staffordshire the daughter of a Jewish tailor, she studied at Manchester School of Art before coming to London in 1925 to study lithography under James Fitton at the Central School. She became active in left-wing politics and was a member of the Artists International Association. Her work was published in the *New Masses*. She lived in the East End slums for several years and used her experiences to illustrate Thomas Burke's *The real East End*, Constable, 1932. She was a freelance lecturer, book illustrator and stained glass designer, and a ceramic designer for Wedgwood.

F. V. Burridge 1869–1945

He studied painting and etching at the RCA. As principal of Liverpool School of Art from 1897 to 1912 he transformed the school and obtained a place on the Board of Education Standing Advisory Committee on Art Education from 1911 to 1916 when he was appointed

to replace Lethaby at the Central School. He fostered the methods and objectives initiated by Lethaby, extending and rationalising the scope of the work of the college. In 1916 he was a founding member of the Design and Industries Association and did much to educate buyers and shop assistants to recognise quality in craft and design.

Lindsay P. Butterfield 1869–1948

He attended night classes at Lambeth School of Art in 1887–8, briefly studied architecture under his cousin Philip Johnstone, and then spent three years at the National Art Training School, South Kensington. By 1894 he was established as a freelance designer. He taught at a number of art colleges, and joined the design staff at the Central School in 1916, teaching in the School of Textiles from 1919 until 1934. By then he was widely known for his designs for the leading textile manufacturers of the day, and in 1922 published *Floral forms in historic design*. In 1930 he was a founder member of the Society of Industrial Designers (now the Chartered Society of Designers).

Joyce Clissold 1905–1982

As a student of Rooke and Adeney at the Central from 1924–7, she worked at Footprints, a workshop founded at Durham Wharf, Hammersmith, in 1925 by Elspeth Little (also a Central student), Gwen Pike and Celandine Kennington, to supply textiles for Little's shop, Modern Textiles, which opened in London in 1926. She returned to Footprints in 1927, taking it over in 1929 and creating all subsequent designs. Footprints moved to Brentford in 1933, and had two London shops in the mid to late 1930s. Clissold taught textile design at the Central from 1936 to 1940 and after the War continued to run Footprints on a smaller scale until her death. Central Saint Martins College of Art & Design holds a substantial Clissold collection and the copyright of her designs.

Jeannetta Cochrane 1882–1957

A student at the Polytechnic School of Art where she developed an interest in historic costume. She taught dress design at the Central School from 1914, became head of the department of theatre design and continued teaching until 1940. She founded Sheridan House (a costume business), which she ran alongside her post at the Central School. She also designed for Liberty and the Craft Studio at Heal's. She designed for many London theatre productions and costumes for masques in Regents Park. She campaigned for a theatre at the Central School which was opened in 1964 and named after her.

Leslie Durbin 1913–

He won an LCC trade scholarship to the Central Day Technical School of Silversmithing at the age of 13. In 1929 he was apprenticed to Omar Ramsden, one of the leading designers and silversmiths of his day. He won two scholarships from the Worshipful Company of Goldsmiths in 1938 and 1939, one to study full-time at the Central School and the other to travel in Europe. After the War he taught part-time at the Central School and the RCA. He had a very successful career with many prestigious commissions, the most important of which was his work on the gold and silver sections of the Stalingrad Sword in 1943.

John Farleigh 1900–1965

Apprenticed in 1914 to the Art Illustrators Agency, he attended evening classes in life drawing at the Bolt Court School. From 1919 to 1922 he was a pupil of Noel Rooke who introduced him to wood-engraving. He taught at Central from 1925 to 1948, training many outstanding wood-engravers. As well as working as a printmaker and book illustrator he designed fabrics and graphics, including posters for London Transport. President of the Arts and Crafts Exhibition Society from 1940 to 1949, he was one of the founder members of the Crafts Centre of Great Britain. He was a respected and influential writer and broadcaster on design, craft, book production and illustration.

James Fitton 1899–1982

Apprenticed to a calico print designer in Manchester in 1914, he attended evening classes until 1921 at Manchester School of Art, where he met L. S. Lowry. He moved to London in 1921 and worked as a studio assistant to Johnson Riddell (printers), while taking evening classes in lithography at the Central School under A. S. Hartrick. He taught lithography at Central from 1933. A founder member of the Artists' International Association, with several of his students he drew many political cartoons for the *Left Review* and *Time and Tide*. He worked as an illustrator, poster designer, oil painter, and textile designer and was elected to the London Group in 1934 and RA in 1954.

Anthony Froshaug 1920–1984

A student of drawing and wood-engraving at the Central School from 1937 to 1939 and a freelance printer, exhibition designer and typographer from 1941, influenced by Jan Tschichold he produced early British examples of progressive European typography, with his own printing press in Cornwall. He taught at the Central School in 1948 and from 1952 to 1953, and 1970 to 1984. He also taught at Coventry and the RCA as well as being professor of graphic design and visual communication at the Ulm Hochschule für Gestaltung from 1957 to 1961. His greatest contribution was probably as an influential and charismatic teacher.

Anthony Gross 1905–1984

He studied fine art at the Slade under Tonks and took evening classes with W. P. Robins at Central. He then studied at the École des Beaux Arts in Paris and travelled widely in Europe. In the Second World War he was an official war artist working in Egypt, India and Burma, as well as Europe. He taught book illustration, etching and engraving at the Central School from 1948 to 1954. He worked extensively as a book illustrator and also did work for the *Strand Magazine* and *Radio Times*, but preferred to be known as a painter and etcher. A retrospective exhibition of his etchings was held at the V & A in 1968. He was elected RA in 1946.

A. E. Halliwell 1905–1987

A student of commercial art at the Southport School of Art in the mid 1920s he went on to study at the RCA from 1923 to 1926. As a freelance designer he became well known for his striking poster designs. He also worked part-time teaching commercial design at Beckenham and Bromley Schools of Art. In 1938 he was appointed to teach at Camberwell School of Art where he became head of the Junior School of Art, taught graphic design and established a basic design course. He moved with William Johnstone to the Central School in 1947 where he started the industrial design course.

Gilbert Harding Green 1906–1983

Born in London he had little formal education. In his late teens he lived in Brazil, travelling up the Amazon and learning Portuguese. He subsequently moved to Italy and lived in Palermo and Rome. On his return to England he studied modelling at Central with John Skeaping and Frank Dobson, and painting at Chelsea. From 1950 he virtually gave up his own modelling to teach with Dora Billington on the Central ceramic course. He took over on her retirement and was head of the Ceramic Department until 1971. He was a very influential teacher encouraging drawing and study of design in other crafts and architecture.

A. S. Hartrick 1864–1950

Born in India, he studied at the Slade School of Fine Art and the Academie Julien in Paris where he knew Gauguin and Van Gogh. He was a founder-member in 1909 of the Senefelder Club with F. E. Jackson, Kerr Lawson and Joseph Pennell. In 1918 in his capacity as war artist he produced two portfolios of lithographs for the London Underground,

War work and *Women's work*. He taught drawing and painting at Camberwell School of Art from 1908 and lithography at the Central School from 1914 to 1929. He worked as a book illustrator and water colourist and did work for magazines, including *The Graphic*.

Luther Hooper 1849–1932

Trained as a book illustrator and wood engraver, he had begun producing repeat patterns by the 1880s and during the next two decades acquired extensive knowledge of cloth and tapestry weaving, having a series of workshops from 1900. He lectured at the Central School from about 1908, running the course on textile trades and distribution from 1916 to 1919, and becoming a staff member in the School of Textiles from 1920 to 1922. *Hand-loom weaving, plain & ornamental*, his 1911 contribution to Lethaby's 'Artistic Crafts Series of Technical Handbooks', remains a standard text, and was illustrated by Hooper and other Central teachers, Rooke and Charlotte Brock. In his retirement he perfected the modern drawloom, detailed by himself in *The new draw-loom*, 1932, and by his student, Alice Hindson, in *The designer's drawloom*, 1958.

Margaret Calkin James 1895–1985

She studied at the Central School from 1914 to 1915, specialising in calligraphy, and at the Westminster School of Art. In 1916 she set up the Rainbow Workshops for the art department of the Central London YMCA. From her marriage in 1922 she designed in a studio at her home. A prolific calligrapher, designer and artist, her clients included London Transport (posters), Jonathan Cape (book jackets), the Curwen Press (pattern papers), the BBC (programmes and booklets) and the GPO, for whom in 1935 she designed the first of the new GPO Greetings Telegrams. For her own home in the mid-1930s she cut lino blocks and printed textiles from them. Some of these were later produced commercially.

Edward Johnston 1872–1944

Invited by Lethaby to start a class on writing and illumination in 1899, he was responsible for the revival of calligraphy in this country. He taught at the Central School and was immensely influential: his students included Eric Gill; Noel Rooke; and Graily Hewitt, who took over his class when Johnston moved to the RCA in 1912. He designed type for Count Kessler's Cranach Press and in 1916 was commissioned by Frank Pick to design type for the London Underground. His typeface Railway is still in use today. He also designed for them the circle and bar symbol, an early corporate identity. Johnston's influence was particularly strong in Germany. His book *Writing & illuminating & lettering*, 1906, was a seminal work.

William Johnstone 1897–1981

Son of a Scottish farmer, he studied at Edinburgh College of Art under Morley Fletcher, in Paris in the 1920s with André L'Hote and Ozenfant, and travelled extensively in the USA. He taught art in various schools and colleges at all levels before becoming principal of Camberwell School of Art in 1938. He became principal of the Central School in 1947, where he gathered together a group of outstanding teachers including some of the most vital young artists of the day. He published a number of books on children's art. There was a major exhibition of his paintings in the Hayward Gallery in 1981.

Morris Kestelman 1905–1998

From 1922 to 1925 he studied at the Central School under Hartrick and Meninsky. From 1926 to 1929 he was at the RCA where his interest in theatre design developed. He designed a number of plays at the Old Vic and Sadler's Wells during the late 1930s and 1940s. He taught at Wimbledon School of Art and from 1936 life drawing at the Central School. He was head of the School of Painting and Sculpture from 1951 to 1971 thus influencing many students. He was a prolific painter changing his style dramatically in later life

to become more abstract. He had a number of one-man exhibitions of his work. He was elected to the London Group in 1951 and RA in 1995.

William Richard Lethaby 1857–1931

Born in Barnstaple he was a student in the department of science and art drawing class there. He was apprenticed to the architect Alexander Lauder in 1871 and became Chief Clerk to Norman Shaw in 1879. A disciple of William Morris and Philip Webb, he was active in the Art Workers' Guild, exhibited at the Arts and Crafts Exhibition Society, and founded Kenton and Company. He was art inspector to the Technical Education Board from 1894, appointed founding principal of the Central School of Arts and Crafts in 1896, and professor of ornament at the RCA from 1911. He was surveyor to Westminster Abbey from 1906. He wrote extensively on art and architecture and edited the *Artistic Crafts Series* of handbooks.

Enid Marx 1902–1998

Educated at Roedean and the Central School from 1921 to 1922 where she studied drawing, pottery and printed textile design, she proceeded to the RCA in 1925 where she studied wood-engraving and painting. In spite of being one of the most outstanding students of her year she failed the final examination because the subject of her painting (a fairground scene) was deemed inappropriate for Fine Art. She worked with Barron & Larcher from 1925 to 1927. She was extremely versatile; her wide range of interests and technical abilities included wood-engraving and autolithography for pattern papers, book jackets and illustrations, postage stamps, textile designs, wallpapers and ceramics, posters and moquette upholstery for London Transport. She was elected RDI in 1944.

Bernard Meninsky 1891–1950

Born in the Ukraine, Meninsky came with his family to Liverpool as a baby. He attended Liverpool School of Art, the RCA and the Academie Julien in Paris. He was the prize pupil at the Liverpool School of Art where he met F. V. Burridge, Lethaby's successor at the Central School. In 1912 he won a scholarship to the Slade. From 1913 to 1950 he taught drawing and painting at Central where he influenced many students. He was a member of the London Group. Meninsky suffered from mental illness for much of his life, finally committing suicide in 1950. A major retrospective of his work was held at MOMA, Oxford, in 1981.

Theo Moorman 1907–1990

Having trained at the Central School under Walter Taylor from 1925 to 1928, producing kelim-style rugs, she joined the Craft Studio at Heal's under the direction of Jeannetta Cochrane. In the early 1930s she had her own studio in London and became a member of the Red Rose Guild. About 1934 she was invited in to set up an experimental unit at Warner & Sons Ltd, Braintree, to hand-weave prototypes for power-weaving. From about 1940 she carried out war-related work and was Assistant Regional Director for the Arts Council from 1943 to 1953. Thereafter she pursued her career as a weaver, developing her own techniques and becoming widely known as a teacher of workshops.

May Morris 1862–1938

The younger daughter of William Morris and well known as an embroiderer in her own right, she directed and then visited the Central School embroidery classes from their inception in 1897 until 1910. During this time, in 1907, she also founded the Women's Guild of Art, and exhibited annually through the Arts & Crafts Exhibition Society. In the 1890s at Morris & Co. she trained Ellen Mary Wright, who taught embroidery at Central from 1899 to about 1937 and was joined there in 1908 by her sister, Fanny Isobel (Mrs Beckett from 1916), who also taught until the late 1930s and had worked at Morris & Co. Both sisters briefly taught at Camberwell in the early 1900s.

H. G. Murphy 1884–1939
He studied metalwork and jewellery at Central from 1898 as a day technical apprentice and then at the RCA with Henry Wilson. He also spent some time studying silversmithing with Emil Lettre in Berlin. He taught jewellery and silversmithing at Central from 1912 and became head of jewellery and metalwork. He became principal of the college in 1935. He established the successful Falcon Studio Workshop in 1915. He was one of the first artist craftsmen to be made an RDI in 1936. He received the Freedom of the Goldsmiths Company in 1929 and became a member of the Court in 1938.

Victor Pasmore 1908–1998
He worked in local government as a clerk in County Hall, London, from 1927 to 1937. He studied in the evenings at the Central School. Sir Kenneth Clark became his patron, freeing him to paint full time. Founder member of the Euston Road School with William Coldstream and Claude Rogers in 1937, he taught painting at Camberwell from 1943 to 1949 and Basic Design at Central under William Johnstone in the early 1950s. At this time he changed his style of painting from representational to abstract. From 1954 to 1961 he was director of Fine Art, University of Newcastle. He was a member of the London Group and was elected RA in 1983.

Margaret Pilkington 1891–1974
She was a student at Manchester College of Art from 1911 to 1913, and from 1913 to 1914 a pupil of Lucienne Pisarro at the Slade; she became a friend of the Pisarro family. She joined Rooke's class in 1914 and was very much influenced by his teaching. In 1920 she founded the Red Rose Guild of Craft Workers and organised annual exhibitions in Manchester. She was an early member of the Society of Wood Engravers, becoming the honorary secretary in 1924. In 1935 she became the director of the Whitworth Art Gallery. She was elected chairman of the Society of Wood Engravers in 1952 and a member of the Art Workers' Guild in 1965.

Katherine Pleydell-Bouverie 1895–1985
Her interest in pottery developed while living in London in the 1920s and seeing pots made by Roger Fry for the Omega Workshops. She studied under Dora Billington at Central from 1921 to 1923 and then spent one year working with Bernard Leach at St. Ives. 'Beano' as she was known got to know Matsubayashi, a Japanese potter who helped her set up a pottery at her family home, Coleshill, in Wiltshire. She was joined by Norah Braden, another former Central student, from 1928 to 1936, and they experimented with a wide range of wood and vegetable ashes for glazes. She was a founder member of the Craftsman Potters Association and served on the Council for over six years. She wrote regularly for *Ceramic Review*.

William Roberts 1895–1980
Apprenticed to Sir Joseph Causton (commercial artists), he attended evening classes at St Martins and held an LCC scholarship at the Slade from 1910 to 1913 when he joined Roger Fry's Omega Workshop. He exhibited as a member of the Vorticist Group in 1915 and signed the Vorticist manifesto, published in *Blast*. His own style is known as Tubism. A member of the London Group, AIA, and an official war artist in both World Wars, he has work in the Imperial War Museum. A major retrospective was held at the Tate Gallery in 1965. He taught drawing at Central from 1925 to 1960.

Noel Rooke 1881–1952
Son of the artist T. M. Rooke he was educated in France, at the Slade, and the Central School under Edward Johnston and W. R. Lethaby. He taught book illustration at Central from 1905 and wood-engraving from 1912. He was responsible for the revival of the art of

wood-engraving and trained Robert Gibbings, John Farleigh and Clare Leighton; his influence can be seen in the work of many students. He was a founder member of the Society of Wood Engravers. He also taught book illustration, composition, poster and advertisement design. He retired from the Central School in 1947.

Douglas Scott 1913–1990

He studied silversmithing and jewellery at the Central School from 1926 to 1929 and worked for a number of design practices, including Raymond Loewy Studio (London), from 1936 to 1939, for whom he redesigned the Rayburn and Aga cookers for Allied Ironfounders. In the Second World War he worked for de Havilland on aero engines. Alongside his own practice he set up a pioneering industrial design course at Central from 1945 to 1949, and taught there again from 1952 to 1976. His wide range of designs include work for London Transport, Rediffusion and the GPO. He designed the Routemaster double-decker bus in 1953. He was elected RDI in 1974.

Naum Slutzky 1894–1965

Trained as a goldsmith in Vienna he became a member of the Wiener Werkstatte in 1912. From 1916 to 1919 he studied at the Johannes Itten Wiener Kunstschule. From the early 1920s he taught as a goldsmith and metalworker at the Bauhaus in Weimar. In 1933 he fled from the Nazis to England and taught at Dartington Hall and the Royal College. From 1945 to 1956 he was at the Central School teaching both jewellery and industrial design. From 1957 to 1964 he was head of the Industrial Design department in Birmingham School of Arts and Crafts. In 1961 he exhibited at the first international exhibition at Goldsmiths Hall to be held after the War.

Herbert Spencer 1924–

He worked with London Typographic Designers from 1946 to 1947 and established his own design practice in 1948. He taught part-time at the Central School from 1949 to 1955 where he introduced students to modern European typographic developments and encouraged them to experiment. In 1949 he founded *Typographica*, an influential avant-garde journal on printing and typography, and was editor until 1967. He has held many consultancies including Lund Humphries (publishers) since 1950, the RIBA, W.H. Smith and the Tate Gallery. He was professor of graphic arts at the RCA from 1978 to 1985. His publications include *The visible word*, 1968, and *Pioneers of modern typography*, 1969. He was elected RDI in 1965.

Marianne Straub 1909–1994

Having studied at the Zurich Kunstsgewerbeschule, Bradford Technical College and in Ethel Mairet's workshop, Gospels, she began her career as a woven fabrics designer as the peripatetic designer from 1934 to 1937 for the seventy-two Welsh woollen mills supported by the Rural Industries Bureau. She became the head designer of Helios, an independent subsidiary of Barlow & Jones Ltd, Lancashire, from 1937 to 1950, and managing director from 1947 to 1950. From 1950 to 1970 she was a designer for Warner & Sons Ltd, Braintree. With a wide knowledge of the materials, machines and markets for which she designed, she remained relatively anonymous as a designer until late in her life, being better known for her extensive teaching from 1956 to 1992. This began at the Central School, where she taught from 1956 to 1964, having been persuaded to do so by the presence of Dora Batty whom she knew through the latter's design work for Barlow & Jones and Helios. She was elected RDI in 1972.

Hans Tisdall 1910–1997

Born Hans John Knox Aufsesser in Munich, he studied at the Academy of Fine Art, Munich, and was apprenticed to a sculptor in Paris. He married Isabel Gallegos of Tamesa Fabrics

for whom he made many designs, as well as for Edinburgh Weavers. He also designed murals, tapestries and mosaics. He is known for his distinctive book illustrations and jackets. He taught at Central from 1947 to 1962, initially in the textile design department but mainly in the School of Painting. He won the competition to design the entrance to the fun fair, Battersea Pleasure Gardens, at the Festival of Britain, 1951.

R. R. Tomlinson 1885–1978

Between 1906 and 1909 he studied etching under Sir Frank Short at the RCA. He won a Royal Exhibition scholarship and travelled extensively in Europe. He became chief pottery painter and designer to Bernard Moore and from 1913 to 1919 was art director of Crown Staffordshire Porcelain. He was principal of Cheltenham School of Art and from 1925 to 1951 senior inspector of art to the LCC. From 1939 to 1947 he was also acting principal of the Central School and supervised the Central contribution to the Stalingrad Sword. A painter in oil and watercolour, he also wrote on art, including *Lettering for arts and crafts*; *Memory and imaginative drawing*, and several books on art for children.

Robert Welch 1929– 2000

A student at Malvern School of Art, Birmingham College of Art and the RCA, he developed a special interest in stainless steel in 1954–5 and established his workshop in Chipping Camden in 1955. His work in silver and stainless steel was displayed in Foyle's Gallery in 1956 and seen there by Halliwell, who invited him to teach part-time in the industrial design department at the Central from 1956. His silverware and stainless steel were exhibited at Heal's in the 1960s. He is particularly known for his Old Hall tableware, cast iron cookware, and Alveston cutlery. He was elected RDI in 1965.

Irene Wellington 1904–1984

A student at Maidstone School of Art from 1921 to 1925, she won a Royal scholarship to the RCA where she was a pupil of Edward Johnston from 1925 to 1930, and his assistant in the calligraphy class from 1927 to 1928. She taught Writing and Illuminating, part-time, at Edinburgh College of Art from 1932 to 1943, and part-time at the Central School from 1944 to 1959. Very much in the Johnston tradition, she also developed calligraphy as a personal statement. Her vision of the craft has made an important contribution to the art form it is today. The Crafts Study Centre, Holburne Museum, Bath, has a large collection of her work.

Edward Wright 1912–1989

A student at Liverpool School of Art and Bartlett School of Architecture from 1930 to 1936, he specialised in lettering for architectural environments, such as the rotating triangular sign for New Scotland Yard, London, 1968, and an illuminated sign for the Tate Gallery, Liverpool, 1988. He taught evening classes in experimental typography at the Central School in the early 1950s which were very influential; he also taught at the RCA. He was head of graphic design at Chelsea School of Art in the 1970s. Co-designer with Theo Crosby of the 'This is Tomorrow' exhibition at the Whitechapel Gallery, 1956, he also designed 'Art in Revolution', at the Hayward Gallery, 1971, and 'Dada and Surrealism Reviewed', Hayward Gallery, 1978. A major exhibition of his work was held at the Tate in 1985.

Selected general reading
on Central School staff and students

The Arts Council of Great Britain, *Thirties: British art and design before the war*, Hayward Gallery exhibition catalogue, The Arts Council, 1979.

Sylvia Backemeyer and Theresa Gronberg, eds, *W. R. Lethaby 1857–1931: architecture, design and education*, Lund Humphries, 1984. (Contains biographies of early Central staff.)

Sylvia Backemeyer, ed., *Object lessons: Central Saint Martins Art and Design Archive*, Lund Humphries in association with the Lethaby Press, 1996.

David Buckman, ed., *Dictionary of artists in Britain since 1945*, Art Dictionaries Ltd, 1998.

Central School of Art and Design, Department of Industrial Design, *Central to design central to industry*, Central School of Art and Design, 1982.

Peter Docherty and Tim White, eds, *Design for performance: from Diaghilev to the Pet Shop Boys*, Lund Humphries in association with the Lethaby Press, 1996. (Contains information about the Central Theatre Design Department and many short biographies of staff and students.)

Oliver Green, *Underground art*, Studio Vista, 1990.

Alan Horne, ed., *The dictionary of twentieth century British book illustrators*, Antique Collectors Club, 1994.

Alan and Isabella Livingston, *The Thames and Hudson dictionary of graphic design and designers*, Thames and Hudson, 1998.

Fiona MacCartney and Patrick Nuttgens, *Eye for industry: Royal Designers for Industry, 1936–1986*, Lund Humphries, 1986.

Colin Naylor, ed., *Contemporary designers*, (Contemporary Arts Series), St James Press, 1990.

Godfrey Rubens, *William Richard Lethaby*, The Architectural Press, 1986.

Joanna Selborne, *British wood-engraved book illustrations 1904–1940: a break with tradition*, Oxford, Clarendon Press, 1998.

Janice West, *Made to wear: creativity in contemporary jewellery*, Lund Humphries in association with the Lethaby Press, 1998. (Information about Central jewellery designers.)

Royal Academicians

who were former students or staff at the Central School, with dates of election and preferred media

ARA	RA			
1894	1902	Sir George Frampton	1860–1928	*sculpture*
1900	1913	Alfred Drury	1856–1944	*sculpture*
1922	1930	Sydney Lee	1866–1949	*painting, printmaking, wood-engraving*
1922	1931	Alfred Turner	1874–1900	*sculpture*
1929	1936	Richard Garbe	1876–1957	*sculpture*
1935		Eric Gill	1882–1940	*sculpture, printmaking, book design, typography, illustration*
1939		C. R. W. Nevinson	1889–1946	*painting, printmaking*
1944	1954	James Fitton	1899–1982	*painting*
1944		F. Ernest Jackson	1873–1945	*painting, printmaking, lithography*
1950	1959	John Skeaping	1901–1980	*sculpture*
1958	1966	William Roberts	1895–1980	*painting*
1962	1970	Edward Ardizzone	1900–1979	*watercolour painting, illustration*
1963	1971	Gertrude Hermes	1901–1983	*printmaking, illustration, wood-engraving, sculpture*
	1995	Morris Kestelman	1906–1998	
1972	1979	Sir Eduardo Paolozzi	1924–	*sculpture, printmaking*
	1983	Victor Pasmore	1908–1998	*painting, printmaking*
1974	1984	Paul Hogarth	1917–	*printmaking, illustration, watercolour painting, graphic design*
1977	1983	Michael Rothenstein	1908–1993	*printmaking, painting*
	1988	Cecil Collins	1908–1989	*painting, printmaking*
1979	1980	Anthony Gross	1905–1984	*printmaking, etching, illustration, watercolour painting*
1982	1990	Theo Crosby	1925–1994	*architecture, interior design, town-planning*
	1991	Sir Denys Lasdun	1914–	*architecture*
1988	1991	Norman Ackroyd	1938–	*printmaking, etching, painting*
1989	1991	Diana M. Armfield	1920–	*painting*
	1992	Adrian Berg	1929–	*painting*

Royal Designers for Industry

who have been students or staff at the Central School
with dates of election and preferred media

1936	Douglas Cockerell	1870-1945	bookbinding
	Eric Gill	1882-1940	sculpture, lettercutting, typography, wood engraving
	James Hogan	1883-1948	glass and stained glass design
	J. H. Mason	1875-1951	printing, typography
	H. G. Murphy	1884-1939	gold and silversmithing
1943	Enid Marx	1902-1998	textile and graphic design, print making, illustration
1947	Ashley Havinden	1903-1973	graphic and textile design
1959	F. H. K. Henrion	1914-1990	graphic identity and corporate identity
1965	Herbert Spencer	1924-	typography
	Robert Welch	1929-2000	product design, silversmithing
1972	Alan Fletcher	1931-	graphic design
	Marianne Straub	1909-1994	textile design
1973	Noel London	1925-	engineering product design
	Howard Upjohn	1925-1980	industrial design
1974	Edward Ardizzone	1900-1979	illustration
	David Carter	1927-	industrial design
	Colin Forbes	1928-	graphic design
	Lynton Lamb	1907-1977	book design and illustration
	Douglas Scott	1913-1990	industrial design
1975	Eileen Diss	1931-	television, film and theatre design
1979	Paul Hogarth	1917-	illustration
1983	Derek Birdsall	1934-	graphic design
1984	Eileen Ellis	1933-	textile design
	Ralph Koltai	1924-	theatre design
1988	Bill Moggridge	1943-	product design
1989	Ron Sandford	1937-	graphic design
1990	Rodney Kinsman	1943-	furniture design
1991	Alan Tye	1933-	product design
1994	Alan Kitching	1940-	graphic design
1995	Robin Levien	1952-	ceramics and glass design
	David Lewis	1927-	engineering design
1996	John Napier	1944-	theatre and film design
1999	Anthony Powell	1935-	costume design
	Wendy Ramshaw	1939-	jewellery design

Manuals and technical handbooks

A selection by former staff and students of the Central School

BOOKBINDING

Douglas Cockerell, *Bookbinding, and the care of books* (The Artistic Crafts Series of Technical Handbooks), John Hogg, 1901.

CALLIGRAPHY

John Biggs, *The craft of lettering*, Blandford Press, 1961.

John Biggs, *The craft of the pen*, Blandford Press, 1961.

John Biggs, *The craft of script*, Blandford Press, 1964.

Alfred Fairbank, *A handwriting manual*, Dryad Press, 1932.

Alfred Fairbank, *A book of scripts*, Harmondsworth, Penguin, 1949.

Graily Hewitt, *Handwriting: everyman's handicraft* LCC Central School of Arts and Crafts, 1915.

Graily Hewitt, *Lettering for students and craftsman* (The New Art Library), Seeley Service & Co. Ltd, 1930.

Edward Johnston, *Writing and illuminating and lettering* (The Artistic Crafts Series of Technical Handbooks), John Hogg, 1913.

Irene Wellington, *Copy books: omnibus edition*, A. & C. Black, 1979.

DRAWING, PAINTING AND PRINTMAKING

John Biggs, *Illustration and reproduction*, Blandford Press, 1950.

Harold Curwen, *Processes of graphic reproduction*, Faber & Faber, 1934.

Anthony Gross, *Etching, engraving and intaglio printing*, Oxford University Press, 1970.

A. S. Hartrick, *Drawing*, Pitman, 1921.

A. S. Hartrick, *Lithography as a fine art*, Oxford University Press, 1932.

Paul Hogarth, *Creative ink drawing*, Watson Guptill, 1968.

Lynton Lamb, *Preparation for painting*, Oxford University Press, 1954.

Lynton Lamb, *Drawing for illustration*, Oxford University Press, 1962.

Lynton Lamb, *Materials and methods of printing*, Oxford University Press, 1970.

Mervyn Peake, *The craft of the lead pencil*, A. Wingate, 1947.

W. P. Robins, *Etching craft*, Batsford, 1922.

Henry L. Trivick, *Autolithography*, Faber & Faber, 1960.

FASHION & EMBROIDERY

Anne Brandon-Jones, *Simple stick patterns for embroidery*, Batsford, 1926.

Mrs Archibald H. Christie, *Embroidery and tapestry weaving* (The Artistic Crafts Series of Technical Handbooks), John Hogg, 1906.

Archibald H. Christie, *Traditional methods of pattern designing*, Oxford, Clarendon Press, 1929.

May Morris, *Decorative needlework*, Joseph Hughes & Co., 1893.

Norah Waugh, *Corsets and crinolines*, Batsford, 1954

Norah Waugh, *The cut of men's clothes*, Faber & Faber, 1954.

Norah Waugh, *The cut of women's clothes*, Faber & Faber, 1968.

GRAPHICS & TYPOGRAPHY

John Biggs, *An approach to type*, Blandford Press, 1949.

John Biggs, *Basic typography*, Faber & Faber, 1968.

Ken Garland, *Graphics handbook*, Studio Vista, 1966.

Ken Garland, *Illustrated graphics glossary of terms used in printing, publishing, photography,* Barrie and Jenkins, 1980.

Hal Missingham, *A student's guide in commercial art*, Faber & Faber, 1948.

Herbert Spencer, *Design for business printing*, Lund Humphries, 1952.

POTTERY

Dora Billington, *The art of the potter,* (The Little Craftbook Series), Oxford University Press, 1937.

Dora Billington, *The technique of pottery*, Batsford, 1962.

SILVER WORK AND JEWELLERY

A. R. Emerson, *Hand-made jewellery*, Dryad Press, 1953.

H. Wilson, *Silverwork and jewellery*, (The Artistic Crafts Series of Technical Handbooks), John Hogg, 1912.

STAINED GLASS

C. W. Whall, *Patterns for lead-glazing by C. W. Whall and his pupils*, Chiswick Press for Lowndes and Drury, 1900.

Christopher Whall, *Plain glazing*, Chiswick Press for Lowndes and Drury, 1907.

C. W. Whall, *Stained glass work* (The Artistic Crafts Series of Technical Handbooks), John Hogg, 1905.

WEAVING

Alice Hindson, *The designer's drawloom: an introduction to drawloom weaving and repeat pattern planning*, Faber & Faber, 1958.

Luther Hooper, *Hand-loom weaving: plain and ornamental* (The Artistic Crafts Series of Technical Handbooks), John Hogg, 1910, Facsimile reprint first edition, Pitman, 1979.

Luther Hooper, *Weaving with small appliances*, parts 1 and 2, Pitman, 1922.

Mary Kirby, *Designing on the loom*, Studio Publications, 1955.

WOOD CARVING

George Jack, *Woodcarving: design and workmanship* (The Artistic Crafts Series of Technical Handbooks) John Hogg, 1903.

WOOD ENGRAVING

John Biggs, *The craft of woodcuts*, Blandford Press, 1963.

Dorothea Braby, *The way of wood engraving*, The Studio, 1953.

John Farleigh, *Graven image*, Macmillan, 1940.

John Farleigh, *Engraving on wood*, Leicester, Dryad Press, 1954.

Clare Leighton, *Wood engravings of the 1930s*, The Studio, 1936.

George Mackley, *Wood engraving*, The National Magazine Co., 1948, republished Old Woking, Gresham Books, 1981.

Frank Morley Fletcher, *Wood-block printing*, John Hogg, 1916.

John O'Connor, *The technique of wood engraving*, Batsford, 1971.

Noel Rooke, *Woodcuts and wood engravings*, Print Collectors' Club, 1926.

Michael Rothenstein, *Linocuts & woodcuts*, Studio Books, 1962.

Michael Rothenstein, *Frontiers of printmaking: new aspects of relief printmaking*, Studio Vista, 1966.

Michael Rothenstein, *Relief printing*, Studio Vista, 1970.

Index

Numbers in italics refer to illustrations